THE ANATOMY OF ART

THE ANATOMY
OF ART

PROBLEMS IN THE DESCRIPTION
AND EVALUATION OF WORKS OF ART

By

THOMASINE KIMBROUGH KUSHNER

WARREN H. GREEN, INC.
St. Louis, Missouri, U.S.A.

Published by

WARREN H. GREEN, INC.
8356 Olive Boulevard
St. Louis, Missouri 63132

Library of Congress Catalog Card No. 760528
ISBN No. 87527-248-7

Printed in the United States of America

Preface

The subject of this inquiry can be posed in a simple question, "Can art be evaluated, and if so, how?" To address this question seriously requires a more general approach to aesthetics than is current. Instead of concerning themselves with the broader issues, most contemporary aestheticians have focused their attention on more specific matters, such as how various aesthetic vocabularies are used in the particular arts. This narrowing of objectives can probably be traced to a persistent doubt current since the 1930's that any general theory of art is possible. It has been assumed that a general theory would depend on locating those necessary characteristics which things must share to be called works of art, a will-o'-the-wisp search rooted in what is described as "the fallacy of essentialism."

More recently, Morris Weitz has suggested that the very question, "What is art?" is meaningless, and the most we can say about "art" is that art is, as Wittgenstein described "games," a "family resemblance" notion; that art is, according to Weitz, a term without boundaries which accounts for difficulties of definition. One can grant the position of men like Weitz, Sibley and others, that there are no necessary and sufficient conditions linking together all those things we refer to as "art" without concluding that boundaries cannot, or should not, be drawn. Wittgenstein, it will be remembered, clearly took the view that for special purposes we can draw boundaries for concepts, and it is my point that aesthetics, in so far as it is involved in criticism, *is* just such a special purpose. A primary function of this inquiry will be defining art, but defining it for a special purpose—the purpose of evaluating works of art.

There are problems which still trouble the common intellectual community, such as how one might go about showing how Bach is not so great as Beethoven, or that one composition

by Beethoven is better than another composition by Beethoven. Issues such as these will not be resolved by having aestheticians talking with other aestheticians and working out the fine points of their agreement, but rather by taking into account the practical needs which critics in the various disciplines have for a reasonable way of describing works of art, in analyzing their construction, so that they may then be evaluated.

While the interest of contemporary aestheticians has not been in constructive aesthetics, that is, offering suggestions as to how aesthetics can move ahead to provide a useful account of art, their criticisms of the errors of the past provide a considerable contribution in sharpening the perimeters of the question and enabling us to focus our attention on it more precisely. The purpose of this study will be to construct a general theory of art, taking into consideration not only what modern aestheticians say, but also keeping in mind constantly the basic trends of criticism in the various arts. The goal will be to construct a theory in such a way that there will be a common language in terms of which specific art types can be discussed so as to make their common features apparent, leading, therefore, to common standards of evaluation.

Acknowledgments

I would like to acknowledge most gratefully the help of the following: Dr. John Knoblock for engendering these ideas on aesthetics, encouraging me to explicate them, and for generously giving aesthetic phrases by the yard during their development; Dr. Edith Watson Schipper for introducing me to the kaleidoscope of aesthetic problems; Dr. Joseph Rohm for his musical instruction and analysis of Beethoven's Opus 111; Thomas E. Crowder for his bouts of editing; my husband Malcolm and daughter Kim, to whom this book is dedicated, for giving me heart to play the game.

T.K.K.

Contents

PART I

Chapter One

Conceptual Difficulties

Deciding what a work of art entails is not a task that usually demands attention until galleries, with great solemnity, display objects such as a fur-lined tea cup, saucer and spoon by Oppenheim, Brillo cartons and Campbell Soup cans by Warhol, or concert audiences are presented John Cage's *Silence—4 Minutes 33 Seconds* where a pianist sits at a piano in total silence for that amount of time.[1] Then one begins to wonder by what standards can a work of art be judged or if this is a work of art at all? The answer to this question seems to call for a definition, and a promising line of investigation might appear to be asking what it is that all works of art share. Initially however, this approach appears to be confusing, to say the least, when one considers the diversity of works of art. For example, if, for the purposes of examination, samples from various areas of art such as a Beethoven sonata, a painting by Michelangelo and a poem by Rilke are chosen, what feature(s) can be said to be common to them all?

Current thinking about the issue charges that there simply are no common denominators in art and this position is reflected in the many abortive attempts to come to some satisfactory definition of the term "art" itself. The suggestion is that to suppose all works of art share a common essence or necessary characteristics is to commit what has been called the "essen-

[1] The limit would seem to have been reached with Robert Barry's statement written in October of 1969, "My exhibition at the Art and Project Gallery in Amsterdam in December '69, will last two weeks. I asked them to lock the door and nail my announcement to it, reading: "For the exhibition the gallery will be closed."

tialist fallacy."[2] Essentialism can be traced back to the Aristotelian view that what a thing is and what we can know of it lies in its essential nature which it shares with other objects of the same kind. Examples of essentialist assumptions in aesthetics are not hard to find. For example, in the first chapter of his book, *Art*, Clive Bell says:

> ...if we can discover some quality common and peculiar to all the objects that provoke (the aesthetic emotion), we shall have solved what I take to be the central problem of aesthetics. We shall have discovered the essential quality of a work of art...For either all works of visual art have some common quality, or when we speak of 'works of art' we gibber ...What is this quality?...Only one answer seems possible— significant form.[3]

Suzanne Langer too begins her work *Feeling and Form* convinced that a definition of art in terms of necessary and sufficient conditions can be given:

> I also believe that art is essentially one, that the symbolic function is the same in every kind of artistic expression, all kinds are equally great, and their logic is all of a piece, the logic of non-discursive form (which governs literary as well as all other created form)...there is a definite level at which no more distinctions can be made; everything one can say of any single art can be said of any other as well. *There lies the unity.* All the divisions end at that depth, which is the philosophical foundation of art theory.[4]

However, skepticism regarding a general definition of "art" appeared as early as 1785 when the Scottish philosopher, Thomas Reid declared himself unable to conceive of any common denominator liking all the various things that are referred to as beautiful. The thrust of Reid's discussion was to deny the existence of a common essence in either beautiful objects or in works of art.[5]

[2]See Chapter I of W. Elton's *Aesthetics and Language*. New York: Philosophical Library, Inc. 1954. For articles critical of essentialism in aesthetics see: W.B. Gallie, "The Function of Philosophical Aesthetics" in *Mind* 1948. Vol. LVII, p. 302-321 and Frank Sibley, "Aesthetic Concepts," *The Philosophical Review,* Vol. LXVII (1959) pp. 421-50.

[3]Clive Bell, *Art*. New York: Capricorn Books, 1958, p. 17.

[4]Suzanne Langer, *Feeling and Form*. New York: Scribner's 1953, p. 103.

[5]Harold Osborn, *Aesthetics and Art Theory*. New York: E.P.Dutton & Co., Inc., 1970, p. 254.

More recently, Morris Weitz extends the attack against essentialism in aesthetics by suggesting that the very question "What is art?" is meaningless and the persistent pursuits carried on by aestheticians for definitions of art that have characterized the history of aesthetics have been doomed from the start. Weitz uses arguments that he says are based on Wittgenstein.

Although Wittgenstein makes only passing references to art in his work, what he has to say on definitions, and specifically his remarks on "games," have had an influence on art theory. He suggests that the urge to discover essential characteristics is prompted by an erroneous notion about language; that is to identify correctly things as belonging to a group one must identify some common denominator. Wittgenstein asks the reader to

> Consider the example, the proceedings that we call 'games.'
> I mean board games, card games, ball games, Olympic games, and so on. What is common to them all?[6]

His conclusion is that there is no characteristic which is common to each and every thing we call "game;" therefore, there is no characteristic necessary for something to qualify as a game. Instead, he says " . . . we see a complicated network of similarities overlapping and criss-crossing."[7] These criss-crossings he terms "family resemblances"[8] by which he means those similar trends and conditions that correspond between things. The point of Wittgenstein's argument is that as words function in language itself, as they function in everyday usage, they are not precise in regards to their boundaries. Because this is the case, Wittgenstein says we should respect the "open-texture" of language and realize that a word has a variety of meanings and that new meanings will arise in accord with uses.

In applying Wittgenstein's thesis to a theory of art, Weitz

[6]Ludwig Wittgenstein, *Philosophical Investigations*. Trans. Anscombe New York: MacMillan, 1953, p. 32e.

[7]*Ibid.*

[8]Dugald Steward anticipated Wittgenstein's notion of overlapping similarities or "family resemblances." He says "I shall begin by supposing that the letters A, B, C, D, E denote a series of objects; that A possesses some one quality in common with B; B a quality in common with C; C a quality in common with D; D a quality in common with E; while at the same time no quality can be found which belongs in common to any three objects in the series." Quoted in Osborne, *Aesthetics and Art Theory*, p. 254. Steward does suggest also that the entire series can be referred to by a common designation.

argues that "art" like "games" is a term without boundaries (i.e., an "open concept") which accounts for its evasiveness. He says:

> 'Art,' itself, is an open concept. New conditions (cases) have constantly arisen and will undoubtedly constantly arise; new art forms, new movements will emerge which will demand decisions on the part of those interested, usually professional critics, as to whether the concept should be extended or not. Aestheticians may lay down similarity conditions but never necessary and sufficient ones for the correct application of the concept. With 'art,' its conditions of application can never be exhaustively enumerated since new cases can always be envisaged or created by artists, or even nature which would call for a decision on someone's part to extend or to close the old or to invent a new concept. (E.g., "It's not a sculpture, it's a mobile.")
> What I am arguing, then, is that the very expansive, adventurous character of art, its ever-present changes and novel creations, makes it logically impossible to ensure any set of defining properties. We can, of course, choose to close the concept. But to do this with 'art' . . . is ludicrous since it forecloses on the very conditions of creativity in the arts.[9]

Because of this, Weitz suggests the study of aesthetics is inherently vague. He says that while various theories of art pretend to be complete statements about the defining features of all works of art, each leaves out something which other theories treat as central (e.g., Bell and Fry leave out representation, while Croce leaves out physicalness, etc.).

Weitz appropriately raises questions about the advisability and feasibility of attempting to ferret out necessary and logical properties of art, and correctly suggests that "If we actually look and see what it is that we call 'art' we will find no common properties—only strands of similarities."[10] However, the accuracy of this observation does not provide grounds for sharing in Weitz's conclusion that boundary drawing with regard to the concept" 'art' . . . is ludicrous." In this respect, Weitz seems to have misunderstood Wittgenstein's position. Wittgenstein, in suggesting that definitions are no more than the designat-

[9]Morris Weitz, *Problems in Aesthetics,* Second Edition. New York: MacMillan, 1959, p. 176.

[10]*Ibid.*

ing of shared family resemblances, cautions that to attempt to deal with definitions in a stricter manner would only be playing with words. But for special purposes a concept can *be given* limits, and when this is done it is like bringing a picture into a clearer and clearer focus. If it were desirable, rigid limits could be set to the word "game," that is, one could use the word for a limited concept (draw a boundary or a frontier) but so far none has been drawn since one "can also use it so that the extension of the concept is *not* closed by a frontier" and he adds, "This is how we do (in fact) use the word 'game'."[11]

It is the suggestion here that in so far as aesthetics is concerned with criticism as evaluation, the process of creating an aesthetic theory is just the sort of "special purpose" mentioned by Wittgenstein; that is, it must involve the process of delineating the use of the word "art" more precisely and more narrowly than the word would occur in our ordinary language game. *This is not to claim that either philosophy or more specifically aesthetics, need always be concerned with drawing relatively clearer and clearer conceptual boundaries; but simply that for the purpose of dealing with the relationship of aesthetics to criticism, which is the interest of this paper, it is an effective procedure.*

Wittgenstein would, of course, warn against our equating the precise boundary of a concept that we draw for some special purpose (like aesthetics) with the meaning of the word itself. Thus, while boundaries may be drawn, an error is committed if the supposition is made that the boundary outlined for a specific purpose is the boundary for all uses of that word in all language games. The fact that people might, when going from one language game to a more precise language (like that of aesthetics) be confused, is only to be expected—just as a novice in the discipline of physics makes some mistakes in the use of the word "mass" or the word "motion," or any other terms which may happen to occur not only in the particular discipline but also in ordinary language.

Another difficulty with Weitz's position is that there is no reason to assume, as Weitz does, that aesthetics is inherently vague because of the undefinability of art as a concept. For the same charge could be leveled against any discipline, for example, chemistry, biology or physics. It is only part of the maturation process of an intellectual discipline that its ambiguities gradu-

[11]Wittgenstein, *Op cit*, p. 33e.

ally disappear as more successful means of dealing with the subject matter are developed. In short, Weitz's definition of concept is itself so broad that it applies to every concept which has ever been articulated and his objection is no more applicable to aesthetics than it would be to any intellectual endeavor, including his own work. So, the vagueness which he thinks is art, which makes aesthetics impossible would make physics, chemistry and biology equally impossible, along with other areas that are usually thought to be more cogent than aesthetics.

The point to be made here is not that we would want to take exception with Weitz, or any other theory, which says that the best way to approach the concept of art is to see it as a family resemblance notion. To the contrary, a neglected challenge in aesthetics has been to take the suggestion that the way to look at the term "art" *is* as a family resemblance notion and this being so, go on to consider what those resemblances are, and how the notion of family resemblance works in relation to art. A concern of this investigation will be to work out in some detail a boundary for a term like "art," differing from Weitz about the unadvisability of drawing frontiers and setting boundaries for art. Even though art consists only of family resemblances, any particular part of the family will have to have sufficiently distinct boundaries so as to be able, for example, to exclude extraneous elements from the work and from the experience of the work. To be able to demarcate in this way is a necessary criterion for any kind of critical evaluation. Thus, even with a family resemblance approach to art it is still necessary to draw boundaries; for if a concept is blurred and we blur it more by not marking a boundary, then theoretically one reaches a dead end.

Keeping these things in mind it seems that the solution to the problem of defining "art" is this: it is not that there is some necessary definition for "art" to be uncovered, but that we use the word "art" in many different ways and that the definition one draws is going to be determined by the context in which one employs the definition. Now in coming to draw a boundary for the way "art" should be used in aesthetics it would be erroneous to suggest either of two things: (a) that one can suggest that the boundary which one draws is the boundary that anyone who examines the subject will always and inevitably draw and (b) that aesthetics will always be a vague area of inquiry in that no boundaries can ever be drawn. Putting it another way, it would be quite wrong to insist that anyone who intelligently examines the field of fine art will inevitably come to a previous-

ly formulated definition; on the other hand, it is also wrong to judge from the difficulty in devising a definition that no definition at all can be offered and that therefore, all definitions are of equal value.

Approaches to Boundary Making

Before embarking on the task of sketching out the perimeters of the boundary of art within an aesthetic context, it is necessary to examine the ways the term is used and some of the factors that go into determining how one draws a particular boundary. The task of sorting out how the term "art" is used for aesthetic purposes is a baffling task when one considers the various kinds of "art" that exist; and for this reason, it is unfortunate that only one word for "art" exists in English because the word has such a variety of functions. First, there are uses of the word "art" that have to do with the art of cooking, weaving, woodworking and other highly developed skills. But aesthetics is not the study of skill or technique, though it is true that all those things which aesthetics examines do include some degree of skill or technique. This means that although a skill may be a necessary condition proper to the realm of aesthetics, it is not a sufficient condition. That is, art cannot exist without some skills, on the other hand, skills may be utilized without resulting in art from an aesthetic point of view. In addition, there is the notion of what are called "fine arts" and in college catalogues a distinction is usually made between those courses that teach "arts and crafts" (such things as pottery making and courses that deal with the "fine arts" (painting, sculpture, etc.).

The method by which one differentiates "arts" that are really skills or crafts from the fine arts, which is the concern of aesthetics, will be determined by the fundamental decision made about what the core of aesthetic value is. That is, the precise boundary one draws concerning the way "art" is used for purposes of criticism, i.e., evaluation which is the focus of this thesis depends, in part, on one's choice between two basic evaluative approaches commonly taken by critics in answering the question, "Is aesthetic value fundamentally concerned with the structure of a work of art, or a message contained in that structure?" The disagreement between these two foci of criticism is outlined by Walter Sutton in *Modern American Criticism:*

Behind the confusion of critical language is a lack of agree-

7

ment about the object of criticism. Psychological critics have tended to consider the work a construct of *dream symbols,* to be interpreted in terms of Oedipal relationships or rebirth archetypes. The New Humanists' concern for *dualism,* the *inner check,* and the *ethical imagination* restricts literature to a narrow scheme of moral, philosophical, and religious values. Marxist critics, interested in the relationship of the literary work to its social environment, have viewed literature as a projection of the *class struggle.* The New Critics, to whom the work is a self-contained language system, have focused upon *irony, paradox,* and *tension* as structural principals. The neo-Aristotelians, attempting to revive the doctrine of art as *imitation,* have relied heavily upon the terminology and genre classifications of Aristotle's *Poetics.*[12]

What will be referred to here as the "message approach to art" emphasizes what it is that the work of art communicates; that is, one might purport that every work of art contains some information, theory or idea in the sense of a paraphrasable message and it is there that the work's value is to be found. According to a message approach the work of art consists not only of the structure, which is akin to the grammar or logical syntax of a sentence, but also includes the "idea" which can be akin to a philosophical or religious doctrine and is contained, as it were, within that structure. Consequently, what is important about a work of art from this perspective is its message. Thus, when a person understands a work of art, understanding is in terms of that message. The structure of the work of art becomes the medium through which the ideas of the artist are in some sense or other communicated to the person who responds.

Some readers may be puzzled as to why I am including, for purposes of examination, a message approach to art since most contemporary English-speaking aestheticians no longer regard this as a major issue in art theory. Again, I would like to emphasize that the focus of this investigation is not just what has gone on in aesthetics in the last decade or so, most notably English-speaking aesthetics, but to be concerned also with what criticism is like in the various arts. One need only turn to criticism as it is currently being written, whether it be in books authored by critics, in art journals, or in the mass media, to see that an interest in the message conveyed by a work of art is thought to be, by many, an important aesthetic concern.

[12]Walter Sutton, *Modern American Criticism.* Englewood Cliffs, New Jersey: Prentice-Hall, 1963, p. 287.

In the visual arts, the current enthusiasm for Conceptual Art is just this preoccupation with "art as idea." Concern for the message of a work is also evidenced by the fact that some critics attack abstract art on the grounds that it fails to serve a social function, i.e., it lacks a proper message; while others view abstract art as being able to transmit powerful messages for good or evil, and the role of critic as making clear those statements. Another example that a message approach is not a relic of the past is the contention that if one is to understand the new wave of emerging feminist art one must be able to convey feminist values and that these are suppressed by the "formal anti-content tradition" characteristic of formal aesthetics.[13] Not only critics, but frequently artists too speak as though their work conveys some important statement to the viewer, and this kind of communication is not restricted to those who have aligned themselves with ideologies or who are usually associated with more realistic styles. Those artists working in an abstract style sometimes define a message view of their work. In literary criticism a message approach explicates "motives" of "characters" and equates the "excellence" of the author's treatment in this area, sometimes called "development" as equivalent to the "excellence" of the work of art. In addition to the numerous examples one could provide in current Western criticism, there is no doubt that Marxist critics regard message as fundamentally significant in art and this includes all of Russia and China and much of Latin America.

While contemporary aestheticians no longer write as did Tolstoy in *What is Art?* where message is clearly of primary importance, critics and artists are not the only people who talk in this manner. If one talks with people about poetry, English professors for example, even if they do not specialize in criticism, it is apparent that they believe that literature, novels in particular, are conveying some kind of message, and that this message be it political, religious, or whatever is important aesthetically. Also, that there could be a public issue like pornography in arts shows that the message that art conveys is still of concern; and, indeed, the dividing line between "hard core" pornography and fine art, the test of "redeeming social value," makes the issue even more pointed. People raise the issue because they believe that a work's being pornographic is relevant

[13]Lucy Lippart, *From the Center: Feminist Essays on Women's Art.* New York: E.P. Dutton & Co., Inc., 1976, p. 7.

to whether it is art,[14] and they believe that it is relevant because of a message which is "obscene" and "appealing to purient interests." Given this message view of art, it follows that if what is important about the work of art is the nature of its message, then works of art which do not have profound messages are not great works of art.

The message view of art raises questions, for there are some things that are presumably aesthetic, or have been regarded as having aesthetic values which do not convey any message at all. Two notable examples are Chinese Sung vases and Persian rugs which from a message point of view cannot be considered works of art, being only structures. As far as the rug is concerned, the weaver who wove the rug did not intend any message, and when people apprehend it, they get no cognitive response because there is no message to respond to. Similarly, the Sung porcelains have neither symbolism nor message; and though they are akin to shapes of vases which were used for some purpose or other, they themselves never had any purpose, they are just pure shape. So, from a message approach, accounting for these kinds of objects within the realm of art becomes a problem.

Quite contrary to the message view another aesthetic approach is possible which emphasizes the structure of the work of art. It should be pointed out that structure is not used here simply in the sense of shape; rather structure takes into consideration the internal organization, the way one element of the work relates to another. Briefly put, a structural emphasis contends that every work of art has a structure inherent in a system of relations between the elements and *it is the characteristics of structure which cause a work of art to become valuable.* Thus, from this point of view, what makes something a work of art, in so far as evaluation is concerned, is its structure only.

Structural approaches can be quite varied, they can range from the austerity of Clive Bell and his limitation of structural value to what he terms, "significant form,"[15] but it also includes those theories which maintain that structures in art are expres-

[14]It will become clear in Chapter III that my own view is that a work's being pornographic is simply irrelevant to whether it is art.

[15]"In each work of visual art, lines and colors combine in a particular way, certain forms and relations of forms, stir our aesthetic emotion. These relations and combinations of lines and colors, these aesthetically moving forms, I call 'Significant Form . . .' " Clive Bell, *Art.* New York, 1914, paperback edition, 1958, pp. 17-18.

10

sive of things such as feelings, as does Langer. It might be said that my inclusion of Langer as a structuralist is unsound since what counts for her is *what* is arranged and not the *way* it is arranged. In defense of my choice, let me refer the reader to Langer's discussion of the Freudians in *Philosophy in a New Key*. The Freudians explicate the *what* of an artistic expression; for example, what Hamlet expresses is the Oedipus myth and its tensions which are universal and therein lies its appeal and value. In the following passages, Langer rejects this view entirely:

> . . . These are strong recommendations for the psychoanal-
> ytical theory of aesthetics. But despite them all, I do not think
> this theory (though probably valid) throws any real light on
> those issues which confront artists and constitute the philo-
> sophical problem of art. For the Freudian interpretation,
> no matter how far it be carried, never offers even the rudest
> criterion of *artistic* excellence. It may explain why a poem
> was written, why it is popular, what human features it hides
> under its fanciful imagery; what secret ideas a picture com-
> bines, and why Leonardo's women smile mysteriously, but
> *it makes no distinction between good and bad art.* The
> features to which it attributes the importance and signifi-
> cance of a great masterpiece may all be found just as well in
> an obscure work of some quite incompetent painter or poet.[16]

She continues this line of argumentation later on:

> An analysis to which the artistic merit of a work is irrelevant
> can hardly be regarded as a promising technique of art-
> criticism, for it can look only to a hidden *content* of the work,
> and not to what every artist knows as the real problem—
> the *perfection of form*, which makes this form 'significant'
> in the artistic sense. We cannot evaluate this perfection by
> finding more and more obscure objects represented or sug-
> gested by the form.[17]

Thus, to interpret Langer's position as one which emphasizes the *what* rather than the *how* of artistic expression would seem to align her with a view she explicitly argues against.

Theories are structurally oriented when *the value of the work of art is not connected with the value of what is expressed or what motivates the expression; the value of the work of art is*

[16]Suzanne K. Langer, *Philosophy in a New Key*, A Mentor Book, Published by the New American Library, 1942, pp. 177-78.

[17]*Ibid.*

connected with the excellence of the expression.

The method by which one distinguishes between fine arts and crafts will depend on whether one pursues a message approach or a structural approach to the question of setting boundaries for evaluating art. For someone emphasizing message, the crucial difference is that crafts do not have any message; that is, one does not think of carpenters as communicating anything when building a table no matter how intricate the finished product. Thus, even though skill is employed in the performance of their function, it does not involve the expression of any message. A structural approach finds it more problematic to draw the distinction between crafts and fine arts (but this is not to say that it cannot be done, and forming the basis for such a distinction is one of the issues dealt with in Chapter IV). From a structural point of view, rugs, vases, or carpenter's products are at least potentially art since they do have structure; but the word "art" and the word "structure" are not synonymous and the structuralist must be prepared to state the principles by which one would call some structures art and not all structures art.

Similarly, the way in which one handles a related question, "Can something which occurs in nature, for example, a sunset, be a work of art?" will be determined to some degree by whether one emphasizes message or structure in art. It is clear that people do talk about such natural things *as though* they were works of art, and it is here that we run into a distinctively western notion that "beauty" has something to do with art. From a message point of view, we can surely say that a naturally occurring object cannot have a message. The sunset, for example, is by everyone's standards meaningless; it does not convey anything, nor does it express anything, and the same thing is true about any other natural objects. Similarly, the animals that secreted the sea shells did not by those patterns express themselves, hence, they have no meaning in terms of the message thesis.

On the other hand, it is also clear from a structural analysis that there will not be any question but that natural objects are not art. This is the case, because sunsets, sea shells and other natural objects do not have an analyzed structure. This is not to deny that it resembles structure which people do create, and people do make use of naturally occurring elements in their structures because they live in the world and use its vocabulary, but analyzed structure is lacking. To say that they have no analyzed structure means that they do not involve a principle

of selection and ordering and that their pattern does not involve arranging, unless someone wants to deal theologically with the problem of structure.

Thus it is clear that a person who approaches aesthetics from a message point of view is going to have a different conception of art from someone who takes a structural position. The fundamental decision one makes about what the core of aesthetic value is, whether it is related to structure or to what is contained within the structure, will determine the precise boundary that a person draws about what art entails. However, the fact that different boundaries are drawn by divergent approaches to identical problems in aesthetics does not mean of course that these approaches, or the theories that ensue, are of equal value, and it is to methods by which one might choose among competing positions that we shall now turn.

Criteria for Evaluating Theories

We have said thus far that basically there are two evaluative approaches to works of art. One approach emphasizes the message a work may convey, while the other emphasizes the structural components; and, further that the qualifications that are placed on that very important aesthetic term "art" must be viewed in light of those respective positions. From the foregoing, it is clear that one who adopts a message approach will have a very different conception of art from that of someone who approaches art as structure. But how is one to decide between the two? Why adopt one way of viewing art over the other? What needs to be done is to establish some criteria for identifying successful theories so that critical views based on these approaches may be evaluated.

Philosophy is a peculiar area of intellectual endeavor and its oddness may lead to the assumption that the characteristics of a successful theory in philosophy will be different from those that mark theories in other areas. What philosophy actually is is unusual in that philosophy is an activity which has as its goal the asking of questions. Before a problem can be solved it must be understood, and the fundamental task of philosophy is to lay bare the problems which bedevil people because of inconsistent thinking and misapprehensions. Consequently, one cannot legitimately expect conclusions of philosophy. In this respect, philosophy does not have results since, as soon as we are able to conceive a theory with adequate clarity it can be turned into what amounts to a purely critical en-

deavor. But, asking the right question is often the most important part of intellectual insight, because once the question has been asked and it is answerable, finding the answer is only a technical difficulty, and is no longer a theoretical difficulty. Now, it may be true the practical implementation of the theory is exceedingly difficult. It may, in fact, be so difficult as to make the theoretical structure impractical; but, that is a different kind of judgment and one that is outside of philosophy.

This understanding of the goal of philosophy indicates a difference between philosophical thinking and scientific inquiry in that instead of dealing primarily with empirical facts, philosophy focuses on conceptualizations and argumentation. The philosopher does have reference to facts on occasion to show that what is stated in an arguement is contradicted by what was previously stated, or by facts that we initially accepted. In this respect there will be access to a wide body of factual information to be able to deal with philosophy satisfactorily, but philosophy *itself* does not have any facts. In philosophy then, there are no objective truths that a person is expected to master. However, this difference between science and philosophy does not mean that the characteristics which make a successful theory in one area will be different from those used in the other area. On the contrary, the intellectual processes involved in attempting to reach understanding are basically similar and therefore the same requirements used to measure any theory of intellectual explanation should be applied equally to an aesthetic theory. These requirements or criteria are essentially three in number.

The first and absolute requirement of any theory is that it be *consistent*. Being consistent means that difficulties or contradictions in the theory are not repeatedly encountered. If a theory is inconsistent it is already nonsensical and not worth pursuing. However, it is also possible that consistent theories may be of no value whatever. And, if a person is willing to admit that what is said is nonsensical then it is not necessary to be consistent; but philosophers want to be taken seriously and are not willing to say that.

The next test is that the theory must be *adequate*; and this means that the theory can offer a solution to the problems which do occur within the realm of the theory. That is, if a question is raised concerning the problem with which the theory deals, the theory should provide a means for working out the answer. Now whether or not people can actually work out the answer

will depend largely on their ability to solve problems, it will not be the fault of the theory. Thus, a test of a theory is its ability to offer solutions to the questions that arise in connection with the theory and provide an account of the issue. A pattern of inability to solve problems connected with the theory is a measure of its inadequacy.

The third basic test is that of *comprehensiveness*. This is an external test of the theory, and, as such, is in contrast to adequacy and consistency, which are internal tests. Comprehensiveness means that in solving one problem the theory may give rise to another problem which does not clearly fall within the theory, but which must be satisfied in order that one arrive at an adequate understanding of the issue. Thus, a comprehensive theory is one that takes in possible side issues or links up with other theories which will solve side issues.

Now, if one must choose between two (or even more) theories which are consistent, adequate and comprehensive, then there are two final tests which are essentially aesthetic in character: *economy* and *elegance*. But, since consistent, adequate and comprehensive theories do not abound, these two final tests rarely need be applied. The principle of economy, or "Ockham's razor," named after the philosopher William of Ockham who articulated the proposition, states that of two equally adequate and comprehensive explanations, both of which are consistent, one chooses the simpler on the basis that simplicity of explanation is itself desirable. Lastly, the test of elegance involves the ability to work out a great many implications from a very few assumptions. As an example of this final test: if of two proofs one is able to solve a problem by a series of very quick deductions while the other necessitates long and laborious steps, the first proof is said to be elegant while the second lacks formal elegance.

A preliminary step to evaluating a theory will be to uncover all the possible implications of that theory, its connections, and how it differs from other positions. Similarly, in our investigation and evaluation of message approaches to art as opposed to structural approaches, it is necessary to understand the implications of each position. These implications can best be dealt with systematically and comprehensively if they are viewed in light of the various areas that comprise aesthetic investigation,[18] and a decision be made based on what is known

[18] Also, the relative importance of each of these areas is determined by the particular approach, message or structural, that one takes to aesthetics in general.

about art, and which approach is the more demonstrably useful in working out the family resemblances between the various media.

Essentially aesthetics involves three areas of problems and some of the basic suppositions and questions that arise in those areas should be briefly outlined:

(1) **The Artist and the Problem of Creation:** What is the difference between creating (or producing) a work of art and doing anything else? We have the impression that the creative process as applied to art is somehow different from making a table or chair and that the artist in some respect is a different sort of person from the usual person. In connection with this problem, we need to determine *how* it is that the artist makes a work of art. In other words, "What exactly is entailed in the activity"? We want to know, for example, the process of selection and whether or not the element of creation is involved. Are artists creative in any sense, or is it even desirable that they be so? In Western cultures, it is commonly thought that artistic activity and creation are largely synonymous; but this is a distinctive view of our own culture and it is certainly not shared by other cultures where the last thing that would be wanted or expected would be for the work of art to be creative. Instead, one wants a work of art, in most cultures for most of the world's history, that falls firmly within the tradition of an art form. For example, the more traditionally and more nearly perfectly a Chinese artist reflects antiquity, the better the painting is in theory. Thus the really fundamental question involved here is the *"how"* with regard to artistic creation.

(2) **The Problem of the Work of Art Itself:** Here we want to know the value. "What is the nature of the value of the work of art" and "Wherein does the value really lie, in the message or in the structure?" Or, we might start with a prior question. It is evident that a work of art must of necessity have structure or it would not be perceived. A work of art cannot be dealt with aesthetically if it is only in the artist's mind, and it seems pointless to speculate on something about which we have no information. Perhaps we can, for purposes of criticism, discount the notion of unarticulated masterpieces. Thus, there is no doubt but that a work of art must have structure.[19] However, the question remains whether or not a work of art contains a message;

[19]In this first chapter, I have not presented my own view of what structure entails, but the design of the thesis is such that this is the subject of Chapter III.

and, if so, is it only trivial or something more?

We can illustrate the difficulty in knowing where to place the value of a work of art in the following examples. If we look at a work of art from another culture, let us say a statue of the Buddha, the content of the Buddha's theology which the statue represents is not normally understood by Westerners who nonetheless think they appreciate the aesthetic value. Now it is quite clear that to some degree, at least, we can appreciate the aesthetic value of Buddha's statue without subscribing to the theology of Buddhism which the statue is said to represent by Buddhists. The same thing is true when we look at Egyptian paintings. All paintings deriving from Egypt are religious, but we look at them without regard for the particular theology which gave rise to them, and which are in the opinion of the Egyptian artists who created them, the true meaning or message thereof. Again, the same thing is true of Christian cathedrals. Theoretically, every element of the cathedral exemplifies one or another tenet of Christian theology. Everything in the cathedral can be explained in religious terms and those persons who made the cathedrals were certainly aware of the symbolism of each and every element therein.

This problem of symbolism is a very difficult one since it happens that the deterioration rate for a symbol is very rapid. For example, it is quite probable that when one views a painting that is more than two hundred years old, the symbolism in it is not understood. This raises the question: even if we do admit that there is message can we understand the painting, or can we appreciate the value of the painting if we do not understand its symbolism? For someone who adopts a message approach the answer is important. However, it is apparent that people do respond to a work of art even without such knowledge.

Basically then what we want to know is "Where is the value of a work of art"? With regard to structure we want to determine "What kinds of elements in a work of art can be part of structure?" or, more simply put "What counts as structure and what does not?"

(3) **The Apprehender and the Problem of Response:** And then finally there is the problem of what people do when a work of art is encountered. It is doubtful that the reader was noticeably moved by reading this page, and yet it would be considered strange if one attended a Beethoven concert or viewed a Da Vinci painting for the same amount of time and experienced nothing. What is being dealt with is called the response to the aesthetic object. The nature of this response will be discussed

17

below along with the relationship between this response and the work of art. Specifically, does the work of art cause a response, or is the work of art merely an occasion for a response as the concert hall in which one hears the concert may be the occasion for a response? In short, just what *is* involved in the aesthetic response and how can it be distinguished from a non-aesthetic response?

Very often people want to know if what the artist intended is similar to what is felt by the apprehender. Is there a connection between them, and if so, what is the nature of this connection? And, if apprehenders do not feel what the artist intended, why not. Was it their fault, or the fault of the artist in that she or he was simply a bad artist? These are the kinds of questions that give rise to aesthetic inquiry in the first place.

There is a multiplicity of views which one may hold with regard to each of these questions and the relative importance of each of these areas is determined by the particular approach one takes in general. As such, an issue which may be of great importance for one approach will simply not appear in another. For instance, the question of censorship which will be very significant for someone emphasizing message, will disappear completely for someone who approaches art as structure. Also if one emphasizes structure it is evident that not a lot of time will be spent with details about the intentions of the artist, that just will not be a significant question. On the other hand, if one wants to say that the function of art is to communicate a message, then it is certainly relevant to understand what the intentions of the artist are. This would be so because if there are two people who disagree as to what the message of the work of art is, reference to the artist's intentions can determine which one is correct and which one is in error.

Metarules for Proceeding

At this point, the theoretical basis for this inquiry should be stated since everything done hereafter will be framed in those terms. From the beginning, we shall adopt certain metarules outside our system to guide our investigations, and these shall be referred to as (1) *the rule of symmetry* and (2) *the rule of commonality*.

The symmetry rule simply stated will be that in theory, *every statement that we make in aesthetics in any one of the three areas (creation, work of art, or response) will have some corollary in the other two.* Thus, the true understanding of a state-

ment involves working out what those other corollaries must be. We will use this rule to develop the connections between the three areas of aesthetics; since by using our symmetry rule we can ensure consistency and test for the adequacy of a statement's implications, consistency and adequacy being the first two criteria for a successful theory. The employment of this metarule makes it possible to check almost instantly whether a line of procedure is, or is not, profitable.

The rule of commonality, on the other hand, will organize the work in developing an aesthetic vocabulary useful for all the arts since we shall take as a fundamental rule that *all aesthetic descriptions and judgments must be common, that is, applicable to the various media.* Such a rule differentiates aesthetics from art criticism and points out the fact that the goal of aesthetics is different from the goal of art criticism. This point needs elaboration.

It is usually agreed that by the analysis of a work of art one can show, if one can ever show, what the value of the work is. In *specific* fields this is called "criticism." Thus, there is a body of musical criticism, the consensus of which is that Beethoven is a greater composer than Auber. Similarly, there is a body of criticism in literature, the consensus of which is that Shakespeare is a greater playwright that Scribe; and there is a body of art criticism which deals with comparable problems in painting and decrees that Rembrandt is a greater painter than Jan Steen.

Criticism differs from aesthetics in one very important aspect. Criticism is concerned with the particulars of a certain area of art. In contrast, aesthetics concentrates on those things that are characteristic of all art, or potentially characteristic of all art, and avoids those things that are media specific. This means of course that something might appear to be quite valuable from the point of view of the critic, yet could be from the point of view of the aesthetician utterly useless, since what may be an acceptable rule of criticism is not necessarily viewed as an aesthetic rule. For example, while it might be an important point in literary criticism that a play does not satisfy the description of a real tragedy, or in musical criticism that a composition is not a real sonata, these are not aesthetic issues. Also, the result of applying the commonality rule will mean that if we want to say that only poetry has ideas or messages and not music, then we have left aesthetics altogether because we are assuming that a rule cannot be considered aesthetic if it does not meet the basic condition of commonality or generality.

This indicates that the best aestheticians would have to know music, painting and poetry as well as the other art forms and the extent of their success in doing aesthetics would depend to some degree on their knowledge of all forms of art. Of course, such a fund of knowledge rarely happens and this explains why historically, in aesthetics, the longest activity has been on the part of persons who are concerned with a particular art form.

It is true that some critics (using the broad sense of that term) have attempted to be general and far reaching in their scope, but upon inspection, they clearly fall short and wind up with a fragmentary system and remain critical rather than aesthetic. Clive Bell is an example of one whose notion of "significant form" requires a visual art, and Suzanne Langer's theory is really plausible only if one is using a musical frame of reference, for it does not work satisfactorily with regard to painting.[20] However, Langer's pioneering provisional efforts in this regard are helpful in indicating the way in which one can proceed. The goal fundamentally in aesthetics has been to explain one's own personal experiences of art and once that has been done the aesthetician has been more or less satisfied. This, I think, is the limitation of virtually every work in aesthetics so far; that is, the range of purpose is fairly narrow and they do not systematically explore the connections that can be drawn among the various media.[21] Thus, while various theories are fairly good for the domain that they use as their source material, they are not often valuable once you go beyond that domain, and it is this shortcoming that the rule of commonality is meant to resolve.

Thus, we approach a critical point. One often hears that a poem cannot be compared to a musical composition, for instance; but, if that is true, then there are not any general aesthetics. People can recognize that the nature of their responses to poems is not different from the nature of their responses to music or painting, understanding "responses" in this instance to mean "sense responses" or "sensations." (These sense responses form the basis for the process which will be described in Chapter II

[20] As George Dickie asks, "of what human feeling is a Mondrian painting iconic?" *Aesthetics: An Introduction*. New York, The Bobbs-Merril Company, Inc., 1971, p. 82.

[21] My own theory will consider painting, music and poetry. The reason for this, given in Chapter III in more detail, is that we need not cover any others since these take care of the basic types of art in terms of involving the major sensory modalities, sight and sound, exploited by artists.

as "decoding.") It is the uniformity of the nature of sense response[22] and the perceived common values which people report they experience in aesthetic contexts and not the physical properties which are peculiar to any one art type which is the ultimate basis of the values with which aesthetics must deal.

At present, what hinders such cross media comparisons? Descriptions and evaluations remain media bound simply because a satisfactory vocabulary with the precision and clarity required to be useful for all areas of art is lacking. Theoretically, an implication of the commonality rule is that one could determine whether Beethoven's *Fifth Symphony* is better than Shakespeare's *MacBeth* and if both of them are inferior to Rembrandt's *Night Watch*. This would be as feasible and reasonable a thing to do as do literary critics who normally maintain that Goethe is better than Keats. It is not unreasonable to anticipate that one could compare Beethoven with Shakespeare or Rembrandt. The perception of the relations of structures is the same whether with the eye or the ear and this is why people usually perceive a similarity between works of art in different media. Equivalent reactions to works of different media presumably has to do with a single intellect which perceives structures to be the same regardless of whether they are chemical structures, mathematical structures, musical structures or poetic structures. If this were not so, it would make no sense to talk of composite arts such as opera where the lyrics are not thought to be unrelated to the music, or drama where the performance is not taken to be disconnected to the text.

At the outset, the question can be raised, "Even if one were to be successful in devising a general language for describing and evaluating works of art, is all this worthwhile as an intellectual enterprise?" What practical purpose would, in fact, be served?

From the point of view of the critic, if the critic's purview is just that of a single solitary area of art, then the answer as to the worth of such an enterprise is unequivocally "No." The task is too difficult to warrant the effort. But, if the critic expects that anything that is said to have significance outside that narrow framework then the answer is unequivocally "Yes." A general language would also make more feasible cross cultural evalua-

[22]While it is true that the response is a private experience, terms for private sense experience are held to be common; and the way this is established is that people are able to function consistently with the hypothesis that they perceive the same things. This point is developed in Chapter II.

21

tions within the media of a critics own special interest; since as far as evaluation is concerned a disagreement as to whether Goethe or Shakespeare is the greater writer can only be settled by a general aesthetics. This is because the criticism which prevents one from comparing music and poetry, also prevents one from comparing German and English. That is, if one knew both languages a comparison would be possible, but there will always be languages one does not know in which there are poetic traditions; and while it may happen by chance that the structure of the German language and the structure of German poetry is related, the same way that the structure of the English language and the structure of English poetry is related, that would not however be true of Arabic and Chinese poetry.[23]

From the point of view of a reader of criticism, it would seem to be a substantial contribution because of the haziness and confusion with the way terms are employed.[24] Sutton makes this point clearly:

> It is generally recognized that the confusion existing in critical language is an obstacle to communication. Language barriers separate groups of critics, each of which has tended to develop a specialized vocabulary . . .
>
> A certain amount of specialization is unavoidable. But the peculiar weakness of critical vocabularies is the absence of a common foundation and a lack of agreement about the precise meaning of basic terms . . . Critics themselves are often not certain of the meaning of terms upon which their arguments depend—a fact that has been too frequently demonstrated in the discussion period following the presentation of critical papers. It is possible for two critics to conduct a technical discussion in which neither has an understanding of the other's meaning, except in his own terms.
>
> One of the pressing needs of current criticism is for a broader, generally accepted vocabulary drawn from all relevant areas

[23]Chinese and Arabic poetry tends to be highly classical. For example, Chinese poetry, as it is commonly written, relates to the way the language was actually used centuries ago, not the way it is used today; so it is an entirely learned phenomenon and people who are not learned in this respect cannot appreciate it.

[24]This view that the terms of criticism as they are presently employed are muddled is not incompatible with the fact that when people make critical judgments they know what is meant by those judgments, e.g., "I like it." But this is quite different from saying "I like it because of attributes like balance, rhythm etc." and have everyone know what "balance" or "rhythm" means. The fact that a person knows privately what he or she means does not mean that it is clear to others.

of experience . . .[25]

The difficulty lies in the lack of carefully defined terminology and in the fact that the same term is used differently in various media. For example, if we read the works of painting critics we will discover that they use words like "movement" and "rhythm" which seem inappropriate to a type of art which is spatially organized. Similarly, literary critics regularly use visual words like "balance" and "proportion." By refining the vocabulary now being used by critics, it would be possible to understand what the relationships could be between using "rhythm" in reference to a painting and its corollary with respect to music. It is evident that the overlapping vocabulary which critics borrow from other areas of art, as it is now employed, lacks the exactness necessary to really be useful.

The task of refining the vocabulary of art will essentially be a revisionist activity for which the criticism of art language will serve as the basis. That is, words that can be applied to various media will be culled from the literature of criticism and an attempt made to define them more exactly. One might ask, why use existing aesthetic terms at all; why not begin anew? However, this tack would needlessly complicate matters; so in the interest of preserving already existing avenues of communication, we shall take the tags as they are now used and try to clarify them to make them commonly applicable.

A caveat which applies to working out a system of aesthetics: It may well be that we shall complete our investigation with a reliable program of aesthetics, a way of describing and evaluating art, which many people would not find appealing, or even palatable, because it does not do what they would want aesthetics to do initially. However, in any case, we should by devising metarules, have made progress toward constructing something which is at least remotely consistent, and this effort itself would be a contribution.

The focus of attention will now be upon developing the connections between the various areas of aesthetics: the artist, the art object and the apprehender. Given the rule of symmetry, which posits that every statement made in any one of the three areas will have some corollary in the other two, any examination of aesthetic value must deal with the questions and problems inherent in each of these areas.

[25]Walter Sutton, *Modern American Criticism,* pp. 286-288.

While the emphasis of a theory may be on the structure of a work of art, it must also be able to present plausible accounts of reponse and creation as well. The point is that it is inconceivable that there could be a fully worked out theory of art emphasizing structure which could not at the same time be able to account for the nature of response and the nature of creation. Of course, the same will be equally true for a theory which emphasizes message.

Chapter Two

Decoding: Aesthetic Response and Encoding: Artistic Creation

The discipline of aesthetics has remained one of the most undeveloped and neglected areas of philosophical inquiry as far as systematization is concerned. The reason for this is simply that people have been thinking about it confusedly. Aesthetics is no different from any other area of inquiry in that the problems encountered are more likely due to unclear thinking than to any inherent complexity in the subject matter itself. This point can best be illustrated by going outside philosophy for an example. The first major treatise on physics was written by Aristotle and the first major treatise on psychology was also written by Aristotle. Since Aristotle, we have had 2200 years of human thought expended on those two areas. There is little question as to which of those areas is more advanced, and the reason is clarity or lack of clarity with regard to the conceptualizations which they each study. Psychology has lagged behind physics because it has been plagued with conceptual confusions such as a preoccupation with an entity called the "mind" which has no physiological correlate.

Aesthetics has suffered from similar conceptual confusions in that too frequently attention has been focused on acts of creation and response as having to do with private thoughts or feelings and emotions belonging to the artist and the apprehender.[1] In his example of the beetle in the box, Wittgenstein points out the difficulties we embroil ourselves in when we be-

[1] "Apprehender" will be used throughout this thesis rather than "spectator," since it avoids the limitations implied by that term.

come involved with something that amounts to a private language, and this relates to the problems of private emotions as well. In Wittgenstein's parable we are to imagine that everyone has a box whose contents is referred to as "beetle." No one has access to anyone else's box, and each knows of "beetleness" only by looking at the contents of one's own box. In such a situation, it might well be the case that each box held different contents or held nothing at all. Or, the contents might be constantly changing.[2] So, although each person might say that what the box contained had the characteristics of a beetle, they might in fact have very different things. In this example, group members make use of a universal common term, but since the referent can be known only to themselves, as their private thoughts and feelings are, then one can never be certain that what one person calls a "beetle" is in any way akin to another's experiences. Thus, there is no way of checking conflicting propositions since there are no common points of reference, and so even the minimum conditions for any kind of discourse to take place have dissolved.

If we want to contend that understanding in the area of aesthetics is possible, we shall have to extricate ourselves from territory that is essentially unknowable. For this reason, theorists should disregard in their accounts of art private thoughts and feelings which are inexpressable. That it is quite possible to do so can be shown by pointing out that while no one can confirm that what one person sees when using the word "yellow" is what other people see when they use the word "yellow," we can test that everyone understands what the word "yellow" means. Let us suppose that the same group of people who, in Wittgenstein's story, knew what a beetle was only by looking into the contents of their own boxes now decide together that each will retire and bring back a yellow book. When they reassemble if everyone then agrees that the books brought are indeed yellow, then although it must be conceded that sensations are private and can never be known by another person and that yellow is irreducible and cannot be articulated or defined; nonetheless, we can by means of a behavioral test determine that everyone did understand what the word "yellow" meant. This example, points the way to what we have to do in art. We can talk of course as if "yellow" or "art" had to do with things that are quite mystical and not susceptible to analysis, but in this case nothing would be accomplished. An appeal to the pri-

[2]Ludwig Wittgenstein, *Philosophical Investigations*, p. 100e.

vate contents of a person's thought is like insisting on talking about boxes which are inaccessible to others, whether it be in the area of art or any other kind of interaction. So, private feelings or events cannot be the basis for aesthetics since there is nothing that could be affirmed, denied or evaluated.

While the inaccessability of private events makes either the act of creation or response unsound foundations on which to construct an aesthetic theory, this does not mean that nothing can be said about them or that they are without aesthetic interest at all. It is to a discussion of these two areas, creation and response, that we now turn.

Decoding: Aesthetic Response

Since the area of response is something everyone can deal with introspectively, that will serve as a proper beginning for an investigation of aesthetics. We shall explore the nature of aesthetic response; in other words, how does one account for the development of aesthetic taste, and for the erratic quality of aesthetic taste. From there, we shall proceed to a discussion of the act of creation and finally to the work of art itself.

Whenever theories deal with the problem of response, they share a certain fundamental assertion; that is, they attempt to distinguish the mere *concomitance* of the apprehender's reaction to the work of art from the *congruity* of the apprehender's reaction to the work of art. They endeavor to separate a reaction which accompanies exposure to a work of art in an incidental way from a reaction which consistently accompanies exposure to the work. This is in order to differentiate a "random" reaction a person might have from a reaction that might properly be called "aesthetic;" that is, one that directly connects the person to the work of art. If this stipulation is not made, the apprehender's reaction can have its origin elsewhere. It is not satisfactory to say that because someone reacts in the presence of a work of art the reaction is a response *to* the work of art. We want to say that the response someone has to a work of art, in so far as it is aesthetic, is the logical product of the work of art and it is not merely a concomitant of it. The idea of the aesthetic response is that there cannot be simply a conjunction between the work of art and the response (W • R): necessarily, for something to be considered an aesthetic response, it must have been the consequence of the work of art (W ⊃R). It therefore follows as a corollary that anytime that it can be shown that there is an incongruity between what is called the response and the

27

work of art, it is not then an aesthetic response, but merely a reactive concomitant to the work of art. By "reactive concomitant" is meant that the reaction that accompanies exposure to the work is not a response to the work at all, and while one could not know of this incongruity a priori it could be made apparent through questioning.

If we therefore insist that an aesthetic response must be prompted by the work of art, then it must be possible to locate in the structure of the work of art something which correlates to the response. Hence, we have a check between the nature of the response and the nature of the work of art. The nature of the work of art imposes certain kinds of limitations as to what can be a true response to the work of art rather than merely the conjunction of an emotional reaction which is analogous to a response.

To illustrate this point, let us examine three kinds of responses one might have to a work of art, or three basic possibilities to what one can mean when the word "appreciation" is used in connection with a work of art. It will become apparent that two of the possibilities really involve reactive concomitants while only one qualifies as a genuine aesthetic response.

First, one can mean that he or she responds to the work of art, as Dewey puts it, in the ordinary manner.[3] The art world of New York City is dominated by that phenomenon. We read about "the world" as recognizing certain artists, but what such statements really mean is that the forty or so people in New York who dominate the art world recognize their work. Therefore, when a person sees a painting of Coca Cola bottles it is recognized as "a fine expression of modernity;" or plastic telephone booths displayed in a museum, are seen as a "profound expression of our inability to communicate." All this means is that a person is conforming to the conventional wisdom of the day and is responding accordingly.

This reflection of conventional attitudes is one kind of appreciation that people are likely to have when they are in the process of developing tastes. That is, people tend to follow recognized authorities for guidance. This is particularly true in the case of some contemporary art where what is said about a painting is really far more important than anything else. In fact, the apprehender almost has to have the ideology behind

[3] John Dewey, "Having an Experience" Chapter III, *Art As Experience.* Capricorn Books, 1934. Paperback 1958 Ed. G.P. Putnam's Sons, New York.

the painting to have any idea that it is a painting, or indeed a work of art at all. For example, it is not obvious that Roy Lichtenstein's stenciling of comic strips on canvas would be viewed as high art, while the ones that children read in the newspaper are just amusement; or that Andy Warhol's Campbell soup cans would be considered a major statement about ultimate reality, (or something akin to it) whereas the soup cans that a person opens for a meal, perhaps in desperation, are things to be discarded. In both cases, it is only the result of an acquired sensibility that allows us to interpret them in these ways.

Almost all persons engaged in the process of coming to know an art type in a systematic way, will find themselves being influenced by conventional judgments. It is conventional wisdom that says that Michelangelo is better than most of his contemporaries, and it is the same kind of conventional wisdom that says that Balantine Ale cans in bronze are profound statements about modern life; and, as is typical of conventional wisdom, neither of them is obvious.

It may well be that the product of a detailed aesthetic analysis and evaluation will correspond to these conventional judgments; but the point to be made is that there is no reason for assuming that the popular views are initially made on fundamentally aesthetic grounds. A person may, without reflection or analysis, accept the conventional wisdom that Michelangelo was the greatest painter of his time, but this is very different from the person who *through understanding* comes to accept that conclusion. In the second instance, the work of art is involved in the decision; while in the first case the judgment is not made on aesthetic grounds since the work of art is outside the judgment and therefore it cannot be counted as aesthetic. A judgment made on aesthetic grounds will involve responding *to* the work of art itself and in this respect, there is a distinction to be made between an uncritical embracing of accepted clichees as opposed to a person who comes to agree with that conventional wisdom through a recognition of the work itself. The response in these cases always involves the question of conventional attitudes, and unfortunately, for certain people the difference between being perceptive in an art type[4] and being Philistine in the same art type is whether or not the person's reactions correspond to the conventional wisdom of the day, i.e., correspond to the tastes of a small coterie of people involved with art and who deal in art. It does not mean any more than that.

The second kind of response a person is likely to have is one

29

which is affected by other sets of circumstances which we shall refer to here as "mnemonic devices," meaning irrelevancies which derive from the circumstances in which the person perceives the work or apprehends the work. This is to say that one is likely to be affected by the context and by the occasion of the art as much as one is likely to be affected by the art work itself. This is the most common difficulty in the usual appreciation of a work of art in that works of art attract to themselves a whole complex of associations and memories which arise from the occasions on which one has encountered the work of art, and in circumstances attendant to those occasions. As a result, this causes the work of art to be viewed as "better," "more profound," "more moving," etc. than it would be otherwise, or to a more objective apprehender. This is one reason why musical works in particular which have titles are so much more popular and so much more widely appreciated in this sense of the term than works which do not have titles. Titles inspire some connection outside the work and provide the apprehender with a hinge for mnemonic associations.

Thus, in this second type of response, we have a reaction which is a direct product of the apprehender's biography and not a part of the work of art itself. These responses tend to be, on the whole, what might be called a "massive reaction." This is a very strong emotional response which is in general noncritical, and which tends to disappear if critical examination is applied. This is due to the fact that critical analysis tends to detach the work of art from the context in which a person comes to know the work of art; hence, analysis, in this case, quite likely will result in the person's no longer appreciating the work of art on this level. This explains why so many people are exceedingly reluctant to engage in analysis of works of art. This loss of appreciation of certain works is because of the fact that it was not the work of art that had any bearing on the response in the first place, but rather some mnemonic irrelevancies such as the context in which one viewed or heard the work

[4]The term "type" is used here instead of the usual "form" to refer to the various areas of art such as music, poetry, painting, etc. This is to avoid confusion between "form" as an area of art and "form" having to do with the structural elements of a work of art. Thus, in this paper, "type" does not refer to the "type," "token" distinction suggested by Peirce and discussed at some length by Wollheim where Wollheim talks about an instantiation of a work of art as a "type" while its copies, i.e., various reproductions are "tokens" of that type. For example, the book *Ulysses* constitutes a "type," whereas a particular copy of it would be a "token."

that caused the emotional reaction. *Pomp and Circumstance* is a piece that might be used as an example since besides its associations, it is not a particularly significant piece. While it is true that people may feel certain emotions, such as pride perhaps, when they hear the work, it would be a mistake to say that this is what the work expressed or that while feeling this emotion that the people are responding to something in the work. Rather, it is that this piece of music is used on certain ceremonial occasions and not that emotions experienced by the listener are brought about by any understanding of the work itself. (It is worth mentioning in connection with this point that while an emotional reaction is not the *same* as a response to a work of art, people *can* have emotional reactions which may or may not be the consequence of the work of art. If it is prompted by the work of art, the emotional reaction may be called an aesthetic response; if it is not prompted by the work then it is an emotional reaction which does not happen to be an aesthetic response.[5])

By defining these two classes of response, we have already indicated that *they would not be properly regarded as "aesthetic" because neither of them fundamentally involves the work of art itself.* What they involve is either the context, or what "experts" regard as valuable, rather than the work of art; hence, they are not in the pure sense "aesthetic" at all.

How would an aesthetic response be defined? A necessary condition for an aesthetic response to an art work will involve two things: (1) approaching the work as an object of attention without regard for the circumstances attending to the occasion of its apprehension; and (2) recognizing that one may appreciate the work of art to the degree that one understands it, this latter point, is one that needs some elaboration.

To understand a work, means to be able to expose the structure of that work and to apprehend in clear terms the way it is put together; in this regard, the degree of one's aesthetic understanding of a work of art is directly proportional to the perception of the intelligible structure of the work of art. This brings

[5]The same point can be made about other kinds of reactions one experiences in the presence of works of art which are not emotional in character. For example, if one views a painting and is suddenly reminded that something has been left on the stove at home, I would call such a reaction non-aesthetic in that I do not see how we can attribute that response as being caused by the work anymore than one might contend that the museum building caused it. I think it more acceptable to say the reaction was only *occasioned.*

us to the idea that the process of appreciation, or understanding, both being the same, will involve analysis. The purpose of analysis is to make clear the intellectual structure of the work itself. As such, analysis will entail the process of decoding what is involved in the work's structure. Analysis then, is fundamentally a matter of perceiving relationships between the disparate elements of which the work is composed. Thus, the decoding of the work of art on the part of the apprehender and aesthetic appreciation of the work of art are one and the same thing. This process of decoding will produce an appreciation of certain configurations and mental attitudes (which will be dealt with under the section devoted to artistic creation) and these will be what is experienced as the emotional response to the work of art.

Although the process described above is intellectual, it has an emotional concomitant. This is not surprising since other intellectual processes do have one or another kind of accompanying emotional feature. For example, mathematicians will frequently discover when they are able to solve a problem, particularly one on which they have been working for a long time, that they experience an enormous sense of exhilaration. That is obviously an emotional response to what is fundamentally an intellectual process. Emotions and intellectual activities are frequently dissociated and as a consequence it may seem peculiar to some people that the aesthetic reaction, which is an intellectual process, does in fact possess an emotional facet.

While we want to say that a person appreciates a work of art to the degree that it is understood, at the same time it should be pointed out that understanding a work and being able to *state* it in a careful analysis, as an aesthetician would, are two different matters. A person can understand the work and can go about showing how it was put together, but to be able to state the construction involves the development of a technical language which is necessary in the interest of precision. For example, many people can hear music with exceeding ease. They can hear the structure of music so that they can take a piece and reproduce it; this is referred to generally as "playing by ear." That is, they can work out the harmonies but would not be able to state the correct musical notation for the structure.

Similarly, many people can hear poetry well; that is particularly true in oral traditions. They can hear the poem and can also compose a poem with the same structure, but they would not be able to state the type of metrical foot involved, or that they were using a sonnetic form, etc. Therefore, the amount of detailed analysis necessary for an aesthetic theory need not be

present for a general appreciation of the work, and, in fact, the sheer amount of detail involved in a scholarly analysis can be exceedingly tedious. However, while it is not normally necessary for apprehenders to become involved in a great detailed analysis of the work, they should be able to do it at least in a fragmentary way so that they will be able to confirm that their judgment of the work is essentially sound and correct; and where two people disagree, the disagreement can be solved on some level of analysis. The point being that if people are doing analysis for the purpose of formal aesthetics, then precision is a desirable quality; if they are doing it for themselves and their companions, then they need not be anymore precise than the most cantankerous of their friends insist that they be.

Still, the fact that detailed aesthetic analysis is not necessary for appreciation, does not rule out that appreciation can be increased to the degree that understanding of the work is increased. However, it is not likely that as a consequence of aesthetic analysis people will increase their appreciation if they think of appreciation in the first and second senses of the term (conventional attitudes and mnemonic irrelevancies); but they *will* increase their appreciation if they take it in the third sense, that is the *ability to perceive the intelligible structure.* Most people seem to find it part of their experience that if specific things about a work of art are explained they are able to see more of the structure and therefore better able to appreciate it.

It is a common phenomenon that people discover that certain works of art which they "appreciated" rather considerably when they first encountered them, come in time, not to be very impressive at all; while other works gradually become more impressive. Presumably, this fact relates to the initial difficulty of perceiving the structure of the work of art. Subsequently, a person's tastes are quite likely to be changed, and changed markedly, by aesthetic activity, mainly because the focus of the person's attention when it comes to response will be shifted by this kind of enterprise.[6] The probability is that what one later comes to regard as aesthetic is likely to be more contemplative than heretofore. It may be that this involves some sort of philosophic judgment that a contemplative response is better than one characterized by involvement; but since that would be a non-aesthetic judgment we need not pursue it here.

By employing the rule of symmetry, we are able to work out a theory of how works of art are to be interpreted and analyzed, at the same time certain kinds of conclusions about how they are created are being reached, and any satisfactory theory of

interpretation will at the same time expose how the work was created. This idea should not be surprising since a theory of artistic creation and a theory of interpretation will necessarily need to be parallel in a certain sense, unless of course, one would want to come to the conclusion that what is understood about a work of art has nothing whatever to do with what the artist did when creating the work. Of course, such a theory is possible, but otherwise any theory that contends that there is a connection between what the artist does and what the apprehender does when analyzing or interpreting the work so that it can be understood, will have to insist that theories of interpretation and creation be parallel at least. That is, there will be symmetry between the process of encoding and the process of decoding. This does not mean, however, that there is symmetry between the content of the experiences of creation and appreciation. Rather, it is the *process* of both that is the symmetry.

From this it follows that for every term in an interpretative theory there should be an analogous term in a creation theory, and vice versa. This parallel structure makes it possible to test almost immediately the consistency and adequacy of any theory. For example, if what someone says is true about the process of creating a work of art, then we can check what implications there are for a theory of interpretation. If no satisfactory or useful corollary is forthcoming, there is an inadequacy or flaw in the creation theory that is being advanced. We can see what implications this would have for message approaches as opposed to structural approaches to art. Specifically, the

[6]It is not denied that this view leads to "elitist" notions of art, but this term need not be a pejorative, since we can hardly fail to notice the efficacy of teaching. The efficacy of teaching is upheld by I.A. Richards in his book *Practical Criticism* in which he maintains that instruction can eliminate the common preconceptions which, according to Richards, preclude aesthetic awareness. This conclusion comes as a result of an experiment Richards conducted among Cambridge honors English students where the students were asked to evaluate "blindly" thirteen poems. The results were predictably disasterous since almost to a one, without the crutch of established authority to lean on the students "more or less reversed all the accepted judgments of poetic value." For example, the work of someone called J.D.C. Pellew was preferred to Shakespeare and Donne. The results imply that if traditional critical interpretations of aesthetic values have any merit whatever (and Richards does not question traditional criticism since he points out that "the sheer idiocy of their remarks and the plain inability to read or even to notice the simplest and most blatant physical facts in a poem make it clear that the fault was theirs") most works of art are either unintelligible for most people or that they have no value for most people. It is Richard's point that presumably correct exposure would be sufficient to overcome these limitations.

34

corollaries of a message approach in the areas of creation and response would lead one to say that the artist has a message which he or she communicates through the medium to the apprehender. The apprehender then must understand the message since it is the value of the message and the clarity of the apprehension that makes the art. From this perspective, the intentions of the artist become important (i.e., whether they were evil or not). But a structural approach, as we have outlined it, is simpler and less problematic in the sense that we do not have to be concerned with things which are not public, such as the intentions of artists long since dead, for example.

According to the way in which it has been worked out, for purposes of evaluation it is not necessary to know why artists do anything, but it is important to know the manner in which they do it; because, if a person is going to be able to interpret music or poetry or painting, or any other art type, she or he must be able to discern the manner in which it is put together. And we hypothesize that the way in which it is put together will tell us how the artist goes about creating in the first place. That is, interpreting is taking apart step by step what was put together initially by the artist. The two processes are parallel; or we might say that each is the mirror image of the other. Thus, a theory of interpretation and a theory of artistic creation will have certain points in common—both of them involve only the function of the structure of the work of art. We do not need to know how the apprehender responds to the work and we do not need to know why the artist created it in the first place. In other words, we do not need to interest ourselves in why the artist did the work and we are not interested in what happens to the apprehender when it is experienced.

Would this mean that aestheticians who understand the process of the work's construction and what makes art valuable would then be able to produce masterpieces in the medium of their choice? There is no more reason for that to follow than that mathematicians who understand the principle of mathematics would then be able to go on and do original and expert mathematical theses. All such mathematicians have done is to master what others have done, and that does not in the least imply that they will be brilliant mathematicians. The fact that they know how a given proof was constructed does not imply that they will then be able to furnish fresh proofs. The fact that people understand something does not imply that they will have further insight in regard to that subject, and presumably a new work of art is the product of insight. It is therefore evident that

knowing how works of art are put together in the first place would not be the same as having the insight to produce another one. This would be true of all human endeavors. We cannot expect that expert theoretical knowledge of a field will imply that one can excel in practice in that field. For example, an expert musicologist could not be expected to play the piano, or for that matter an expert pianist could not be expected to compose music because what is involved is entirely different. The expertise needed in taking things apart is not the same as that needed in putting things together. That is, the process of decoding on the part of the apprehender and the process of encoding on the part of the artist are separate operations even though the principle involved is analogous. Keeping these things in mind, we now turn to an examination of the encoding process, the act of artistic creation.

Encoding: Artistic Creation

We have concluded thus far that every work of art has a structure and that this structure is intelligible. This further suggests that a genuine aesthetic response, or aesthetic appreciation, entails understanding the work. "Understanding" in this context means simply "grasping the intelligible structure." The issue of an apparent anomaly may be raised here in that if, as certainly seems to be the case, most persons cannot describe the structures which they have seen or heard in works of art, would we then not have to conclude that most people do not understand them? Music provides a good example for this challenge since most people who say they like and appreciate music cannot in any meaningful way discuss the structure of music. The issue is resolved if we keep in mind that the problem of describing works of art is basically a technical one not involving understanding. That is, the difficulty in not being able to describe the structure of music may hinge, not on a lack of understanding, but rather on the fact that the person lacks the vocabulary of sufficient abstraction to state precisely what it is he or she apprehends. This fact can be tested quite clearly by noting that a person can detect errors in structures. In music, for instance, it is not impossible for a listener to say with authority that a piece is played too fast, or there is too much pedal applied to a certain portion. The point being that one can identify the nature of the problem as it applies to structures thus *demonstrating* understanding without describing it by technical means.

It is undeniable that certain of these talents are physical in character. That is, musicians do in fact hear substantially better than most people do. In particular, many of them have a kind of accuracy of memory which is called "perfect pitch," which enables them to determine whether or not two notes are correctly tuned without reference to a tuning fork. Thus, they have very often what appears to be an uncanny ability to discriminate sounds. This ability is something which is obviously physiological, and which is important because it provides a background for the kind of "talent" which is necessary to be a musician.

Keeping in mind these points, we move now from the understanding which is the result of the apprehender's ability to decode the structure of the work, to the activity of the artist, creation, which entails putting the structure together initially, encoding.

Could we not simply inquire of artists how they go about doing what they do? In reading through the letters of Wagner for example, one is unlikely to find much information that is useful about the relationship of artists to their work. This should not be surprising because artists do not really know how they create anymore than orators know about the grammar of the language they speak. Artists are unlikely to be aesthetically sophisticated and we should not expect them to be any more aesthetically aware than we would expect an orator to be a fine philologist; their expertise lies elsewhere. Expertise in being an aesthetician consists in working out the values inherent in a work of art; the strength of artists lies in the fundamental process of artistic creation itself, essentially a process of translating the structure of their thinking into some concrete expression, i.e., the work of art. We shall refer to this process as "encoding" for reasons which will be described and an exploration of the possible details of this process forms the subject of this section.

If, as we have maintained, art is an intellectual structure, then all art involves "thinking" as opposed to what we might describe as "spontaneous emotional reactions" since it involves fundamentally the process of selection and analysis which are exactly what all kinds of thinking entail. And, without indulging in undue speculations about the psychology of the artist, certain assumptions can be made about the process of creative thinking. For example, creative thinking consists of a series of causes (sometimes called the "inspirations" or "motivations") which result in an effect (the concrete expression, which is the

work itself). Normally, this creative process is spoken of as if it were one step; however, it is evident from discussions about works of art that creativeness involves a double step process. In other words, there is a difference between factors which inspire and motivate the artist and the artist's adapting motivations and inspirations into the aesthetic activity. In notebooks written by artists, for example, it is evident that the creative process can cover vast spans of time. For example, from Beethoven's notebooks one learns that melodic motives sometimes occurred to Beethoven as long as twenty years before they were actually employed; during the ensuing time they were vastly modified and then put together. This may appear to contradict the case of the Zen painter who has a perfectly conceived structure before setting brush to paper, but that can involve a very long mental process as well. Ideas seem to occur sporadically, then are assembled into a mental framework which enables the artist to produce the work of art.

However, artistic creation on this level does not differ from thinking in general, for one can find exactly the same process, in so far as we have documentary evidence, in the work of Newton or Leibniz or Einstein in that ideas occur independently and then in conjunction result in a theory; and, sometimes it is clear that the occasion of the conjunction is fairly trivial. This is not to equate artistic products with scientific products but simply to say that the processes of thinking which lead to the summation are the same.

This raises the question whether, if one were to develop a general theory of thinking, perhaps as a philosophical project, one would encounter any problem which is specifically aesthetic. Is art a special type of thinking? That is, if a satisfactory thesis of what thinking entails were developed, would the explanation of this thesis reveal certain varieties of thought which have special characteristics which would have to be called "aesthetic?"

The statement that art involves "thinking" obviously employs the word in a broader sense than either true/false judgments or judgments the denial of which would be contradictory. Neither of these two criteria is required of a mental event in order that it be called a thought. To be a thought, a mental event can merely have a coherent structure; that is, it may not be random. What we want to reinforce here is that rational statements are simply one form of thinking and that there are other kinds of thinking as well; for example, some thoughts are linguistic, others are not;[7] some thoughts involve true/false judgments,

others do not; some thoughts involve judgments of self-consistency, others do not. Art is thinking that does not require the criteria of truth and falsity or the criteria of self-consistency; but it does not follow that art is therefore "irrational." It is simply a class of thinking which involves a certain clarity of perception regarding the symmetries of structural relationships. To say that the kind of mental act in which the artist is involved, has a clarity superior to more ordinary mental acts does not indicate some unique characteristic of aesthetic thinking, since the same statement could be made of areas besides art where some people are able immediately to perceive things as a whole.

The process of translating these coherent thoughts into a concrete structure is the process which elsewhere in this paper is called "encoding," but which is more popularly described as "expressing." The idea that the artist expresses something is a fundamental concept in aesthetics, and while there is no disagreement here in using the term "expressing" to describe the relation between artist and product, the term "encoding" is preferred for reasons that will be outlined after the content of the notion of expression is explored.

Melvin Rader is correct in noting in *A Modern Book of Esthetics* that although many thinkers will use words like "communication" (Tolstoy), or "symbolization" (Langer and Arnheim), or "embodiment" (Reid and Bosenquet), these various terms can be subsumed under the single term "expression." Although most modern aestheticians agree that works of art somehow involve a process of expression, there is a dispute as to what is expressed and how it is expressed and what causes it to be expressed. So, while disagreeing on various points, aestheticians nevertheless generally agree that expression is a fundamental key to art itself.

The term "expression" has the happy advantage of approaching neutrality with regard to the message-structure controversy. If, for example, the word "communication" is used instead of "expression," the case would already be prejudiced. To show that this is so, let us take the idea that the artist communicates

[7] Perhaps the best example of non-linguistic thinking is the way children grasp the emotional aspects of a language long before they grasp its content. As a result children intuit the emotional appropriateness of certain words long before they have any notion what they mean. For example, children know what one should say when hitting a finger inadvertently with a hammer, yet have no idea of what damnation means.

something and examine the problem involved. When people say that the artist wants to "communicate" something, it is difficult to ascertain what is meant by that word. In general usage, the word seems to carry the vague implication that works of art somehow influence viewers in the sense of changing their attitudes or the way they are as people and art is regarded as important to the extent that it effects these changes. In other words, the idea is that if people respond to art then they are not unaffected by the art. What causes people to think they are affected by art? It is possibly because of a reaction to art which is normally characterized as an emotional one, sometimes coupled with "pleasure." But all of these terms are not truly informative because it is clear that the art people like most is not necessarily the art they regard as qualitatively best. Almost everyone, if the matter be given reflective examination, makes the distinction between the art regarded as important and the art regarded as pleasant.

It is apparent that the art regarded as important is the art that "communicates;" thus the work of a particular artist is regarded as being more important than the work of another artist even though the latter's work may be preferred. But, what does the artist communicate in important works of art? Surely, the intention is not to say that the artist wants to convey some fact since it is clear that art is not a way of giving information. This is not to overlook the possibility that works of art may contain incidental information; for example, historians often make use of poems because they include a chance reference to some person or event, but such information is trivial in theory. Moreover, it is clear that the meaning is not that the artist intends to tell something about the world so that we may react to circumstances in the same sense that we would react to warning signs or to scientific information. That what is communicated is not ideas, theories or facts we can be fairly certain. If it were any of those things the works would be true or false, and if such categories pertained to art, it would be sufficiently clear that two persons observing the same work would know exactly what is meant, and there would be no dispute over it. Since this is manifestly not the case, it is obvious that when the word "communicate" is used it should not be meant in the *strict* sense of the term. To avoid the problems just stated, it is preferable to find another term for the artistic activity and to say that the artist expresses rather than communicates. The idea is that we can express something without communicating it.

The very use of the word "expression" gives rise to a common notion that art involves *self* expression on the part of the artist. Since aestheticians want to make art intelligible, it must be pointed out that if a work of art involves solely the self-expression of the artist, it is fundamentally unknowable unless one knows the artist and what he or she *intended* to express in the work; however, this is irrelevant to aesthetic consideration of a work of art.

Perhaps the difference between expression and self-expression can be illustrated by pointing out that a perfect example of self-expression is the babbling of an infant. That is, the babble is simply sounds connected in a fashion which is either attractive, or commends itself in some way or other, to the infant who is doing the babbling. Even after they learn to speak children sometimes make up languages and babble on (and would anyone deny that adults too are guilty of this kind of thing?). In any case, this is a clear cut case of self-expression; and while the infant may intend something by it, we cannot determine the intention from the babbling. Eventually, one might note that there is some regularity in the sounds, and parents who live with children can sometimes tell that what seems like babbling to others is actually mispronunciation of standard words.

In the problem of expression *vs.* self-expression of the artist, a similar situation develops. As long as the work is simply self-expression, the artist might as well be babbling, and babble is not the kind of thing one can deal with, since there is no clue as to its substance or structure. Only when we determine substance or structure can we deal with art in any reasonable way.

Obviously, if one holds art to be solely the artist's self expression, the inevitable outcome will be a discussion of the artist. If one says that all art is self-expression, art is essentially subjective; so, in a fundamental sense, it could never be known. If, however, art involves some kind of expression, for example as Langer says, not of the artist's own emotions, but what is known about emotions,[8] then in some dimension art is not subjective, but rather objective or public. Thus, the person who sees the work of art or hears the work of art sees as much, or

[8]"An artist, then, expresses feeling, but not in the way a politician blows off steam or a baby laughs and cries. He formulates that elusive aspect of reality that is commonly taken to be amorphous and chaotic; that is, he objectifies the subjective realm. What he expresses is, therefore not his own actual feelings, but what he knows about human feeling." *Problems of Art,* New York: Scribner's 1957 (paperback).

potentially as much, as the artist does.

To view art as expression, but not self-expression on the part of the artist, helps solve some of the problems of creation in that often the artist does not see in the creation all that those who apprehend the work see. In fact, sometimes artists are actually surprised that others see things in their work that are not visible to them. By making a distinction between expression and self-expression, two phenomena can be explained: first, how someone else can understand a work of art better than its creator, when of course this is impossible if one maintains that art is purely self-expression; and secondly, the way in which a work of art can be viewed as being public and objective rather than private and subjective.

Although "expression" is an adequate term I have preferred to introduce my own word "encoding" to describe the activity of the artist. "Encoding" has been chosen for very specific reasons. It is a neutral word which does not imply that the artist is creative in the sense of originality. It implies nothing about his or her psychology. Also, the term "encoding" is very much more positive in describing the activity. That is, if something is "encoded" the implication is that it can be "decoded." Moreover, the term suggests that the process of response is akin to the process of expression, whereas there is no necessary connection between the way someone understands a work of art and what was intentionally expressed by the artist. The term was chosen to make clearer the symmetry between the activity of the artist, the product and the activity of the apprehender. Other than striving for a certain clarity concerning these issues, there is no essential difference between calling what the artist does "encoding" or "expression;" similarly, the product, the work of art itself, can be called that which is "expressed" or "encoded."

Two kinds of ability are fundamental for an artist. First, there is a process of selection and techniques of organization which are mental; these combined may be referred to as the artist's *techniques of encoding.* Secondly, there is the physical medium of which the work is made and the creative manipulation which consists in applying the techniques of encoding in a concrete work of art. We can call this particular creative ability an artist's *technique in the material.* These abilities need to be examined in some detail and while they cannot be entirely divorced from each other, for purposes of elaboration they will be discussed separately.

Techniques of Encoding: In the technique of encoding,

42

artists create certain mental patterns of choosing, which they translate into a particular medium. Once these are translated into a medium, they become distinctive and recognizable and are referred to as the artist's "style." Through style, an artist may become like a friend whose missing word one can supply in a conversation; that is, it is possible for one to grasp an artist's pattern of choosing. In theory, there is nothing inevitable about the medium in which the work of art is produced and when artists encode they gather together their choices in such a way that the end thought has certain identifiable characteristics or organization.

Patterns are chosen for a particular process of encoding because of what the work of art "expresses" or, in our terminology, "encodes." There has been much discussion in the literature of aesthetics as to what this might be. Unfortunately, the English language, and most others, uses words for "thoughts" and "emotions" that are discrete. For this reason, some philosophers want to say that aesthetics is not rational because aesthetic utterances clearly involve emotional responses. Thus, what poets do when they write poetry, what painters do when they use visible objects, and what musicians do when they use tones, is to manipulate the emotional resonances of these tools to create what is often called "mood." Thus, what emerges from a musical composition, for example, is not an idea in the intellectual sense, but more accurately, an "attitude" that will be referred to here as a "constellation of mental attitudes."

The word "attitude" is chosen for two reasons. It is much broader than the word "emotion" which is frequently used with regard to works of art; and, on the other hand, it is more definite than mere "feelings," which is so vague a term that one does not have a clear idea of what is meant. Although an attitude cannot be defined with pristine clarity either, the term does apply to something more definite than feeling. Attitude, of course, does not refer to *what* is done but the *way* something is done, and is always elusive because it involves a pattern. It may exemplify a particular attitude of life, but it may simply call one's attention to the way things must be constructed. That is, an attitude can be somewhat precise, as in the case of stylistic art which has a common attitude; (that is the reason, presumably, one can identify Renaissance art); or, attitudes can be more general. For example, one can speak of attitudes in the way people sit, the way they walk, and one can even speak of the attitude of a tree or other natural objects. The point is significant because it means that attitudes are visible in structure.[9]

The word "constellation" is used to convey that what is involved is a series of associations of attitudes which may or may not overlap and which form a kind of pattern in and of themselves. The word "constellation" does not pre-judge the nature or character of the pattern, but indicates at least some kind of organization.

This is not to deny that in many ways ordinary people exhibit attitudes in their daily lives but only to point out that the patterns, the constellations of mental attitudes, which artists have are presumably more complex, more subtle, richer in their dimensions, not that they are different in kind. If this were not the case, if artists did not have attitudes which are more vivid, richer, more complex etc., than the ordinary, then the works they produce would not be different from our lives. To say that the artist's constellations of mental attitudes are distinctive is not to say that these constellations are distinctive in their rarity, only that they are distinctive in their vividness, richness and completeness. Even though all people have intuitions and experiences of constellations of attitudes, the artist's have about them an intuitiveness which extends beyond the ordinary form of awareness.

Because of the symmetry of our system, we can say that the aesthetic response also involves the extension of awareness. The result is that instead of art being valuable because it communicates an idea to the apprehender, the value of art is that it extends the *range* of the apprehender's awareness. To say that a work of art is too difficult is to say that the threshold of understanding demanded by the work is higher than our threshold of awareness. Similarly, what is meant when we say that the work of art has come to be understood is that through expo-

[9]This is not to say that when it comes to works of art that one can easily specify the "attitude" of the work, the descriptive language of attitudes and moods is too poverty stricken for this. But, there are groupings of terms that are more appropriate, or less so. For example, if one compares Beethoven's *Sonata 32 in C Minor* to Mendelssohn's *Midsummer Night's Dream* or Wagner's *"Liebestodt"* from *Tristan and Isolde* certain distinctions can be made as to what attitude words would be appropriate. The word "stately" would not be appropriate for any of the three, while "sprightly" might be appropriate for the Mendelssohn but not for the Beethoven or the Wagner. Whatever attitude words apply have nothing to do with the quality of a work of art, but only what we perceive to be the mood of the work. While the attitudes that are expressed in a work of art are not important for the value of the work, they make a work appeal to us or not. For example, the attitude displayed in Picasso's *Guernica* is one of the things that makes a powerful impression on people; presumably, they concur in the horror Picasso expresses about war and destruction.

sure to it we have raised our threshold to the level of the work of art itself. Thus, it is possible to say that works of art influence people because they extend the range of a person's awareness.

A work of art, then, gives expression or definiteness to areas of experience which almost everyone has, but does so in a more vivid, more precise form than one's ordinary intuitions, since artists have the advantage of talent which enables them to express in a way that most people are not readily capable of doing. This brings us to the artist's techniques in the material.

Techniques in the Material: A person can think beautiful thoughts but not be a successful artist unless there is something else in addition to techniques of encoding, and that is what can be called "techniques in the material." That is the artist must have the *skill* to translate the structure of thought into the artistic medium. To be a musician, one must do more than think musically or to have thoughts that could be given musical expression; one must have an awareness of how to deal with the problem of what we will call the "grammar" of music. That is, musical sounds do not follow each other randomly. The choices that one makes in musical composition must be made in context of certain pre-established regularities which limit the kinds of choices which are made. Historically, this is the style of the era in which one happens to live. A style period in the history of art simply means that there are certain assumed limitations on the kinds of choices which artists can make if they expect to be in touch with their era.

This shows two things: one is that the more distant the epoch, spatially and temporally, from our own, the more obscure the music is likely to be. Conversely, we are likely to understand music of certain epochs more easily than others. For example, if people grasp a work of one epoch, then they are likely to grasp other works in that epoch more easily as a consequence of having grasped the general technical assumptions in terms of the material which limits the kinds of choices which an artist can make.

We now have a clear statement of the role of selection in the act of creation in that it involves both a mental and material phase. The artist has a constellation of mental attitudes and the process of artistic creation is the process of selecting from amongst the elements in the particular art type those which seem appropriate to give expresssion to this constellation of mental attitudes. The phrase here "to give expression to" means to create a configuration, or form, that will successfully encode

45

the mental attitude into the work of art. By hypothesis, a person given the same set of assumptions about the way in which the art language works,[10] will then be able to interpret these in such a way that he or she will have as the product of the appreciation of the work of art, a response which will be similar in structure if it is to be considered as an aesthetic response.

This does not mean that there are any correspondent ideas concerning conclusions about life, nor correspondent conclusions about the nature of the world or indeed any objective facts at all. In other words, there is no information involved in either case. Hence, the idea of truth, if truth means a description of some kind of objective reality is not something that is involved in art.

In addition to the fact that art does not transmit information, it is evident from what has already been said that it is not the case that it is only the artist's psychological profile that we are getting in the work. What happens in artistic creation is that the particular configuration of attitudes which gave rise to that artistic expression are transmuted into an objective form. This objective form is what prompts the process of decoding. The decoding has as its necessary concomitant another attitudinal configuration. The decoded configuration most likely will not be the same in its content as the original configuration of the artist, and actually they may have very little to do with each other, but the structures will be analogous. The intellectual structure involved in the response, if it is an aesthetic response, and the intellectual structure involved in the artistic expression will be similar in the geometric sense of the term. Though the content of the response may well be different from the content of the inspiration, the form of the inspiration and the form of the response will be the same.

This means that in so far as the aesthetic significance of the work is concerned the work of art is not a catharsis for the artist, a venting of emotions, just as aesthetic response is not an arousal of emotions. Expression is giving form to attitudes while the response is coming to understand those attitudes. Thus, an artist need not be sad to understand human sadness, a person need not be sad to respond to human sadness. A tragic work

[10]The reason for using the language metaphor is to suggest that there are certain regularities in the various art types that a person must learn to recognize. The process of being exposed to art is the process of learning to recognize these things. For example, one learns to "see" painting and "hear" music the same way one learns language fundamentally.

of art is quite possible without the person hearing or seeing it being affected or the artist creating it being affected. Works of art represent a view, an understanding, an intellectual appreciation of some configurations of attitudes and not the attitudes themselves.

In this section, we have said that the act of creation is fundamentally twofold: (1) an intuitive sense of the appropriateness of elements and the organization of elements into the mental constellations which gave rise to the expression, and (2) the mastery of a language implicit in the way artists and their contemporaries look at and make art. This last fact is important because along with the artist's own vocabulary which determines personal style, there is also the language which characterizes the style of a period. That is, the general population as well grows up with just such a language in terms of which they look at and are exposed to art, so that while the particulars of a language of a given art type are not easy to articulate, it is clear that virtually everyone is exposed to them in the course of growing up. For example, in the course of learning to play an instrument or learning to paint or becoming familiar with any type of art, as a process of learning technique, a person picks up certain kinds of vocabulary about the way in which the art type functions. This vocabulary is a kind of primitive criticism, the intent of which is to give clues as to what the elements of an art type are, and clues as to the preferred way of organizing according to the style period in which one happens to live. In some style periods, these specifications are very exacting.

We happen to live in a period of artistic activity where they are exceedingly indirect because of a stylistic preference for non-verbalizations, but in earlier periods there have been virtual rule books written as to how the artist should go about creating. For example, Polyclitus, along with Phidias one of the most celebrated sculptors of antiquity, is credited with describing a canon of ideal proportions which he then used in his work. Similarly, the current mode of analysis of traditional music is based upon the text book written by Rameau who articulated the basic rules of harmony. Even though these rules are antiquated by contemporary standards and have been updated by people like Schoenberg and Hindemith, these rules serve a kind of narrow purpose, and that is to give clues and references to the art language and to give historical perspective so that a person can relate what occurs today in contemporary composition to earlier composition.

This situation is not restricted to art or music since the same

47

thing occurs in criticism of all sorts. Rules are developed which are intended to refer not only to one style, but to several styles or to a whole tradition—normally the tradition of European painting. A limitation of this situation is that criticism becomes entirely culture bound. Thus, the criticism which we find in painting and in poetry and in music is normally confined to those activities of artists who lived in Europe since about the year 1,000. And, although this criticism is sometimes applied to classical artists as a kind of afterthought, the antecedents of Greek art before the year 1,000 (Summerian and Egyptian cultures) are excluded.

It is evident however, that this kind of vocabulary, while it enables one to deal more or less effectively with a limited style period and art type, is not successful in encompassing various types of art of different cultures or with diverse art types themselves. Thus, there is not a vocabulary of painting which will apply uniformly to Indian painting, Chinese painting, Persian painting and Western European painting or which would permit one to speak of painting, music and poetry in a uniform way.

Considering our fundamental rule of commonality, that all aesthetic judgment and description must be general and applicable to all types of art, it is apparent that a major difficulty that must be met in Chapter III, when the work of art is considered, will be the creation of an abstract vocabulary for the analysis and description of art works that will not be restricted to a particular style period or by any single type of art.

Chapter Three

The Work of Art

It seems clear that whatever conclusions one ultimately comes to regarding art, the only area which can be discussed with any degree of clarity is the work itself. For example, if one begins aesthetic inquiry by dealing essentially with the problem of artists and their communication, then the very practical issue of information arises; although artists and their creative endeavors are interesting there are no hard data regarding the creative process. There are reasons for this. First of all, the amount of information available from artists on how they go about the act of creation is very small. Secondly, there is no reason to believe that the information we have is reliable.[1] Careful self-observation is not the object of the artists' endeavors, and their attention is rarely directed to that question. Of the information they do provide, little is of the kind that would be helpful.[2] Artists are not trained scientists who are detached from what they do sufficiently to provide an adequate explana-

[1] Even if we were to grant the reliability of artist's accounts and choose the intentions of the artist as the line of approach to aesthetic value, we face the difficulty of not being able to deal with works of art that are not contemporary (the intentions of dead artists being almost impossible to establish) and if we take an extreme position on this point, only works of art where the artist is known can be dealt with.

[2] A compilation of what artists say about their creative activities is *Artists on Art* by Robert Goldwater and Marco Treves, Pantheon Books, Inc., New York, 1945. An example of the sort of description that artists give of creation that aestheticians find of little help is Picasso's account that "The painter goes through states of fullness and evacuation. That is the whole secret of art. I go for a walk in the forest of Fontainbleau. I get 'green' indigestion. I must get rid of this sensation into a picture.," p. 421.

tion for their operations. In addition, encoding is primarily an internal mental process; therefore, even if a person were sitting in the studio of an artist no insight would be gained into the creative process because there is no way of determining why the artist selects things in the way that he or she does and in the order in which they are selected.

If the word "adequate" has any meaning in aesthetics at all, that is, if we believe that there are interpretations of works of art that are adequate, then certainly one of the minimum things an explanation should be able to establish is that where two conflicting interpretations are encountered one of them is inadequate or less adequate than the other. An explanation based on what artists meant or why they did what they did will be fundamentally unfruitful for we have seen even asking the artist's help will not solve the problem.

In contrast to taking artists and their intentions as the focus of aesthetic value and interest, there is a certain advantage in looking to the response of the apprehender in this regard since here there is the advantage of an abundance of information. This approach, however, is not problem free in that oddities result. For example, we do not want to say that Rembrandt, who was widely appreciated until about the time he was fifty, was a great artist, and then suddenly was no longer great when he ceased to be appreciated toward the end of his life. This position is especially untenable since the works that Rembrandt produced after he ceased to be appreciated are those that today are regarded as more valuable, while the earlier works are at present regarded as less significant.

A phenomenon which must be taken into account when considering responses to art is that our responses and the responses of others vary one from another. One thing that has been established in the realm of aesthetics is that what different people say a work of art means to them, in terms of their responses, is radically divergent. Responses differ to the degree that if we were working only with a person's response to a work of art it would not be possible to determine what work elicited the response. Works of art that are supposed by conventional wisdom to be extremely sad, strike some individuals as ecstatic; and works that some people view as joyous are thought by others to be profoundly tragic. Thus, as when emphasizing the artist's intent, we are faced with the puzzle of establishing which of two conflicting interpretations of a work are correct.

Aside from the multiplicity of responses that exist among people, it is not unusual for the same individuals to report that

their own responses to a work will vary over a period of time. It is not uncommon for persons to realize, after several years acquaintance with a work, that what they come to respond to is totally different from what they responded to initially. Many people have the experience of realizing that the work which immediately attracted them to some type of art often turns out to be, in terms of value, not very good. They come to realize that their initial responses were in some respect uninformed or at least incomplete. This is presumably because they develop some better acquaintance with the mechanics of the art type. For example, almost everyone who has come to like Tchaikovsky's *1812 Overture* does not have difficulty in liking other works by Tchaikovsky, and from there Romantic music in general. However, most people who are at this early stage of developing musical knowledge rarely respond positively to early Renaissance music where the mechanics of composition are less familiar, and it would also be doubtful that they would like late Schoenberg whose work, to the uninitiated, seems incomprehensible. If someone in their initial musical development regards Schoenberg as a hopeless pedant, who by introducing exotic theses of the twelve tone scale ruined modern music, how could this judgment be evaluated? In other words, using response as value criteria, it would be impossible to determine whether Schoenberg is not liked because the intracacies of his work are not fully appreciated, or that his composition is understood but his work is aesthetically inferior.

Due to these kinds of difficulties in using either the artist or the apprehender as the criterion for aesthetic value, it is sometimes suggested, and rightly I believe, that the value of the work of art lies not in the response or in the artist's intentions, but in the work of art itself. The work of art has the advantage that everyone can apprehend it at some level. Thus, if a person says something about a certain work of art "x," then others can judge whether the statement does or does not reflect the reality. We have the advantage of *verifiability*. In focusing on the work of art we are saying that there are certain kinds of intellectual structures in the work of art which are identifiable and inherent values that can be determined. The identification and evaluation of these structures in a way which will be applicable to various media will be the goal of the next chapters.

A fundamental axiom that was adopted at the outset, to ensure adequacy of our system, was that for a distinction to be aesthetically significant it must be applicable to every art type. It was pointed out that it is this feature of commonality of ap-

proach that will distinguish aesthetics from literary criticism, music criticism, art criticism, etc. By using the feature of commonality to build an aesthetic vocabulary, the mistake of saying that something is distinctively aesthetic which may be only a part of some medium or an accidental characteristic of a particular art type, such as a rhyme in poetry, can be more easily avoided. If rhyme were an aesthetic essential, it would make sense to speak of rhymed paintings, and rhymed music; therefore, by applying the rule of commonality it should be possible to show those elements which are fundamentally insignificant and to avoid errors such as the one perpetuated for decades that rhyme was an essential condition of poetry.

After solving the problems of describing the manifest structure of a work of art so that any two people can agree on the descriptive features, we need to determine what function the structure fulfills. Is the structure simply a structure *per se* in the way in which a crystal is regarded as a structure, or does it function structurally as does the grammar of a sentence? That is, grammatic structure is in itself unimportant but conveys something which is important, namely, the idea. For example, most people would say that Wagner's *Ring* cycle is in some sense better than his *Rienzi*. The value question is, does the value inhere in the structure and its properties, or does the value inhere in the idea expressed through the structure?

It should be evident that with the requirement of the rule of commonality that "aesthetic terms be general to all art works," *both* descriptive *and* value terms are included. The conjunction of the two statements that descriptive and value terms are universal to all types of art produces the conclusion that *all art works are comparable.* Thus, there is no theoretical difference between comparing a painting, a poem and a piece of music or comparing two examples of the same art type since the identical processes of analysis and evaluation are involved.

At present, however, such universal analysis and evaluation are not possible because there is no interchangeable vocabulary to all types of art. For example, if we read the works of painting critics, we will discover that a great deal of our aesthetic vocabulary is metaphorical. Critics of painting constantly use words like "movement" and "rhythm" which, unless the metaphors are "unpacked" seem inappropriate since both movement and rhythm imply a temporal sequence and it is manifestly obvious that paintings do not possess this dimension of time; hence, there cannot be any temporal events in their organization. On the other hand, poets regularly use words like

"balance"and "proportion" and those are visual terms obviously maladapted for poetry without explanation. The point here is that a great deal of art terminology is metaphorical and, if these terms are to be aesthetically useful the metaphors need to be deciphered.

This is precisely where the problem of descriptive aesthetics is so critical; for we want to say that whatever aesthetic values there are, are the same for music and painting; but it is clear that the descriptive language used in painting is not the same as that used in music. Thus, there is a technical problem, for if we believe that values of works of art appear in the structure of the work, there needs to be some means of comparing structures of different types so that the same values may be discerned in them. It is necessary to give an account of how the metaphoral language of art criticism works, refining the vocabulary in such a way that it is possible to understand precisely the relationship between elements of various art types, so that if a word like "rhythm" is used in connection with painting, one knows its corollary with respect to overall structure in music. Our fundamental task here will be to create a general vocabulary for the description and analysis of the various art types: painting, music, poetry, etc., so that, being able to describe them in comparable terms, a uniform set of value categories may be applied to works of art. However, having uniform tools with which to describe and evaluate the various media does not imply that everyone will necessarily agree on the way in which these tools should be applied in any particular instance. At least, however, when there is disagreement, there will be a common vocabulary with which to disagree, thus laying the foundation for debate and dialogue which may lead to mutual understanding if not to eventual agreement.

An aesthetic based on a common vocabulary depends upon establishing what a work of art entails; in other words, what kind of account can be given of generalized features of works of art? One way of going about this is to examine the levels of response to works of art and the hypothesis presented here is that there is a certain hierarchy of levels of response.[3] To begin, it is obvious that our responses to works of art differ from responses to scientific works in that for works of art the medium

[3]Ducasse also suggests that there are distinct levels of appreciation. Unfortunately, he only briefly suggests what these levels of appreciation might be. See his article, "Art and the Language of Emotion," *The Journal of Aesthetics and Art Criticism*, Vol. 22 (1964).

of the work is significant. This would mean that the physical properties of the medium, which we shall call the "primary elements" are connected with the aesthetic values in the work of art. There is presumably a sensuous appeal to the art; and this is somehow thought to be an important part of its characteristics. Apparently, it is this which makes it difficult to conceive of the transference of medium. A work of art has certain sensual qualities which other intellectual products do not entail. It is also presumably the sensual qualities of a work of art which account for the fact that responses to works of art in certain traditions are conceived to be vaguely erotic.

Sensual appeal does not seem to be all there is however, and there appears to be an intellectual appeal as well. The intellectual appeal appears to have three different aspects which correspond to what artists do when they encode in a medium; that is, the structure of the work of art consists of (a) the selection of elements by the artist, the arrangement of the physical or primary elements into patterns which are identifiable, (b) the relations of the patterns to each other by means of organizing principles, (c) the inter-relationship of the patterns with respect to the totality of the work.

If we are correct that all types of art involve these levels of appreciation, both physical and intellectual, then we can anticipate that it should be possible to identify factors corresponding to each of these in the various art types that exist, and from this point derive a vocabulary which should be more or less common from art type to art type.[4]

The importance of attributing hierarchical levels of appreciation to works of art is that we have a starting point from which to go about organizing a descriptive vocabulary. Thus, a task of this chapter will be to test out the levels in music, poetry and painting to determine the soundness of the hypothesis set forth above. Since painting, music and poetry take care of the basic types of art in terms of involving the major sensory modalities other art types need not be treated. In naming the division of the arts, or setting forth an order in which they can be arranged, it is immediately apparent that the various arts are sensually presented and can thus be demarcated according to the sensa-

[4]Two kinds of vocabulary words will be involved in this descriptive vocabulary (a) words which describe the physical elements themselves and (b) words which describe the relationships among the elements or the intellectual aspects. Whereas the words describing the physical elements will differ from art type to art type the vocabulary describing the intellectual relations will be essentially similar.

tions involved. For example, visual arts based on the sense of sight include: painting, sculpture, architecture and photography; while auditory arts, based on sound include: music, poetry and novels.[5] In addition, there are "composite" art types based on both auditory and visual sensations: opera, dance, theatre and films.

In addition to the hierarchy of levels of appreciation, it can be anticipated that there will be corresponding value terms appropriate to each of the levels. That is, there will be different qualities, or values, which appropriately characterize the primary, or physical aspects, of a work and there will be values which characterize the intellectual aspects; namely, values which are the product of the selection process of the artist and the creations of patterns, values appropriate to the organizational aspects of patterns relating to patterns, and values which have to do with the structure as a whole. Working out values which might be appropriate for the various levels will be the subject for Chapter IV, "Devising a Common Vocabulary of Aesthetic Value Terms."

Towards a Common Descriptive Vocabulary: As we begin working out the family resemblances between arts on which to build a common descriptive language of art, and eventually common standards for evaluation, we notice straightaway that individual arts will differ. Music cannot possess elements in common with a painting because we hear music and we see paintings. It is not possible to hear a painting and it is not possible to see music; hence, there is no overlap of elements between the two because there is no overlap of sensations. There can be an overlap of two types of art only where there is an overlap of the sensory basis of the arts. This will not rule out, however, elements of an auditory art type performing the *same function* as elements of a visual art type. If we are successful in working out similar functions between art types, each art type will be totally comparable to every other art type. It will not matter that the primary elements are different, it will not matter that the type of associative relationships which may be involved in the art type are different, the fact is that if they all have these similarly functioning elements, then they may be inter-calibrated from one art type to the other, quantified in common, and hence compared. What this means in terms of

[5]The reasons for including poetry and novels under auditory arts will be explained in the section on poetry.

vocabulary is that instead of a uniformity of vocabulary, the true goal will be one of regular rules of transformation.

A good part of what is understood about a type of art deals with the senses and with what the senses themselves supply. To say that understanding of any art type is necessarily rooted in sensations or sense organs is simply to point out that the physiological qualities of the senses relate to, and determine, the elements of that art type.

It is necessary to explore the implicit order in the way things are perceived and the way in which artists exploit these implicit relationships—some to a greater degree than others, depending on the medium in which they are working. Thus, in theory, every art type involves some physical basis which is dependent on the physics of the phenomenon and our sense organs. Since the physiological qualities of music play such an obvious role in the elements of music, we shall begin with that art type and then expand the discussion to include poetry and painting.

As a description of poetry and painting develops, the question may be asked why the language of music is employed, but this is simply to facilitate the goal of establishing a common language of aesthetics. However, if family resemblance relationships can be established among the various media it will make no difference whether (a) we describe poetry in terms of music or music in terms of poetry, or (b) both of them in terms of painting, or (c) construct a language using none of the vocabulary now used to describe any of them. Music has been chosen simply because the language of music criticism is more carefully worked out than either literary criticism or art criticism (i.e., there is more nearly general agreement as to what the terms mean).

Music

Primary Elements: The primary elements of music can be defined as those elements which fundamentally appeal only to the senses, and which are not capable of direct structural type analysis. Music makes use of the four characteristics of sound as the raw material of the art. In the case of music, primary elements may be determined by examination of sound and its distinctive characteristics or properties; consequently, everything in music can be reduced to the characteristic properties of a sound wave. The statement that music is reducible to its primary elements does not mean that a recognition of the

physical elements of sound is to be equated with understanding a symphony; but only that the contrasts and tensions which account for musical relationships are made up of the building blocks of the medium's primary elements.

To begin an examination of music's primary elements, all sound will involve vibration in a three part relationship: (a) a source that produces the sound, such as a vibrating string, (b) a sound transmitting medium, such as air and (c) a receiving mechanism, for example, the human ear. Musical tone may be distinguished from mere noise by comparing the sound produced by plucking the string of a stringed instrument with that made by dropping coins on a flat surface. In the first case, the sound will be produced by a regular and relatively simple vibrating motion which we call "tone." In the second case, the sound is produced by an irregular and relatively complex vibratory motion, thus creating noise or heterogenous sound.

Exploring musical tone in more detail, let us take the string bass as an example. If one were to pluck the thinnest string and then the thickest one it would be obvious that the thinnest string vibrates faster and produces a higher sound than the thickest string which vibrates slower and produces a lower sound. Thus, the frequency of the vibration (the number of back and forth cycles that the string makes per second) determines what we call *pitch*. Since each vibration is equivalent to one wave length, it follows that the faster the frequency, or the more the number of wave lengths per unit time the higher the pitch.

A second element of sound can be observed by plucking one string first very lightly. In this case, the vibrating motion will be very narrow and the sound produced will be soft. If the same string is then plucked with some force, the vibration will be wider and the sound will be louder. The width of the vibration is the characteristic of amplitude which is a measurement of the strength of the disturbance caused by sound waves. It produces what we refer to as *volume* or loudness; the wider the amplitude of the sound wave the greater the volume. (Figures 1 and 2 illustrate these concepts of pitch and volume.)

The third element of sound is that of *duration*. This depends on the length of time over which vibration is maintained; and it is the relative duration of a sound alternated with silence which determines rhythm. In this respect, the absence of sound plays an important, though often overlooked, role in music.

The fourth and last element in music may be demonstrated by plucking the lowest string on the string bass and then strik-

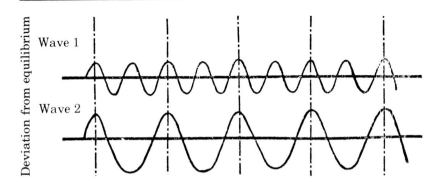

Figure 1. The pitch of a sound is determined by the frequency of vibration of the sound source. The faster the vibrating body is caused to vibrate the higher the pitch. Conversely, the slower the vibrating body is caused to vibrate the lower the pitch. In the above diagram, two vibrations of Wave 1 occur for each vibration of Wave 2. Thus Wave 1 represents a tone whose pitch is higher than that of Wave 2.

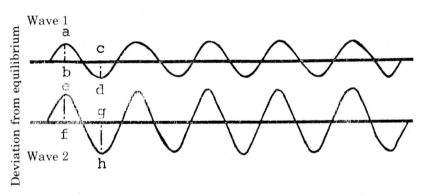

Lines a--b, c--d, e--f, and g--h show how amplitude is measured.

Figure 2. Since amplitude is a measurement of the disturbance caused by sound waves, the greater the agitation the higher the amplitude of the wave and the louder the sound sensation. In the diagram, Wave 2 represents a louder sound than Wave 1.

ing the same note on the piano. It will be apparent at once that even though the pitch and loudness of those two sounds may be the same, they sound very different. This difference is caused by the overtone structure. When the string of the bass is plucked, the string is vibrating not only as a whole unit, but also in halves,

quarters and other proportional units. The string vibrating as a whole produces the tone that is heard most clearly, the "fundamental" or dominant frequency, while the smaller vibrations of the string produce what are called "overtones" which are of higher frequency. Overtones are usually not heard as separate pitches; instead, the number, position and relative strength of the overtones above a given tone will differ from instrument to instrument. It is this combination of fundamental or dominant frequency together with the many overtones which gives each instrument its characteristic quality of sound and this is called *timbre*. A horn, such as a trumpet, which is rich in overtones has a very different sound from a flute which gives a very pure note and is much less rich in overtones.

The significant point is that by totally describing music in terms of physical properties, those elements which are referred to here as "primary elements," we shall have produced an exhaustive description of music in the sense that the themes which make up musical composition are nothing more than the manipulation of these primary elements of sound. Understanding the music involves perceiving the patterns that have been imposed on the physics. Each of the senses has a physical set of properties corresponding to these we have mentioned in music, so that here are the foundations for creating a language which will ultimately enable us to set forth a fully comprehensive descriptive system for aesthetics.

Thematic Elements and Development: Putting together a particular combination of primary elements in such a way as to exhibit an intelligible structure is to create themes. The themes of any art work will be composed of the physical constituents of the medium. In music, a theme is composed of distinctive patterns of pitch, volume, duration and timbre. These patterns of primary elements will be referred to as "thematic elements," and they are melody, rhythm, and orchestration.[6] For example, *melody* consists of patterns of pitch formed by a succession of tones of varying pitch. There are examples in musical compositions that illustrate explorations of pitch patterns in which there is a quotation of a folk tune or melody from another composer which is then systematically developed by the composer. Such a work is Beethoven's last work for the piano, Op. 120, the "Diabelli Variations." While Diabelli's own melody was insigni-

[6]Harmony will not be considered as a separate pattern since it is the combination of tones occurring together whereas in melody the notes occur in succession.

ficant, he invited other composers (including Schubert) to write variations for it, and Beethoven responded with not one but thirty-three. Another famous example is Paganini's "Caprice for Solo Violin." The theme of this last Caprice (24th) was taken by Brahms for his "Variations on a Theme by Paganini" for solo piano and by Serge Rachmaninoff for his "Rhapsody on a Theme of Paganini" for piano and orchestra. The Brahms is particularly ambitious in that he uses the Paganini theme as a point of departure and concentrates on treating his variations in the spirit of Paganini. The result is a comprehensive statement in the art of composition in which every technical possibility and every device of variation technique has been exploited.

Another example of experimentation with melody is Schumann's *Abegg Variations (Theme sur le nom Abegg)* variations in F Major Op. 1. He wrote the composition for a young woman, Meta Abegg, and the opening theme is a musical anagram derived from the letters in her name and containing the notes A, B, E, G and G. The variations are not typical of their day in that they are based on an original melody rather than a popular piece or the work of some other composer.

Rhythm is a pattern produced by a manipulation of the primary elements of duration and, to a lesser extent, volume. A piece exemplifying a specific and noteworthy use of rhythm is Stravinsky's *Le Sacre du Printemps*. Stravinsky shifts metrical patterns in such a way that he creates an exceedingly agitated rhythmic pattern that is appropriate to the sense of frenzy of the piece.

Orchestration is the manipulation of timbre contrast or tone color. Tone color can be produced by the use of different instruments in a composition, or it can be produced in the same instrument. Different effects are created in the same instrument by different pressures that can be put on keys or by various manipulations of pedals. These techniques allow for different coloration. Most pianists will play an impressionist like Debussy differently from the way in which they would play Brahms, so there is a different color effect, even though it may be very subtle.

An enlightening example of orchestration is one in which piano compositions have been orchestrated. The most famous example of this type is Ravel's *Pictures From an Exhibition* by Mussorgsky, originally a piano piece. The effectiveness of Ravel's work is that in setting Mussorgsky's piano work for orchestra, Ravel did not proceed merely to transcribe it, he re-

60

thought the whole work in purely orchestral terms.

In the making of a composition, each of the primary elements of pitch, volume, and in the case of non-western percussive music such as Balinese, timbre, is *potentially* as important as the other, and music can be constructed based upon the contrast of any of them. Themes could be composed almost exclusively on contrast of rhythm (as for example a drum which does not have variations of pitch) or upon melodic contrasts or upon differences in sound color; however, in most instances normally one of these will dominate and others will be used for support.

Some alterations can be done without significantly altering themes, but other changes will result in the loss of its identity. For example, when one hears a melodic theme in a musical composition, what is heard is a distinctive pattern of changing sound levels, or tones. Certain alterations can be made, such as playing or singing it faster or slower, and the result will be regarded as the same melody; but if the internal pitch is altered, the melody will not be heard as the original. Similarly, it can be played on a piano, or sung by the human voice, or played on a violin and the change in timbre is not regarded as significant. One can also make certain modifications of the primary rhythmic structure and these will not be regarded as a significant change. On the other hand, there are certain motifs in musical compositions which are primarily rhythmic, and if one changes those, the theme will have been changed. For example, if the time of the notes of the theme of Beethoven's *Fifth Symphony* is changed so that the last note is not held longer than the first three, or if all four notes are played at the same tempo, the result will not be regarded as the same theme. Thus, sometimes themes involve both rhythmic contrasts and tonal contrasts.

The important point here is that themes involve a distinctive pattern where some elements are subsidiary and others dominate. But this structure is not unique to music since the construction of themes in any art type is based on the organization of the physical properties of the medium so that some become more prominent than others and thus more significant to the integrity of the theme. Themes are then modified by changing the supporting elements and limited modification of the dominate ones, so that while the identity of the theme is never lost, it undergoes considerable variation. In music, this modification is called "development."

Different musical traditions will exhibit different stresses amongst these physical properties and their corresponding organizational patterns. Except for Indonesia's wide variety

of percussion instruments, no other musical tradition has as large a range of instruments as does Western music. Modern music has been exceedingly interested in exploiting the differences of timbre, or the properties of the overtones of individual instruments. However, while tone color is explored, the timbre of various instruments turns out to be not the true source of the structure in Western music. Most people do not regard the orchestration of the piece as materially different from the unorchestrated version of it, or at most it is seen as a difference involving only minor changes. Illustrations such as Beethoven's *Hammerklavier* sonata, Opus 106, may be cited in this regard.

Most people do not regard Weingartner's orchestration as more significant than the *Hammerklavier* on the piano. Conversely, there are reductions of Beethoven's *Fifth Symphony* (Liszt's, for example). In each of these cases, changes of tone color are not regarded as the primary part of the aesthetic structure, and changes in tone color are not regarded as significantly altering the structure of the work itself. Instead of timbre contrasts, our tradition is preoccupied with harmony and thus Western music is based primarily on pitch differences. Therefore, if a piece is played with the wrong degree of contrasts in loudness or it is played too slow or too fast, even if it is played on the wrong instrument, the piece is still recognizable.[7] There are other musical traditions, however, in which pitch is unimportant and the contrasts are rhythmic and not harmonic contrasts. These are those traditions in which percussion instruments dominate as in Indonesian music, African music, and to a certain extent archaic Chinese music. Indeed, most musical traditions are rhythmically considerably more complex than our own. We admit into Western music only a very few signatures (typically 2/4, 3/4, 4/4, or some variant), and as a result have an exceedingly restricted rhythmic base.

The significant point of this analysis is that based on the physical properties of sound, we can account for the kinds of contrasts and tensions which occur with regard to musical composition itself. This will be true not only of music, but of all art types in that there are certain physical characteristics of the medium. It should be remembered that the only thing this thesis is concerned with is the physical instantiation of the work and

[7] In so far as timbre is important, authenticity of instruments becomes an issue, but most people are willing to concede that Bach played on the piano is not Bach defiled. However, there are purists who will say that if one really wants to play Bach archaic instruments must be used.

no other entity which people have sometimes called "work of art," e.g., Collingwood. The artist must exploit these physical properties whether it is done so explicitly or not, and by making fundamental choices he or she establishes the pattern of the work. Even so-called "atonal" music makes use of certain kinds of relationships that are analyzable in these terms, and these relationships are established from the initial choices made by the composer. As they select a series of relationships, composers decrease the range of possibilities and their succeeding choices are not entirely random. For example, while any two notes can be played together, the addition of a third note dramatically restricts the possible choice of the next one and once the fourth note is decided then the order or sequences of chords is in part fixed.

If the composer simply repeats, it becomes boring very quickly. Therefore, by means of manipulating the types of contrast (loud, soft, fast, slow, close, far apart, etc.) the number of possibilities as to what the next chord will be is enlarged. After the artist has put these together in a sequence, these units establish a certain directionality, so that in the composition note relates to note, and also chord relates to chord, and sequences of chords relate to other sequences of chords; each unit produces analogous kinds of organization and expectations. Expectations are aroused in the audience because of the connections perceived between sounds. Most people can hear the connections but they are probably not explicitly aware of them because they do not have the technical vocabulary to deal with them, or they lack musical sophistication. Nonetheless, people can hear the relationships[8] even though they might be unable to state that the relationship is one of a number of notes that the two scales have in common and which determine the degree of contrast. In effect, one absorbs the connections by being a member of a certain culture and musical tradition. This means that the use of identical melodic contours, all of which may be called "themes" are based on certain primitive relationships, the physics of music. Their recurrence is recognizable to the ear. They are recognizable at different tone levels, for example, and while one is aware that they are not the same, they will nonetheless be regarded as equivalent. The listener

[8]And as explained in Chapter II, *perceiving the relationships will constitute understanding;* being able to verbalize this appreciation in a technical vocabulary is another matter.

will see a succession of patterns, each of which is different, as nothing more than variations on themselves.

Within the context of a developed tradition these organizational relationships have regularity which is called "style." Thus, the thing which constitutes a style is a restricted range of choices amongst the possible ways of organization. We can show, for example, that in some historical periods certain chord patterns are artistically extremely rare while other chord patterns are extremely common. In music, one can characterize a style by noting the combinations of various types of elements, rhythm, harmony, phrasing patterns, etc., and as one restricts the choices, the organizational outline becomes progressively clearer. This is true of all art types, not just of music. If in poetry the artist is working with a restricted range of meters (or in painting, a restricted range of colors) a poem will be produced which, given the familiarity of the audience, will be instantly recognizable and interpretable. Thus, styles function as a point of reference in terms of which one can appreciate a work of art, the style providing the key to the way in which the potentialities of that art type are exploited systematically in terms of that tradition.

Regularities of a tradition can be learned and these regularities produce what amounts to a "symbolism," the recurrence of motives becoming recognizable. We can show how this is done in music by noting that in music the same combination of pause, acceleration and movement occurs that is possible in speech itself. In speech, there is no visible punctuation, so that the way the hearer knows to divide language into words and so understand what people are saying is by pause and the beat of accent. Similarly, pauses and beats of accent provide musical groupings which then become intelligible structures in the composition itself.

Wagner, with his leitmotives, developed this technique to its highest degree, so that a single interval in the octave becomes symbolic of the sword of Nothung, and it occurs again and again in the piece. Even though the listener does not know the German or what is being said, the recurrence of that distinctive interval is instantly recognizable as the "sword motive."[9] The audience intuitively grasps the "sword motive" or the "blood brother motive" or any of the others because of the

[9]Even though Wagner did not name the motives, I am using the names which musical scholars have attached because of the occasion of the motive's first appearance.

64

way in which Wagner points (by means of time signatures and cadence of harmonic scheme) to these as intelligible units, and he modifies these intelligible units in regular ways.

It should be pointed out that the word "symbolic" here does not indicate that these motives are referential; that is, these musical intervals do not refer to anything, and thus are not a symbol in that sense. While in their logical organization, their "syntax" it can be called, the symbolic relationships of music become rather like a language, that analogy is not complete.[10] The symbols of music are not instrumental to a semantical function as is the case in language; and as a result, musical structure need not adhere to the rules that are necessary to make semantic interpretation possible. Thus, unlike language whose primary function is referential, the symbols of music do not refer to something extrinsic; they are not *about* anything. Nonetheless, what is similar about music and language is analyzable structure, and it is this rational structure of music that is emphasized here.

The symbols of music are non-referential, except internally so, and are akin to mathematics, since the logical relations in mathematics do not refer to anything exterior to the mathematical formula. A mathematical formula may be used to describe external things, but the logical properties of mathematics are not derived. Mathematics does not "tell" us anything, just as music does not; however, as is the case with language, the analogy is *only* that and not an identity. Here the analogy breaks down at the levels of rules and coherence. The connections between thematic elements in music are not necessary or universal in the way mathematical and logical relationships are. One may say of a particular series of notes in a piece of music that it is "right" that the notes follow each other as they do, but it would not always and inevitably be the case that the notes should follow the same pattern. Instead, it is by means of regular kinds of recognizable units which are introduced very early in the composition that the apprehender is able to understand certain kinds of things about what may be called the "logic" of the composition. It is that which enables one to see what the composer is doing and to anticipate it, but this "logic" of the piece pertains to that particular composition and no other.

[10]A thorough discussion, to which I am indebted, of the limitations of the analogies between music and language and music and mathematics can be found in Roger Scruton's *Art and Imagination: A study in the Philosophy of Mind,* Methuen & Co., Ltd., London, 1974, pp. 169-170.

This brings us to the difference between musical understanding and the understanding of mathematics. Mathematical understanding involves grasping the manner in which one step necessarily follows from the preceding one; and given the initial premises, the conclusion could have been no other. That is, one begins in mathematics with a certain axiomatic system, which after once being established, rules out all conclusions save one. In music, however, the initial statement only limits the possibilities of the development of a composition, it does not determine structure. The expertise of composers is demonstrated in the *way* they develop the possibilities of the original statement. This means that musical understanding entails decoding the structure as a whole, coming step by step to see how the piece was constructed and this entails recognizing the themes and then understanding the way the themes are developed and inter-related to form a totality.

It is the difficulty of decoding the structure, unlocking the symbolism, that makes it virtually impossible for people to understand music outside their own tradition. Those who can claim to appreciate Arabic music, or Indian music, or Chinese or Balinese music are very few, and I know of no book on music criticism or music aesthetics which makes any concerted effort to take into account these alternate traditions in a coherent way. Even encyclopedic works and the standard works on the history of music neglect them because they are not intelligible in Western terms. That means that music has developed into a particular "language" which is culture bound. Thus, the intricacies of stylistic use of symbolic elements is the reason it is almost impossible for most Westerners to have any meaningful appreciation of non-Western music. Westerners have no experience whatever with the techniques of encoding which are appropriate to the exploitation of the physical properties of the music which are entailed in these traditions. One can master them, of course, and then one can listen to Indian music and Chinese music so that after a length of time, one can begin to detect what would be called regularities, and one can anticipate developments and make associations between groupings. Detecting regularities is the first step in deciphering or decoding works of art; and the same could be said of any art type.

Art which in theory is "universal," in that it is theoretically readily available to everyone, in practice is not the least universal, but rather is exceedingly elitist. While there is nothing in the encoding process which is not *potentially* understandable by everyone, there may be unfamiliar encoding techniques,

hence the process of decoding might be more difficult. Because it is not predictable in ways anticipated by audiences unfamiliar with its language, 20th Century music has been difficult for audiences to accept. Composers like Stravinsky and Schoenberg reject the kinds of traditional harmonies everyone has become used to hearing and the types of melodies with which audiences are familiar and attempt to set up new patterns of predictability. This is precisely what Ezra Pound did in poetry; however, not by the creation of some anomaly, but by the readmission of techniques which had been abandoned.

Thus, there is a kind of language to an art type. The process of learning music, for example, is the process of learning the language, the traditional associations within it. New works of music are particularly difficult because they do not use language in the expected way and until we become accustomed to this kind of language and are able to anticipate the new relationships we are illiterate in that art. Therefore, by analogy, the process of becoming acquainted with an art is the process of learning more "words," so we can lay bare the symbolic relationships.

Figure 3. Music: Table of Resemblances

Poetry

Primary Elements: In the discussion of the primary elements of music, the point was made that the physical basis of music is the fact that a vibrating source (e.g., a single string) produces resonances. Also, the themes that make up music can be described in terms of those primary elements of resonance since the thematic relationships that arise are manipulations of those primary elements. In this respect, music can be said to be relatively simple since an account of what occurs in music can be given solely in terms of the physical properties of that medium. Poetry is more complex in this respect, even though poems will be discussed as though they were fundamentally meant to be heard.

The question of whether poetry is an auditory art might be raised.[11] Until fairly modern times, poems were composed to be heard and not to be read.[12] The idea that one fundamentally reads poetry is a modern notion and most of the historical poems that are regarded as fairly significant were written to be recited aloud. Before the invention of movable type, neither literacy nor printing was sufficiently common in the West to make a literary audience possible; thus the notion of writing poems to be read is a recent innovation.[13]

However, poetry remains an auditory art and whether it is heard or read silently is immaterial. What *is* germane is that the thing which distinguishes the poet from the ordinary prose writer is the poet's exploitation of certain qualities of language in a deliberate, self-conscious way. While we need not perceive

[11]It might be said that one has first to read a poem silently in order to understand it and only later can one get the rhythms right since the meaning of the line determines the rhythm. Actually this is more a problem of performing than experiencing a work of art since what is being dealt with here is similar to the kinds of things musicians face when they are confronted with a fresh score. They may well have to look at it for a moment or two initially to be able to construe it; but that is different from experiencing the music. When one talks about reading a poem silently before reading it aloud, the process is probably akin to a musician's examination of a score in preparation for a performance. In such cases aesthetics is not involved.

[12]In fact, most of the poetry being written today is written in a verbal mode. For example, questions of value aside, the lyrics of popular music are derived from the spoken language and the popular poetry of most of the world is designed for auditory appreciation.

[13]An exception to this is in China where poetry happens to have been read from Sung dynasty times, roughly from the year 960 on.

68

the poem aurally to appreciate this, we must be acquainted with the pronunciation and rhythms of language. Otherwise, we could not detect the poetic qualities of a work and distinguish it from prose; for simply to print words in broken lines does not make a poem.

To illustrate the point of poetry's dependence on auditory effect, one need only to consider the case of Chinese poems which are dependent on T'ang pronunciation to produce their auditory effect. Centuries after their writing, one must go about memorizing those ancient rules of pronunciation. While it is true that one *can* pronounce these poems using contemporary pronunciation (or for that matter, English, German or Italian pronunciation) one would hardly argue that to do so, even silently, would be appreciating the T'ang poem as it was meant to be experienced.

As this discussion moves away from music and focuses upon the search for family resemblance relations between art types, straightaway it becomes obvious that the amount of stress placed on primary elements will vary among art types. For example, in "pitch" the human voice is naturally tenor, baritone, alto or soprano, but poets do not take that fact into consideration when, for example, they make use of group chorus poetry. Nor is it normally said that it matters whether a female or male reads a poem aloud, for this is considered trivial and insignificant in the appreciation of a poem. Thus, the conclusion may be drawn that pitch is less important an element in poetry than it is in music.

In discussing "duration" in music, one sees a functional equivalence to the length (and shortness) of a sound in poetry; while what we call "amplitude" in music will be similar to a stress/unstress of sound in poetry. In themselves, these elements are less important than they are in music in that they take on signficance depending only upon the particular language in which the poem is written. This point will be developed below.

Upon close examination, it becomes evident that what was referred to as tone color, or "timbre" in music resembles the sound qualities which are distinctive to a particular language, i.e., the phonemes. Phonemes are the distinctive speech sounds which make up the complexion of a language, varying from language to language. Humans are capable of producing a large number of sounds; and languages employ only a small percent of the possible sounds. Those who learn a foreign language find that they must pronounce sounds they never made in

69

their own language; and that certain things occur in one language that do not occur in another. For example, the German language is capable of combining large numbers of consonants which appear together and, by comparison, the number of vowel sounds are relatively few. When English speaking persons encounter this in German they are not nonplussed because similar combinations occur in English, although not in such proliferation. The flow or "speed" of a language is a function of the number and spacing of the consonants and vowels of which it is composed. Because of its consonant/vowel structure, German is not commonly thought of as a flowing language; but it can be made flowing by the use of particular sounds. On the other hand, Italian has very few consonants and no consonantal clusters; thus, there is a dominance of vowel sounds resulting in an extraordinarily smooth language which lends itself particularly well to the bel canto style of opera. French is in an intermediate position because it has nasal sounds which are semiconsonants; that is, consonantal sounds which interrupt the flow or liquidity of the language, but not nearly to the degree as in German. English exhibits an unhappy combination of the two making it difficult to sing.[14]

This discussion of functional resemblances demonstrates that poetry, being an auditory art type, involves the characteristics of sound found in music, although the emphasis on these primary elements is not the same. But is sound *all* that poetry involves? *If* what is meant by poetry is simply the sounds of what is spoken, then the themes of poetry, like those in music, consist only in the manipulation of the physical characteristics already discussed. If that view were taken, the implica-

[14]It has been my own experience that English, when sung becomes an extraordinary blur, particularly formal pronunciation as might be used in opera. I have interviewed numerous colleagues, native English speakers who enjoy opera, and find that they concur with my impression that even if one is only modestly knowledgeable of Italian, a chorus sung in Italian is more easily understood than a chorus sung in English. Examples of modern operas such as "The Ballad of Baby Doe" or even the more straightforward "Porgy and Bess" seem to me to illustrate this point about the difficulty of deciphering English sung in bel canto style. Why should this be the case? A possible explanation for this phenomenon was suggested to me by linguist Frances Aid, Chairman of the Modern Language Department at Florida International University, who pointed out that English is a language with a large number of syllables that end in consonant groups whereas languages such as Italian and French have a large number of syllables ending in vowels. When singing in bel canto style, these sounds would be extended and exaggerated, giving an added emphasis to the word.

tion would be that the behavior involved in sightsinging a text is not materially different from that of people reading the sounds of a foreign language one does not know in an alphabet with which one is familiar.[15] For example, singing a series of notes such as these:[16]

would not differ from reading aloud "Mega biblion, mega kakon,"[17] for those untutored in Greek. If the symbols of language function as do the symbols of music, then these two lines are equivalent in that they simply inform us as to the correct rhythm of the sound, and one can determine whether an error is made in singing the wrong note or pronouncing the wrong syllable. What needs to be determined is whether poetry consists of anything *more* than correctly reading "Mega biblion, mega kakon?" The question which will have to be answered is, "To what extent do poems involve more than what is just heard?" or, more pointedly, "How do poems differ from music?"

A difficulty in dealing with poetry, as opposed to music, is that the sounds do occur *in language* and the sounds of a poem frequently have references which evoke images. Thus, in poetry, we normally understand that the sounds of a poem are not the poem; and if one hears the sounds of poetry in an unknown language, it could not be said that the hearer understood the poem. That is, one would not have experienced the poem, but would only have perceived the sounds. This observation means that the thematic elements of poetry, unlike those of music, do not reside simply in the physical properties of the work. What these thematic elements entail will become evident as the thematic relationships of poetry are examined in the following pages.

[15] In other words, learning to read poetry would be like learning to read with the aid of the international phonetic alphabet. We can write out the way we are supposed to pronounce the language, proper intonations and phrasing, and it would appear as though we were speaking. This would be akin to sight reading in that we would have mastered the technical skill of reproducing a piece correctly, and just as we can look at a note or line and say that it was not sung correctly, we can look at the sounds in the phonetic alphabet and say it was not read correctly.

[16] "Che faro senza Euridice," the famous 18th Century aria from Christoph Willibald Gluck's opera *Orfeo ed Euridice.*

[17] This was considered the finest work by the Hellenistic Greek poet Kallimachos and was lionized in its day. In English the line reads, "A big book is a big evil."

Thematic Relationships: As in music, the rhythm[18] of poetry involves both dynamics (amplitude) and duration. Consequently there are two kinds of rhythm in poetry: (a) one based on volume or stress rhythm as occurs in English, and (b) a duration rhythm which is based upon the length of the syllables involved, characteristic of Sanskrit and Greek. Thus, when what is called "rhythm" in poetry is dealt with, actually these types of contrast are being considered. Therefore, the regularity of rhythm, or its repetitive aspects, lead us to regard a work as poetry as contrasted to prose. While prose does have rhythm, the absence of regularity distinguishes the prose from poetry.

A very interesting rhythmic device can be found in the opening lines of T.S. Eliot's "Lovesong of J. Alfred Prufrock." Assume for the moment that those lines were written in the following manner:

> Let us go, you and I,
> When the evening is spread out against the sky.

As it is written above, this is a proper Victorian poem. There is a certain symmetry within it as it stands and the rhyme enables the two lines which are of unequal length to be, nevertheless, comparable. However, that is not the way Eliot actually wrote the poem. Eliot introduces a dissonance in the very beginning which destroys this nice Victorian balance since the actual lines read:

> Let us go then, you and I
> When the evening is spread out against the sky.

The important thing about the word "then" is not so much what the word means, but what it does to the rhythm of the sentence. While it is not being suggested here that any word which would not change the rhythm could be substituted, it is obvious at the same time that the primary function of the word is one of emphasis. It is the dissonance created by the "then" that makes an incongruity between the first two lines and therefore makes possible the third line:

> Let us go then, you and I,
> When the evening is spread out against the sky
> Like a patient etherized upon a table:

[18]In poetry this is called "meter," that is, poetry involves metrical patterns which have a certain intricacy.

Without the interjection of the "then" the three lines when read together sound like one long line. The "then" is critical because only with its use does the third line make sense. "Then" creates a rhythmic dissonance akin to the dissonance of the image "Like a patient etherized upon a table." The image is dissonant since if one were not prepared for it by the "then" which interrupts the Victorian style smoothness of the first two lines, the image would be as jarring as a wrong note in music. "Let us go, you and I / When the evening is spread out against the sky" is very smooth and flowing with perfectly recurring features, but "Like a patient etherized upon a table" introduces a shattering note. However, "Let us go *then* you and I / When the evening is spread out against the sky / Like a patient etherized upon a table" is not shocking; since "then" breaks the symmetry of the first line. Altogether, it is the congruity of the dissonances which make the third line compatible in a very important way.

There are numerous examples of this kind of device in poetry, and modern poetry abounds in them. Eliot particularly makes regular use of this kind of rhythmic alteration. For example, in his "Burnt Norton" he writes:

Words move, music moves
Only in time; but that which is only living
Can only die. Words, after speech, reach
Into the silence

Here the important word is "only" by which he relates things in an image sequence. Rhythm here is like movement through time.

There is a twelve syllable line from Racine's *Phaedre* which shows the dramatic effect that a change of rhythm can have: Le jour n'est pas plus pur que la fond du mon coeur.[19] In spoken French, the line would read: "La jour n'est pas plus pur que la fond du mon coeur." But, this is not the way the line is read as poetry. This is the line in which Hippolyte protests that he is innocent of incest, so what happens is that "la" and "du" are not emphasized as they would be; but, instead "fond" and "coeur" are the important words: "La jour n'est pas plus pur que la fond du mon coeur." There is a shift of natural stress pattern in the middle of the line which emphasizes the dramatic necessity of the line in the play. The drama of the poetic line is that it begins

[19]The day is not more pure than the foundation of my heart.

with iambic pentameter and then following "que," which breaks the rhythm, dactylic follows. It is this change of stress in the middle of the line that adds emphasis to what is said.

The same thing occurs in English. Keeping in mind that many Elizabethan lines are written in iambic pentameter and that no one ever stresses "the" in spoken language except for some special purpose; consider some of the most famous lines in the language: "To be or not to be that is the question." If any Hamlet delivered those lines in iambic: "To be or not to be that is the question" his reception would be less than enthusiastic. Instead a more accepted reading would be, "To be or not to be, that is the question" since the focus of Hamlet's consideration on living or dying dictates the stress of the line. From the above examples it is evident that poets employ rhythm as a device for creating various effects.

In music, as has been demonstrated, melody plays an important role.[20] Its equivalent in poetry, patterns of intonation and pitch, are less important; however an exception may be Chinese poetry, in which pitch patterns form the basis of the rhythmic structure of the line. In that particular case, the way in which a verse is constructed, and that which gives the verse its particular rhythm, is the pitch at which a word is uttered. In contrast, orchestration (patterns of different tone colors) which plays a less significant part than does melody in music, becomes the important element in poetry where this element can be called "patterns of phonemes;" that is, patterns of consonants and vowels, i.e., alliteration, assonance and rhythm.

There is a particularly good example of phoneme patterns in Shakespeare's *Antony and Cleopatra*, Act II, Scene II, 11.195-202, where Cleopatra's barge is described. The whole section is quite extraordinary because of its sound color; for example, the use of the "B" and "N" sounds which then give way to "S" sounds: "barge . . . burnished throne, burn'd . . . beaten" then, "sails . . . sick . . . silver . . . stroke:"

> The barge she sat in, like a burnish'd throne,
> Burn'd on the water: the poop was beaten gold;
> Purple the sails, and so perfumed that
> The winds were love-sick with them; the oars were silver,
> Which to the tune of flutes kept stroke, and made
> The water which they beat to follow faster,
> As amorous of their strokes

[20]With the exception of some traditions such as the Javanese, Ancient Chinese or African.

Thus, the pattern of phonemes, as illustrated here, is functionally equivalent to orchestration in music and consists of the particular distribution or the distortion of the natural distribution of the sounds which occur in the language.

Certainly, one of the most remarkable examples of sound quality in the poetry of any language occurs in a line by Rilke in his "Sonnets to Orpheus" Second Part xiii:

sei ein klingendes Glas, das sich im Klang schon zerschlug[21]

In reading this line, notice the recurrence of certain kinds of combinations; for example, the analogous vowel sounds in "sei ein kling . . ." and then a change "Glas, das . . . Klang" and the constant modification of consonant patterns like the change from "s" to "sh," "des . . . as . . . das" to "schon zerschlug." Also, in the "Klang" there is the full "g" sound and in zerschlug the "g" becomes equivalent to "ch."

From what has been said thus far about poetry, we can see that poetry depends on certain kinds of manipulations of rhythmic patterns and certain kinds of manipulation of phonetic patterns as well; but as was suggested earlier, this is not all. If it *were* all, one would appreciate poems in languages that are not understood, and this is obviously not the case. On the contrary, knowing what the line means greatly increases the value of the poem. One cannot truly grasp the structure of the poem from hearing only the sounds of the poem. So one comes hard against the critical problem of poetry; that is, the problem of "meaning." The words in a poem do have meaning as Nietzsche correctly observed in *The Birth of Tragedy*. To use Nietzsche's language, a poem is not Dionysiac. If one did not know the meaning of the words, a line of poetry might be Dionysiac. The line might be a kind of melody which one could imagine was sung or spoken in some unusual way, but unless one knows what the words mean the line does not really become poetry. Thus, the phenomenon of not appreciating poetry in a language one does not understand can be explained by remembering that the words of the poem have intrinsic meanings unlike musical notes. Because of this the thematic elements of the poem, in addition to rhythmic patterns and phonetic patterns, depend on what we shall call "image sequences;"[22] and the sequence of images con-

[21]"Be a resonant glass that shatters while it is ringing."

[22]The word "image" may be too precise, too clean an outline, in that poetic images can be auditory as well as visual, but we shall use it since image is the word traditionally used in literary criticism. By "image" we have in mind a word or phrase that appeals to the senses so that it forms a very vivid impression.

stitutes the meaning of the poem. Just as there is a contour of rhythm and there is a contour of sound, we can speak of a kind of contour of image in a poem.

Image sequence proves to be problematic for if a message approach to poetry is adopted this approach seems to imply that poems have important offerings in the way of ideas. If a structural approach is adopted a difficulty of explanation arises, since images sound distressingly similar to message. To eliminate this problem differentiation needs to be made between the image sequence in the poem and the message of the poem. One should keep in mind that image sequence is a neutral term and discrete from any message a poem may have.

As an illustration, the Rilke line quoted above will be examined. Translated into English this line would read: "Be a resonant glass that shatters while it is ringing." The image sequence here *involves seeing the world a certain way; they are one and the same. That is, grasping the image sequence is seeing what Rilke means.* Seeing the image of a glass shattering is not to get the impact of the poem since the command to "be a ringing glass" is omitted. The imagery in this line is perfectly clear and can be translated from language to language without difficulty. but the strength of the imagery lies in its interrelation with the sounds of the German. Specifically, up until the word "klang" there is nothing unusual, but in "zerschlug" the turning point occurs, and that point is what is involved in aesthetic consideration.[23] Thus, at the end of the line the image is completed and the view of life that Rilke is expressing becomes clear. However, there is a difference between experiencing the structure, seeing what it is like to look at the world that way, and considering looking at the world that way as right, valuable or good. When one is experiencing art she or he does not have to agree with the artist, nor accept the point of view, to see what it is like to view the world from a certain position, i.e.. understand what the poem means.

Thus, I suggest that the image sequence *is* the meaning of the poem, that there is no distinction between the meaning and the images of the poem; however, this is a different consideration from that of the *message* of the poem.

Consider the result of saying that the message of the poem consists in some literal meaning; that is, the passage should be

[23]What in Japanese aesthetics is called the "oddness" of it, the *aware* as in the phrase "*mono no aware.*"

read as an objective recommendation that we become like glasses even though it means we will shatter. Since it is patently obvious that no one would seriously advocate our shattering, someone who values message in poetry would not take the position there is a literal meaning to the line; but would likely suggest that it be taken "metaphorically." That is, the Rilke line is some sort of recommendation about how a person should live life. Thus interpretation from a message approach involves taking an image sequence and ascribing it to some "philosophical" meaning. In the case of the Rilke example, the message might be that a person can be compared to a glass, living life can be compared to the ringing of the glass and the way life should be lived implies taking a risk even though the life might be shattered.

The important question that needs to be answered is, if we translate this message into English, would we have captured what was valuable about the poem? In other words, is poetry different from ordinary speech only in that poetry is an embellishment of ideas which could otherwise be expressed in ordinary speech? Thus, is iambic pentameter, or rhyme scheme or sonnet form merely an embellishment, a decoration of no greater significance than the fine leather binding on a book? If we assume that the message is the important aspect of the poem and the structural aspects merely embellishments of the message, then the prose paraphrase of the poem is not less valuable than the poem itself and there is no good reason for rejecting translation or paraphrases, for the translation of a poem should be performed in just the same way that the translations of an equation in physics or a mathematical proposition is performed. For any equation (like $E=MC^2$), the verbal statements which correspond to that equation (namely that energy is equivalent to mass, times speed of light squared) are identical in significance to the equation itself; so that transposition of an equation to a verbal statement diminishes neither the significance nor the value of the original utterance. In addition, if the message approach is correct and there is something valuable about the message of the poem, not only will a prose translation which adequately conveys that message be useful and valuable, but the implication surely follows that the more profound the message, the more valuable the poem.

Putting aside for a moment the difficulty of trying to offer an example of a profound poem, what could be said of poems that contain factual error? Normally, we do not consider something to be valuable we know to be false. On the other hand it

is quite clear that a large portion of the world's poetry would have to called "false." That is, the "truth" statements contained in poems are certainly invalid. Would one then want to conclude that the line of poetry that contains the falsehood is valueless because of factual error? As a case in point, consider Keat's line from *Ode On a Grecian Urn,* "Beauty is truth and truth beauty. That is all ye know on earth and all ye need to know." That is surely false, since it is perfectly evident that "beauty" (whatever that happens to be) and "truth" (whatever that may be) are not equivalents (presumably what the word "is" in that line means); thus, the line as an epistemological assertion is unconvincing. Or, consider "A thing of beauty is a joy forever." That line is demonstrably false since there have been beautiful things which have been lost, destroyed, or decayed. The question is, "Can falsehood be considered valuable?" If it can, then it would make sense to say that a poem can deceive us, which is exactly what thinkers like Plato and others have maintained and why they advocate censorship and the banishing of poets, because their works are a process of spinning one long lie.

What can we say then about the profundity of poems? Generally speaking, poetry does not contain profound thought at all.[24] Consider for example Shelley's line from *Ode To The West Wind,* (11.69-70) "Oh, Wind/If Winter comes can Spring be far behind?" As a meterological forecast this falls short, and the idea that Spring comes after Winter is banal to say the least. Most poetry, from the point of view of message is silly, trivial, or nonsensical to a modern audience.[25] For this reason, there

[24]In saying that most poems are not profound I mean that whatever empirical truth claims poetry makes are trivial since from an information point of view most poems are quite banal. However, the objection might be raised that while it may be that the messages of poems are frequently erroneous and, if taken literally, trivial, poems can be profound in the sense of "deep." This claim seems to me to go back to an old Hericlitean notion that apparent connections are not the real connections and "deep" means that a real connection which lies beneath the surface has been established. This seems to be only a circumlocution for an underlying truth of some sort. Another defense for using the word "profound" with regard to poetry might be that while we would not say that what a thinker like Bertrand Russel said was "true" or "right," we would still want to say that his work is "profound." That is, we can say that there is a kind of view about the world that we might want to call "profound" but this doesn't mean that the message is factually correct or one we would agree with. In this case, "profound" is being used to convey approval, and not descriptively.

[25]Consider Hamlet's exclamation in Act III, Scene 1, (11.75-76), "When he himself might his quietus make / With a bare bodkin? who would fardels bear . . . "

is no point in studying poetry if one wants to understand the world and why science does not look to poetry for support of hypotheses.

The suggestion could be made that the value of a poem consists of a combination of both structural aspects as well as message. Although distinctions would have to be made between their individual views, some of the critics who came to be associated with the literary critical movement known as "New Criticism" hold precisely this combination view.

Names such as "aesthetic formalism" and "analytical criticism" have sometimes been suggested as being more fitting to describe the work of the group but such appellations fail to take into account basic theoretical assumptions that clearly distinguish the orientation of this group of critics from a structural approach to criticism. Certainly, their disclaimer of the didacticism of Victorian poetry and the Marxist attempt to use literature as propaganda, their opposition to what they felt to be an overemphasis on the background and environment of literature and concentration upon the author rather than the work itself, along with their close textural analysis and desire to "illuminate the center," i.e., the work itself, [26] all point to their concern with structure. However, along with their emphasis on structure some of the New Critics have argued that poetic language supplies knowledge or truth, albeit a knowledge or truth distinct from that provided by science. The idea is that poetry and imaginative literature make possible a unique mode of apprehending reality. Ransom announced in *The New Criticism:*

> I suggest that the differentia of poetry as a discourse is an ontological one. It treats an order of existence, a grade of objectivity, which cannot be treated in scientific discourse ... Poetry intends to recover the denser and more refractory original world which we know loosely through our perceptions and memories. By this supposition it is a kind of knowledge which is radically or ontologically distinct.[27]

Although T.S. Eliot rejects the idea of poetry *as* knowledge, Eliot concludes that the quality of a poet's belief or philosophy is a factor in the criticism of the work. He says, "We can hardly

[26] Vernon Hall, Jr., *A Short History of Literary Criticism*, New York University Press, 1963, pp. 172-176.

[27] Walter Sutton, *Modern American Criticism*, Prentice-Hall, Inc., Englewood Cliffs, New Jersey, 1963, p. 100.

doubt that the 'truest' philosophy is the best material for the greatest poet; so that a poet must be rated in the end both by the philosophy realized in poetry and by the fullness and adequacy of the realization."[28] Similarly, in a famous passage from "Religion and Literature" Eliot writes, "The 'greatness' of literature cannot be determined solely by literary standards; though we must remember that whether it is literature or not can be determined only by literary standards."[29] In *Aesthetics and Art Criticism,* Jerome Stolniz includes a good discussion on this unsatisfactory attempt on the part of Eliot, and many of the New Critics to "face both ways; that is, to extol the importance of structure in aesthetic value, insisting all the while upon the 'importance of the moral profundity, truth, philosophical coherence and the like.'"[30]

What would be the implication of a combination view of aesthetic values? If a poem is such a combination, and there is an "X" which is composed of "A" plus "B," then by calculating "X" we should be able to determine what possible combination of "A" and "B" ought to produce "X." In other words, if a poem is the sum of structural value plus message value, we should be able to calculate the percentage of each for any given poem. Thus, a combination theory consists in two assumptions: (a) we must be able to determine what constitutes message value with regard to the poem, so that we can quantify it, and (b) we must do the same for structural value. Thus we could say of a poem that it is eight parts message value plus one part structural value. If the message of the poem were perfectly translated the result would contain eight parts message value, in which case the product would be 8/9ths as good as the original. Calculations such as these would be perfectly possible if the poem is the sum of its parts as a combination theory suggests, since to affirm that a poem is such a sum is to say that it may be broken down into its components.[31] (There is only a slightly different result if someone were to suggest the relationship is a product one since it could still be factored.)

A structural point of view falls into no such difficulties since no claim is made that a poem possesses any value beyond the

[28]*Ibid.,* p. 105

[29]"Religion and Literature," in *Essays Ancient and Modern,* New York: Harcourt, Brace, 1936, p. 92.

[30]Jerome Stolniz, *Aesthetics and Art Criticism,* Houghton Mifflin Company, Boston, 1960, pp. 484-5.

structural ones. Additionally, such a point of view is free from the encumbering problems of a combination theory in that there is nothing beyond the image sequence which is "message" that needs to be considered in the manner that in addition to the grammar of a sentence there is the message of the sentence that needs consideration. Poetic lines do not function in that way. The succession of image sequence *is* the meaning or attitude of the poem, and this is part of the structure. From a structural position, in interpreting the image sequence of the Rilke line as some sort of advice as to how to live your life is to produce a trivial meaning. Such advice is, at best, impractical; and, at worst, so poorly stated as to be unfollowable. Thus, from the view of someone who places the locus of value on structure, a prose translation of the poem is practically worthless; instead, what *is* significant about a line like Rilke's is *the correlation of phonetic, rhythmic and imagery patterns*, i.e., the structural elements, and *the way they enhance and reinforce one another.* Value lies in the *interplay* among the sounds of the poem, the rhythms of the poem and the image sequence of the poem;[32] and in really fine poetry there is a close inter-connection among them. Sometimes this inter-connection can be seen in a very vivid way, as for example, in the Rilke line.

The effectiveness of the Rilke line consists in the way in which the poem exhibits the onomatopoetic transformation of sounds; for example, the transition from the "klingendes" where one imagines the sound of the ringing glass to be "klang" and then the "zerschlug." The "g" in "zerschlug" is akin to a "ch" in German because of a mode of pronunciation and that sound indicates the moment of shattering. Thus, the effect of the Rilke line is achieved through a particular use of sounds which are very abrupt "ringing," "clanging," and "shattering" sounds so that the sounds of the line reinforce the imagery. It is here that the poetry lies and not in some advice about how to live

[31]The suggestion is not being made here that we have to be able to compute the precise contribution of various values in the total value of a work. The point I wish to make is that sometimes people who hold message to be important talk as though the value of a work of art is really a combination of message plus structure. My example involving the calculations here is only meant to show the difficulty with that view.

[32]Since the value of work has nothing to do with its message, a poem might be written by a fascist poet, e.g., Ezra Pound, and from the structural position the aesthetic value of Pound's fascist poems would be independent of their political viewpoint.

one's life. The connection of the pure sound to the image is particularly unique in this line and there is no way that this line may be rendered into English without some loss, for to make the line intelligible it is necessary to add so many words and so many qualifications that the line is rendered unpoetic in the attempt to show what a curiously nice image it is.

For this reason, the ideal of translating poetry is fundamentally one that cannot be realized. Other literary works may be adequately translated, but the idea that poetry is simply an especially difficult case of translation is erroneous. It should be kept in mind that the most esoteric and difficult religious texts have, without difficulty, been translated from language to language. It is exceedingly unlikely that poetry approaches that level of cognitive difficulty. Some difficult philosophic tracts have, without significant difficulty, been translated from language to language and even between languages which are not akin to each other. So, one must hypothesize either that poetry is the most difficult example of human intellect ever encountered (in which case it probably is not understood by most people who read it) or that the significance of the message of the poem has been exaggerated. From a structural point of view, if we admit that the structure of poetry does not lie in the sounds alone, we are forced to admit that poetic structure is inextricably rooted in the language. Since we know that the language itself has certain unique properties, then we can see that the translation of poetry is virtually impossible. Of course, another poem making use of analogous image sequences may be made in another language but it will be a very different poem from the original. And, indeed, an interesting fact is that those poems which are usually successful as translations are, from a language scholar's point of view, exceedingly unsatisfactory because they have been particularly free translations.

In summary, the crucial difference between a message approach to poetry and a structure approach is one of degree. Both approaches agree that in the process of creating a work of art, the artist, in effect, encodes certain kinds of things in the work of art. The process of interpreting the work of art is the process of decoding. However, in addition simply to decoding the work, that is, laying bare the structure of the work of art, if one takes a message approach then there needs to be a second decoding; that is, one must discover what the true message in those symbols is. This seems to be the fundamental difference between the two positions. The message theorist, while agreeing with the structuralist that image sequences and phonetic and rhyth-

mic patterns are part of the value of the poem, will want to say that the ultimate value of the poem rests primarily, or in combination with, the particular message which is contained in the poem and conveyed through the image sequence, and that the beauty of the phonetic, rhythmic and imagery patterns are merely enhancement of that message. That is, the message conveyed in the grammer of the poetry gives the poem its ultimate, sublime meaning. All message approaches are at least in one regard more complex than all structural approaches because they involve at least one additional step which no structural one will contain; that is, the second phase of interpreting to uncover the view, position or "message" which is the "real" value of the poem.

Examining the implications of that position we see that a message approach is defective because it places an undue stress on doctrine or idea and causes us to neglect that poetry lies not in *what* is said, but truly in *how* it is said, and that what is said is trivial as far as the poetry is concerned. In poetry it is clear that the organization of the poetical structure does not lie in the ideas or doctrines espoused but rather it lies in the relationship between the image sequence, the rhythms and the sound patterns. We can say then that poetry is comprised fundamentally of three things working together: (1) a distinctive pattern of rhythm which is visible with regard to the background of a language; that is, one cannot hear the rhythms of a poem unless it is heard in terms of the regular spoken language (or in cases where the language is no longer spoken, the inferred spoken language); (2) all poems involve sound patterns; that is, there is a peculiar relationship between the values of the sounds themselves which is not found in ordinary speech and (3) the image sequence which is the meaning of the poem. Poetry consists in the coordination of these things.

This kind of analysis demonstrates that poetry differs from music in that music exploits sounds that contain an inherent structure while poetry does not. The physics of poetry emphasizes the particular structure which is inherent in the language of the poem as well as the meanings of the words. The point is that a kind of structure is inherent in each language. Poets create special patterns of structure which take their importance from the contrast between the poem and the language in which it is written. To appreciate the poem one must know both. This means that one must be exceedingly sensitive to not only a poem's most obvious elements, the image sequence, but also to the sound values of the poem. This is because not only does the

83

structure lie in the meaning, but it also inheres in the reverbera-
tion of individual words against the background of the language.

Although poetry is the literary form which has been chosen
as our focus of attention, something needs to be said about
the ways in which what has been said of poetry might be applied
to other literary forms such as the novel. These remarks will be
intentionally brief and intended only to suggest lines of in-
quiry as to how novels might be treated.

So far as sensations are concerned, novels are not different
from poetry and may be regarded as an auditory art type. Like
poems there is nothing in a novel that the reader must exper-
ience through sight; that is, one might perfectly well appre-
hend a novel if it were only heard.[33] By saying that novels are
an auditory art form, I do not have in mind that they must be
listened to as though one were listening to a story, even though
novels originated in storytelling, and their early prototypes
were read or recited aloud. Instead, like poetry, whose charac-
teristics they share, it is sufficient that the sound of the words
are heard in one's head. This is not unlike a person adept at
reading music where the piece is heard silently. Nothing is
contained in novels that cannot be found in long poems. For
example, the *Iliad* and the *Aeneid* can be construed as novels,
and in prose translations they are read as novels. In all the
arts there are properties of the medium which the artist exploits
and forms into patterns and then themes. For the poet, the
medium is language and he or she exploits the sounds of the lan-
guage and the images evoked. This is also true of the novelist;
however, since we are not in the habit of approaching novels in
this manner, some examples may serve to illustrate this point.
Harry Hatfield in *Thomas Mann* cites a particularly effective
use of phonemes in *Buddenbrooks* to create a musical effect:[34]

> Soft and clear as a bell sounded the E-minor chord, tremolo
> pianissimo, amid the purling, flowing notes of the violin.
> It swelled, it broadened, it slowly, slowly rose: suddenly in
> the forte, he introduced the discord C-sharp, which led back
> to the original key, and the Stradivarius ornamented it with
> its swelling and singing.

[33]This is not the case when novels are adapted for films. While one would not
want to say that reading a novel was different from hearing a novel read, one
would want to say that seeing the novel in a film *is* different from reading it.

[34]Harry Hatfield *Thomas Mann*. Revised Edition. A New Directory Paperback,
Alfred A. Knopf, Inc., New York, 1951, p. 46.

Another example, from the same novel, is Mann's description of a warm day in winter:[35]

> The pavement was wet and dirty, and snow was dripping from the gray gables. But above them the sky stretched delicate blue and unmarred, and billions of atoms of light seemed to glitter like crystals in the azure and to dance.

Other illustrations of interesting phonetic patterns in prose may be found in the opening passages of Poe's *Fall of the House of Usher* and the Penelope soliloquy at the end of Joyce's *Ulysses*.

Examples of rhythm beyond that ordinarily encountered in prose can be pointed out in other novels. Hatfield, in discussing *Death In Venice* suggests that "Evocations of antiquity in the novella, like the use of dactylic lines which approach the hexameter, emphasize that Aschenbach is fleeing from the harsh German world to the classic Mediterranean . . ."[36]

While, as the examples show, novels make use of the devices of meter, alliteration, onomatopoeia, etc., the degree to which they are exploited makes the novels' prose different from poetry, on the one hand, and ordinary prose on the other. While novels, like poems, employ language, it is clear that the language in which a novel is written is of significantly less importance than that of a poem. That is, the contrast between ordinary language and the language of novels is far less than that between poetic language and ordinary language. In most of the passages of a novel ordinary prose is used; that is, ordinary rhythm and unremarkable phonetic combination. Nevertheless, it is possible to point out a few places, usually climactic or especially significant passages, where poetic language is employed. Thus, poetic effect (that is, the effect of sound and language rhythms) are secondary to the overall quality of the novel. This explains why translation does less damage to a novel than is done to a poem. Hence, even the more poetic novels can be translated with some degree of success. This indicates the important fact that the structure of the novel does not lie so much in the sounds of the language, but rather in something else—the sequence of images in some cases, and action or events in others. Basically, there seem to be two kinds of novels, those which can be called "reflective" novels and those that can be described as "action" novels. These differ

[35] *Ibid.*, p. 47.

[36] *Ibid.*, p. 62.

85

from each other in the relative emphasis placed on sequences of images or on sequences of events.

In reflective novels, the unifying feature is the sequence of images; that is, leitmotifs of recurring vivid identifiable phrases in constant variation. Laurence Durrell's *Alexandria Quartet* series will serve as a good example of an effective use of image sequence. The same character is differently portrayed in the different novels in this series and this is the point of interest rather than action involving the character. For example, in *Justine*, what Justine *does* in the novel is not important; rather, it is the contrast between Justine as an image as compared to her image in *Mountolive* that is interesting. In other words, what one sees is a kind of icon which undergoes continual change in each of the novels. All four of the novels that constitute the Quartet series involve precisely the same events involving exactly the same characters seen from different perspectives. Speaking metaphorically, it is as though one were looking into oddly placed mirrors in the same room. One could infer from various reflections that the same room is seen but the room looks very different from different perspectives. In reflective novels, characters are developed in an almost portrait-like sense. The character *is* the composit of the images, or the image sequence. The almost intuitive grasp of the nature of characters in a novel, akin to the intuitive grasp of a musical theme, enables the reader to determine whether something is appropriate or inappropriate, thus making it possible to see the relationship between the original form of a theme and its development in music, and the original image of a character and the succeeding variations.

Hatfield comments on Mann's skill in this type of development:

> ... The leitmotiff, as Mann first used it, was nothing new in German literature. The repetition of a few words to characterize a given person or situation was a technique well understood by Otto Ludwig and Fontane; Mann might have hit upon it even without knowing Wagner. Gradually, almost imperceptibly, the leitmotiff is used both more subtly and more extensively until in *Joseph* or *Doctor Faustus* a whole situation may be repeated, more or less varied; or a basic type of character returns under another name: Ishmael as Esau, Abraham as Jacob . . .[37]

In *The Story of a Novel,* Mann recounts the genesis of *Doc-*

[37] *Ibid., p. 3.*

tor Faustus and his enjoyment in working out image patterns:

> . . . like, say, the erotic motif of the blue and black eyes, the
> mother motif; the parallelism of the landscapes; or more
> significant and essential, ranging through the whole book
> and appearing in many variations, the motif of cold, which
> is related to the motif of laughter.[38]

Perhaps this almost pictoral aspect of reflective novels, that
they are a succession of images, explains the close affinity
between novels and films which makes translation from novels
to films so seemingly appropriate; for example, Mann's *Death
In Venice,* in which, so far as action goes, nothing happens.
Throughout the novella, and the film, Aschenbach moves
through images of death and disease which, scattered through
the work, continually reoccur like variations on a musical
theme. The images are linked together by a common referent,
"death," albeit death remains unmentioned except for the title.[39]
However, this illustrates Santayana's point about the evocative
powers of associations.[40] Instead, of "naming," the artist
"evokes" associations through a sequence of associative images.
In *Little Herr Friedemann,* Mann evokes a certain tone through
the patterns of images, as Hatfield points out:

> . . . The repetition of 'gray' in *Little Herr Friedemann* . . .
> combined as it is with words like 'faded,' 'gentle,' and 'faint'
> which have a 'gray' emotional tone, establishes the tone
> economically and with finality.[41]

This associative sequence of images so pronounced in re-
flective novels is akin to the same device in poetry. Yet, novels
differ from poetry in deemphasizing other thematic relation-
ships essential in poetry: rhythmic patterns and patterns of

[38]*Thomas Mann, The Story of a Novel,* Alfred A. Knopf, Inc., New York, 1961,
pp. 70-71.

[39]In novels, like poetry, the image sequence has to do with seeing the world in a
certain way. It is true that in this example the image sequence does not possess
the purity of the incredibly striking Rilke line quoted earlier, but this is because
the poem is much more concentrated than the novel. The same situation occurs
in a long narrative poem which relates to a lyrical poem in much the same way
that a novel relates to a lyrical poem, the techniques of narrative poetry and the
techniques of novels being essentially the same.

[40]George Santayana, *The Sense of Beauty,* New York: Random House, The Mod-
ern Library, 1955, p. 196.

[41]Hatfield, p. 17.

phonemes. Thus, while the thematic relationships of poetry and reflective novels are the same, poetic themes are composed of the tight inter-relationships of the three elements, image sequences, rhythmic and phonetic patterns, while in reflective novels image sequences are far and away the most important—the themes being primarily a succession of images.

On the other hand, in action novels, events form the sequence and it is the events that are important. "Event" novels are those works which are strung together by depiction of what happens to the characters, with a decided absence of emphasis on such techniques as images, rhythms or phoneme development. Detective novels and mysteries are the best instances of this kind of novel. Here, stock characters participate in stock situations although a surprising twist of events may occur. The Agatha Christie novel, for example, which does not fit this pattern would disappoint the reader who is looking for an "action" story.

The disclaimer was made earlier that the purpose here is not to prepare a taxonomy of novels; but only to suggest how the types of novels that manifestly do exist might be critically dealt with, detective stories at the one extreme to works by Proust,[42] Mann, etc., at the other. Of course, there are many possibilities between these poles and more frequently a work shows a dual aspect where both reflective and action devices are combined, such as in Tolstoy's *War and Peace*. In this example, there are not only images in the form of very vivid characters and long sections of the novel which are quite contemplative, there is also a great deal of action. The action, however, is not what makes *War and Peace* the masterpiece it is, and not a single example comes to mind of a great novel whose themes are based primarily on action. Some ideas as to why this may be the case may suggest themselves to the reader in Chapter IV where criteria are proposed for evaluating works of art.

Painting

Primary Elements: We come now to the problem of painting and determining what painting entails. There are two factors

[42]Two texts arguing against the popular notion that Proust's novel, *Remembrance of Things Past,* has no plan, and for the view it is a carefully constructed work tightly pulled together by sequences of images are: Victor Graham's *The Imagery of Proust,* Basil Blackwell, Oxford, 1966, and Howard Moss' *The Magic Lantern of Marcel Proust,* Faber and Faber, London, 1962.

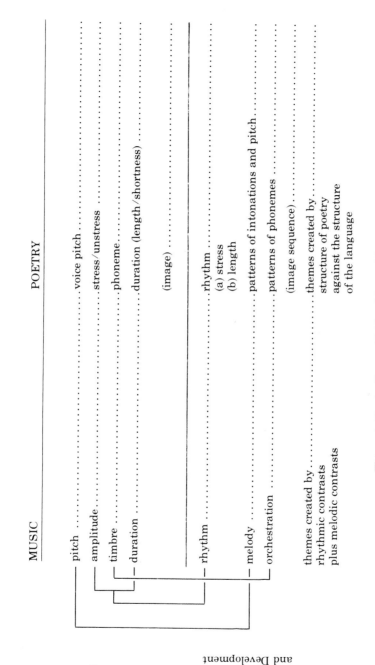

Figure 4. Music, Poetry: Table of Resemblances

89

which comprise the primary elements of painting, the physical properties of light and the properties of space.

All painting involves some kind of differentiation of shading: that is, contrast between objects and the background of the painting. In principle, this really means "color" but frequently there is a misconception of the word "color." "Color" possesses three characteristics that are inseparably involved: hue, saturation and value. Although these characteristics may be discussed as separate entities, they are nevertheless, experienced together in various combinations.

These aspects of color can best be understood by examining them in terms of the physical properties of light. In the process of such a discussion reference will be made to what was said earlier about the physics of sound in describing the components of music.

In viewing any area of shading, one is made aware of its *hue* or pigmentation; that is, its redness or blueness, a characteristic determined by the frequency or the wavelength of light reaching our retina from the area. Red is characterized as being of lower frequency than blue for example, which is of higher frequency. The visual arts are concerned with what may be called the local color of objects. Local color is the name given to the apparent color of surfaces; in other words, the color of the light reflected from the surfaces of paintings. When light strikes a surface, certain wavelengths are absorbed while others are reflected. Only those wavelengths which are reflected and are registered on the retina of the eye are seen. A red surface reflects only the lower frequency wavelength while giving the sensation of hue called red; a blue surface reflects only the higher frequency wavelength and blue is seen. In each case, all the other wavelengths are lost to vision. If all wavelengths are absorbed, the surface appears black; if all wavelengths are reflected, the surface appears white.

Keeping in mind the earlier discussion about music, it is apparent that the common characteristic of light and sound is that they are both forms of energy which travel in waves. If the nature of wave motion is examined, certain features which will help to describe similarities in the manifestation of these two forms of energy may be identified. This will enable comparison between the physics of auditory and visual arts; for example, in the case of light, hue is determined by the frequency of the wave which is analogous to sound energy in which the frequency determines the pitch. Thus, both pitch and hue are functions of frequency, or wavelength, of waves. (Figure 5)

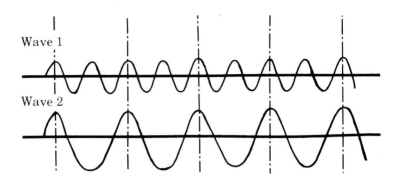

Figure 5. The hue of a color is determined by the frequency of vibration of the lightwave (photon). The higher frequency wavelengths within our perceptual field are seen as blues, while the lower frequencies cluster around the reds. Thus, in the above diagram, Wave 1 would be more characteristic of a bluer hue, and Wave 2 more representative of a redder hue.

Hues have the attribute of both saturation (sometimes called "intensity") and value; that is, saturation and value are terms relating to variations of the same hue, and like hue, their qualities will have their analogous counterparts in sound.

Every particular hue can exhibit a lighter or darker value, *value* referring to the lightness or darkness of hue. Some blues are lighter than other blues, while some yellows are darker than other yellows. When the value of a hue is referred to, the reference is to its relative lightness or darkness on an ideal scale of grays which range between white and black. Another way of considering value is to think of it as the amount of light energy reflected by a surface. This can be demonstrated by exposing a disk of a certain saturation of green, for example, and systematically increasing and decreasing the amount of light falling upon it. The observer will experience the color as lighter or darker depending on the amount of illumination falling upon the disk. This phenomenon demonstrates the impact of brightness upon the value of a color and is a manifestation of the amplitude of the light wave. Again, a comparable situation in music may be described in which the quality of sound that is referred to as amplitude is aurally detected as volume (loudness or softness). Heightening the amplitude of light waves results in the experience of increased brightness, and a mani-

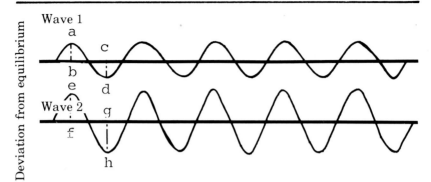

Lines a--b, c--d, e--f, and g--h show how amplitude is measured.

Figure 6. Amplitude involves the displacement or "strength" of a light-wave, and the higher the agitation of the wave the brighter the value of the hue; and conversely, the lower the amplitude the darker the value of the hue. In the diagram, Wave 2 represents a darker color than Wave 1.

pulation of amplitude in sound waves would result in increased or decreased volume. Thus, both volume in music and value in color are the function of the amplitude of the corresponding wave. We can demonstrate these characteristics of hue and value, as we did those of pitch and volume, by a wavelength diagram (Figure 6).

In addition to hue and value, every color also exhibits *saturation* or intensity. The term saturation refers to the dullness or brilliance of the hue. When a hue is pure and at its highest saturation of pigment, it is said to be at its maximum intensity and cannot be made more brilliant, although it can be made duller. Our experiences with sound and light involve being exposed simultaneously to mixtures of various wavelengths or frequencies. We characterize the particular proportion of energy coming at the dominant frequency as the degree of saturation of a pigment. Again, the similarity to music should be emphasized. In the earlier discussion on the primary elements of music, it was pointed out that a musical tone consists not only of the fundamental tone, but also overtones. Similarly, in the case of color, there is not a single frequency; rather, a color is a composite of many frequencies of light which co-exist with the dominant one. The degree of saturation is determined by the proportion of the dominant frequency to the others. Thus, the

WAVE CHARACTERISTIC	SOUND	LIGHT
FREQUENCY	PITCH	HUE
AMPLITUDE	VOLUME	VALUE
PROPORTION of dominant wave length to composite of wave length	TIMBRE	SATURATION

Figure 7. Summary table of the wave form characteristics of light and sound.

characteristics of timbre and saturation both involve proportions of a mixture of frequencies to the dominant frequency; and therefore can be expressed as the degree of purity of the dominant wavelength.

It should be noted that a painting can be monochromatic and involve contrasts between intensity and value though it would be of only one hue. Such paintings are relatively rare in Western art where the normal use of color is to make contrasts of hue. However, Chinese paintings are characteristically monochromatic. These paintings involve the application of ink to a background, and as a result, exhibit no difference of hue, but only differences of intensity or saturation and value, sometimes in combination.

Besides the very brief statement on color and the physics of light just outlined, it was mentioned that paintings also make use of the characteristics of space in their primary elements. Space functions in painting as time does in music; that is, both define boundaries. However, music insofar as the possibility of structure is concerned, will be simpler than painting, because music, being a time organized art, is one dimensional; while, painting, being space organized, is two dimensional.[43] The statement that paintings are two dimensional means that space

[43]Since music is one dimensional it involves only one kind of contrast, duration; whereas in painting, there is a question of location with respect to each of the two dimensions. This is why painting involves complexities that cannot occur in music. However, saying that music is simpler in this respect does not mean for example, that the *Goldberg Variations* are simpler than the *Mona Lisa*. We are not talking about composite structures, but rather the possibilities of structure.

has two characteristics: (a) contour or configuration and (b) shape or outline, thus increasing the possibilities of contrasts.[44] The distinction being made here is between things that derive from the color masses in the case of coutour or configuration, and things that are derived from the delineations in the case of shape or outline.[45] The differences here between the boundary defining characteristics of painting and music are due to differences in the physics of the medium and in the properties of the particular art types; nonetheless, space in painting and time in music are comparable in terms of function.

Color (keeping in mind that this entails hue, saturation and value) in combination with the spatial characteristics of shape and contour are the primary elements that are used to create the thematic elements of painting, out of which themes are developed.

Thematic Elements and Development: As musical contrasts derive from the physics of the music, so contrasts in painting derive from physical properties of the medium. However, in the case of painting we have an oddity in that the structural relationships in a visual field acquire properties of their own. In terms of music, tension arises out of a degree of contrast with reference to some point. In Western musical composition this would normally have to do with pitch, for the "key" or "tonic" is the point of reference.[46] In terms of painting, this is not the case, for the hues of a painting, which are equivalent to pitch in music, are less important than their musical counterpart.

There are exceptions, such as impressionist paintings, where what is loosely called "color" is important. For example, when Monet's *Rouen Cathedral* series is reproduced in black and white the structure of the cathedral is difficult to discern. With this qualification, and remembering what was said earlier concerning the presence in paintings of all primary elements, even though some are emphasized more than others, for most paintings it is possible to understand and grasp the aesthetic values

[44]If the art type is three dimensional, such as sculpture or architecture, then a third property of space, i.e., volume, would have to be added.

[45]One might, of course, say that color masses themselves are delineating things, and that is true in Japanese painting and many of contemporary paintings because in these cases the artists use color like line, sharpened edged or hard edged color.

[46]In poetry, the reference point is the language in which the poem is written.

of a painting from black and white reproductions. Certainly, since the invention of the photograph, a black and white reproduction has been accepted as being an adequate study of a work of art itself for purposes of aesthetic analysis. Moreover, black and white reproductions have the advantage of maintaining the correct relationships of color saturation, while in color reproduction the hues are rarely correct. Leaving hue aside for the moment as being less important in paintings than the organization of space, we shall begin our examination of thematic elements in painting with an explanation of the way space is organized.

Paintings may not have formally conceived borders, but all paintings are limited in size. However, within this limitation, irrespective of its shape, space nevertheless has certain properties which may be exploited uniformly without regard to the type or subject matter of the painting. That is, there are certain characteristics as to the way space is organized which give certain hints about the space, and it is interesting to note that cultures can be characterized by the way in which they habitually show preferences for organizations of space.

Space in a painting may be viewed as a rectangle and may be imagined as divisible in several possible ways. The usual tendency is to divide it into quadrants so that the focal point of the painting is the intersection of an imaginary horizontal and vertical axis which is purely geometric. Thus, the geometric axes of a painting are determined by the space of the painting itself; that is, the relationship of the enclosed space to the frame such that the space is divided into equal quadrants.

Figure 8.

Vertical Axis: One of the most important visual abilities acquired in infancy is the ability to orient ourselves with relationship to the vertical in the environment so that we can maintain our balance and move through the world. Similarly, our natural tendency to orient ourselves with regard to a painting

is done by the vertical axis which in the general case splits the painting down the middle from the top to the bottom. The importance of verticality can be demonstrated simply by hanging a painting sidewise. In such an instance, viewers will almost invariably tilt their heads so that they may adjust themselves to the frame of reference of the painting.

Horizontal Axis: In addition to the vertical axis, a horizontal axis bisects the painting, with half the space above and half below. The horizontal point of reference is of the utmost significance because this defines foreground and background with respect to the painting itself. This became particularly apparent with the introduction of perspective in Western painting.

In addition to the two axes just described, it is of course geometrically possible to divide the painting from corner to corner in a diagonal axis. Such a division will not admit a picture window perspective, and thus is not typical of Western painting. In Western painting, typically the neutral axes are the diagonal axes (the Baroque paintings being an exception); but Chinese paintings typically make use of diagonal axes to such an extent that it becomes a cliche.

Figure 9.

Paintings have all four axes whether or not the axes are significant to the organization of a particular work. They should be considered as possible means of organization of space, and when painters actually construct a painting they choose among these possibilities. Thus, they normally arrange objects in the painting about one or more of these axes or about some combination of them which will be visible through the painting itself. Axes will be considered "dynamic" if objects are arrayed with respect to that axis, and "neutral" if they are not. If axes are moved from the geometric location described above, they are called "organizational" or "functional." This shift will result in the painting becoming one-sided rather than divided into equal quadrants. (Figure 10)

Tension, in any art type, is determined by the relationship of elements to a neutral point. In painting, there are several types of tension. First, tension arises with respect to the functional axes of the painting. An object is tense in proportion to its distance from the intersection of the functional axes of the painting. The closer the object is to the intersection the less tense it is, while the further from the intersection the greater the amount of tension it exhibits. Secondly, tensions may be created by the sheer size of objects. An object in a painting may be said to be tense in proportion to the amount of the total area of the painting it occupies. Hence, the larger the object, the more important it is to the painting, therefore the higher its tension values. There is a proviso here however, for the degree to which an object contrasts with the average object in the painting must also be considered. An object may be exceedingly small, but also exceedingly bright, and therefore be very tense. Thus, it is in contrast to the average, or the inferred average, that an object is tense. A third type of tension pertains to shading or color. We may say that a painting has either a background of average color saturation or brilliance and that an object is tense in so far as it is darker than the average or lighter than that average.

The manner in which these tensions of variations of values and spatial characteristics are manipulated creates *rhythm* in painting. Rhythm in painting is similar to rhythm as we have discussed it in music and poetry in that rhythm is formed by tensions that create interests. However, there will be necessary differences in the construction of rhythm in auditory and visual arts. While all music must have rhythm, because it is a time-oriented art, its rhythm will be in terms of the temporal order of music. Similarly, as there can be no music without rhythm, there can be no poetry without rhythm, but again, rhythm in poetry inheres in the temporal organization of the work. Paintings will have rhythm, but here the organization is spatial, so rhythm will be a function of spatial organization.

Figure 10.

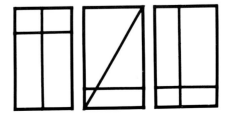

What rhythm means in the various art types may now be more precisely defined. Movement through *time* is rhythm in music and poetry, while movement through *space* is rhythm in painting (and architecture and sculpture).[47] Specifically, what is meant by movement in a painting is directionality created by patterns of contrasts. That is, elements can be regarded as comparable, or moving, which can be arrayed by uniform standards from less to more with respect to any of the three kinds of tensions which have been developed. What may be called primary themes in painting therefore, will be patterns of tension contrast which create a directionality.

In addition to the rhythm of painting, the equivalent of melody will also be found in painting, and this will have to do with color harmonies. Here, one is dealing with the relationships of different hues. Color harmonies are more than just a pleasant arrangement of color, actually referring to the balance of complimentary colors, which is physiological in origin. Due to the physiology of the eye, certain combinations such as red and green, are perceived as complimentary; that is, the presence of one requires the other for a sense of completion. Some paintings use this phenomenon to great advantage. For example, in Bellini's *Portrait of Doge Leonardo Loredan* the relationship of the blues and oranges shows a particularly effective use of color harmonies. It should be pointed out however, that while pitch is extremely important in Western music, its equivalent in painting, color harmonies, are not and one can easily imagine a painting without color, as indeed, color harmony is not significant in most Chinese paintings. On the other hand, there may be a dissonance of color harmony which also creates interest, and this is very often exhibited in Fauvist paintings.

Joseph Albers has described this technique very well:

> According to most color systems, harmony depends on the
> constellation of colors with a system. I go further in saying

[47]Since paintings are static entities, it is obvious that when we use terms like "movement" and "rhythm" we have chosen to use metaphorical language. Of course this difficulty could be overcome by introducing an entirely abstract vocabulary. However, this would mean that no one would know what we were talking about unless they mastered our system. Thus, even though such a solution would be feasible, it would not be worth the effort because of the complexity it would introduce without providing any meaningful results. All that is really needed is to show that on the levels of primary elements and thematic relationships commonality of function is possible and therefore the same terms are applicable to all works of art.

that, first, harmony is not the main aim of color. Disharmony is just as important in color as in music. And second, I say that every color goes with every other color if the quantities are right. This, of course, leads to a new seeing of color.[48]

The themes of a painting are simply patterns of elements; that is, they are elements that are seen as comparable. Their comparability is due to the directionality of their arrangement which is a result of the kinds of tension factors already described. It is interesting to note how similar the construction of musical themes is to the construction of themes in painting. In music, there are no shapes as there are in paintings, so in creating themes what the composer must do is to establish early on certain kinds of regularities. These regularities can be heard without difficulty and they are established by controlling the tension factors. For example, the first series of notes of a composition will establish a key signature and a time signature for the piece and these will serve as a point of reference. These points of reference are equivalent to the two axes in painting so that, in a sense, in music we have a tonic axis and a rhythmic axis. Thus, the minimal requirements for a theme in music will be a series of contrasts in time and a series of contrasts of pitch (pitch being heard to be primary and time contrasts being heard to be secondary in typical Western music). Therefore, everything assumes significance as it advances toward or proceeds away from this point of reference.

Poetry, it must be remembered, cannot be so strictly systematized since each language is different, therefore, the structure of the poetry versus the structure of the language creates tension and interest. This is the criterion by which we hear and define poetry as poetry and not as prose.

Finally, there is the equivalent to orchestration in painting, *chiaroscuro*. The function of orchestration, basically, is to make use of the timbre values of the instruments in the orchestra to enhance the structural effects of the work. The same can be said of chiaroscuro or the variation of shading of a particular hue[49] in the painting—it is primarily an ornamentation. While the structure of the painting will not hinge on the shad-

[48]As quoted in *The Artist's Voice*, by Katherine Kuh, New York: Harper and Row, 1960.

[49]Sometime when making use of saturation or brilliance artists (the Impressionists for example) will use a series of related hues as a spectrum.

ing, chiaroscuro does give depth and subtlety to the colors and the way they are used.

Paintings are not easy to analyze. The reason they are not is that most of our experience in dealing with a painting relates to what is depicted in the work. In this regard, paintings tend to bring out, as do poems, the message/structure controversy. However, in paintings the controversy has a slightly different characteristic in that here it is called "verisimilitude." The question that needs to be answered is "To what degree, if any, is the literal accuracy found in paintings of aesthetic interest?"

As has been mentioned earlier, different cultures place different stresses in their artistic traditions. In the case of Western painting until recently there has been a preoccupation with literal accuracy, or verisimilitude.[50] Before the invention of the photograph, it was thought that a painting should capture the physical countenance of its subject; but the development of photography enabled people to see that literal accuracy is not necessarily what one has in mind with good painting. This can be illustrated by the fact that to say a photograph is a good likeness of a person suggests that it accurately reproduces the configuration of the face; but to say a portrait bears a likeness to the sitter means something else, that it captures the nature of the person.

The question should be addressed as to why verisimilitude seems to be unrelated to the value of a painting. For example, how important is it that a painting entitled "Winston Churchill" resemble him when the work is aesthetically evaluated? It is the view here that objects depicted in a work are not part of the structure of that work. That is, the structure of the painting is unaffected by the verisimilitude since verisimilitude will relate to the informational content and, as will be seen, paintings can be appreciated without reference to whatever information they may contain.

This problem of verisimilitude in painting reintroduces the question of titles. Entitling a painting "Winston Churchill" produces expectation that it will look like Winston Churchill. If however, the painting were entitled, "Painting #10" the objection would not be raised that it did not bear a resemblance to

[50]There is the famous example of Zeuxis, the Greek painter, whose picture of a boy carrying grapes was said to be so remarkable that birds were fooled and flew down to devour the fruit. For a review of the predominance of verisimilitude in the visual arts of the West, see Chapter II of Osborne's *Aesthetics and Art History.*

Winston Churchill. The important point, of course, is that the painting will not have changed whether it is called "Winston Churchill" or "Painting #10."

Literal accuracy in paintings is not limited to the depiction of objects. The depiction of events is also included in the problem of verisimilitude, but the same objection to placing value on the informational content of the work still applies. In the same way that photographic accuracy is not what is demanded in a painting, neither is historical accuracy necessarily expected. For example, there are numerous instances of people dressed in medieval and early modern clothes in some resurrection pictures; and in paintings depicting the Last Supper, the wine service and the decoration of the room are almost always historically wrong. Since our appreciation of such works does not depend on the accuracy of these details, it is evident that historical veracity in one sense is immaterial. Thus the conclusion may be stated succinctly that verisimilitude in a painting is unconnected with aesthetic value.

The conclusion that verisimilitude is not an issue of any consequence in painting has its corollary in music and poetry as well. For example, it is clear that poets do not imitate nature in any meaningful sense of the term. No one expects a poet when describing the sound of an animal to record it literally; and if a poet tried to imitate the sound of the wind by some odd concoction of syllables, it would be regarded as an eccentricity. Similarly, many people regard experiments as have been made from time to time in attempting to render one or another sound naturally in music in what is called "tone poems" as misguided at the very best. Such experiments with literal accuracy as do exist might be considered as quaint and perhaps as interesting, but nothing more.

Some may want to suggest that while it is agreed that literal representations are not important, the value of a painting lies in its symbolic meaning. The symbolic significance of objects, most of which is now lost, was well developed in the early history of Western painting where virtually every object was vested with some esoteric significance. A very famous example of this kind of symbolism is in the *Merode Altarpiece* (Figure 11) in which one side of the triptic (Figure 12) shows Joseph making a mousetrap. Scholars had long puzzled over the interpretation of this picture. It was finally related to an obscure passage in one of the letters of Augustine in which he says that when God created Joseph he was making a mousetrap for the devil. For several centuries that little bit of esoterica had been lost and it

101

Figure 11. The Master of Flemalle. About 1425-28. Robert Campin: The Merode Altarpiece, The Metropolitan Museum of Art, Cloisters Collection, Purchase.

was not until much later that it was once again possible to understand the message in that particular panel of the triptic. The *Merode Altarpiece* demonstrates that the iconography of a painting can remain obscure, but the work may still be significant.

There is also evidence that people can appreciate paintings even where they cannot decipher a work as possibly containing symbols. For example, people who do not believe in the Buddhist faith are nonetheless able to respond to Buddhist sculptures and paintings, or they can respond to Muslim works of art, i.e., mosques, without regard to function in a religious context. It is to be remembered that within a religious context the information contained in these works are considered true judgments, though they are not empirical in the usual sense of the term; and even if Westerners were knowledgeable as to the symbolism they contained, they most probably would not be sympathetic with it. The fact that we can appreciate such works, in the sense of understanding the encoding process, indicates that a work need not be regarded as incomplete even though the idea behind it, its function in society or what it stands for is unavailable.[51] Nor must its value be diminished if the message is one with which we disagree, one that is patently false, or one whose

[51] If this were not the case, we would have to regard historical works of art, where the culture has been lost, to be incomprehensible or virtually incomplete, as in the case of the Indus Valley sculptures.

Figure 12. The Master of Flemalle, Robert Campin: The Merode Altar-piece, Detail. About 1425-28. The Metropolitan Museum of Art, Cloisters Collection, Purchase.

usefulness is outlived.

A particularly interesting example in our own tradition to illustrate this last point is Van Eyck's painting *Giovanni Arnolfini and His Bride* (Figure 13) where we can say there are different levels of messages. This painting illustrates quite well what we have been saying that what the painting is supposed to say is irrelevant to the piece as a work of art. What this particular painting is supposed to convey operates on different levels and is no easy matter to determine.

First, this painting is a legal document, in fact a marriage certificate. We must remember that the idea of needing a license to marry is a modern notion. Before one needed priests or ministers to consecrate the ceremony, all that was required was that there be a witness. At first glance the couple in the picture seems to be alone, but if we look carefully into the mirror on the wall behind them the artist and another person beside him who serve as witnesses may be seen. Since Giovanni Arnolfini and his bride are long since dead, the usefulness of this painting as a marriage contract is finished and has no more interest than would a certificate of any unknown person from the same period. Such documents might be of research interest but would not be art. So, we can say there is no relationship between art, so judged, and function or use, and if the function of a particular piece is obsolete or is unsuccessful, the piece can still be counted as being of aesthetic interest.

While some may quickly agree that the usefulness of the painting can be easily dismissed as being of no aesthetic interest, a more difficult question might concern the importance of the objects we see in the painting, dog, candle, fruit, shoes, etc. Are these to be considered of aesthetic interest, and if so what is their aesthetic function?

In keeping with what we said about verisimilitude, we would *not* want to contend that seeing the candle *qua* candle is what matters because in fact this object like most of the other objects of the painting are really disguised symbolisms having to do with the ceremony of marriage. In this instance, recognizing the candle as a candle is not recognizing it for what it is. It is not a candle but rather the holy spirit, and to say its being a candle is somehow important is to misinterpret the object. This is also true of the other objects in the room, since nothing symbolically is as it is literally portrayed to be. The dog is not a dog, it is the faithfulness of marriage; the shoes which have been removed show the holiness of the ground on which the bride and groom stand; the fruit is not fruit, but the fruitfulness of the

104

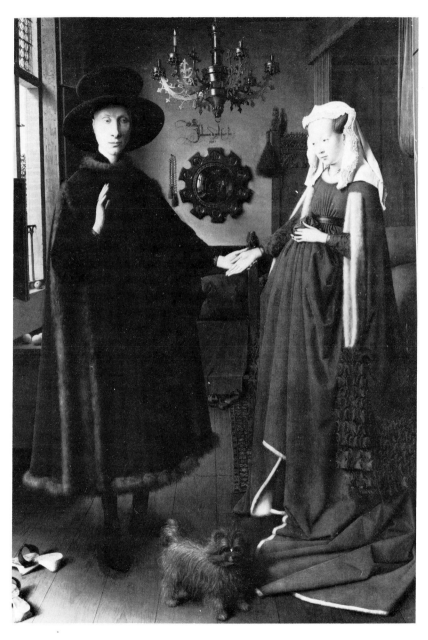

Figure 13. Jan van Eyck. Giovanni Arnolfini and His Bride, 1434. Reproduced by courtesy of the Trustees, The National Gallery, London.

union, and calling it a "peach" is really to misinterpret what it is in the painting.

These observations are not at odds with the fact that knowledge of, and agreement with the message or idea of a work does add a dimension to one's enjoyment of the work. The point being made here is that an aesthetic dimension is not added. The reason the added dimension would not be an aesthetic one is that it could not be part of the structure of the work. If it were part of the structure, the work would not be intelligible without it. That this is not the case will be demonstrated in Chapter V in which specific works of art are analyzed and evaluated.

However, a dismissal for aesthetic purposes of the symbolic aspects or the literal accuracy of the objects in a painting does not lead to a dismissal of the value of their representational qualities; but here we must be clear to point out what we mean by representation. "Representation" is not being used in what Gombrich refers to in "Meditations on a Hobby Horse" as "the traditional view of representation:" i.e., the work of art replicating or copying a motive in the outer world or in the artist's inner world; rather when we use the term here we mean to denote the grouping together of the expressive modalities of a painting. More specifically, what we take representation to be is *the expressive configuration of gesture.* These terms need explaining. "Gesture" is defined in *The Concise Oxford Dictionary* as "significant movement." However, the word "gesture" in our definition of representation is being used as a way of saying "an identifiable object which functions as an element in the composition," and thus only analogically pertains to movement since movement in painting is used to mean consistency of direction. Thus, in Picasso's *Guernica* there are geometrical shapes which are nonetheless interpretable as horses, people, lightbulbs, etc. However, that they are horses, people and lightbulbs is not the focus of aesthetic importance; the function of this grouping of elements is to assist the viewer in working out the expressive configurations of the painting. By "expressive configurations of the painting," we mean those configurations which are structurally functional in the painting, i.e., themes.

If one looks at pastoral scenes in which there are trees and cows, or at still lifes of fruits and flowers, or at pictures in which human figures appear, these objects are gestures, identifiable objects, elements grouped in expressive configurations which serve as keys in decoding the structure. One might ask what representation would be in abstract paintings. Because of the ab-

sence of gesture, there is very little to distinguish an expressive configuration from non-expressive configuration; however, the point could be made that there are no non-expressive configurations in abstract paintings because there are seldom any unimportant objects.

To illustrate the point made above about representation, the expressive modalities of a particular painting, *Cardinal Don Fernando Nino de Guevara* by El Greco (Figure 14), may be examined in some detail. The traditional way of talking about this work is to deal with the personality of the man who is portrayed. When the painting is a portrait, this is the common approach. In this vein, one might say that the Cardinal is maintaining external composure while inwardly he is in a state of turmoil, and in fact, this is the type of analysis that is usually made of this work.

Let us assume for a moment that this interpretation is cor-

Figure 14. El Greco. Cardinal Don Fernando Nino de Guevara. The Metropolitan Museum of Art, The H.O. Havemeyer Collection. Bequest of Mrs. H.O. Havemeyer, 1929.

107

rect. How would the artist achieve this effect? If he wants to depict the Cardinal in a state of turmoil while maintaining a general calm, how might he go about assembling structural elements to realize his intention? And, if viewers want to describe the work in this way, what might be pointed to in order to support their conclusion? There must be present somewhere in the structure of the painting sets of thematic elements which are in tension with one another in that one set will tend to suggest composure while the other set tends to suggest agitation or turmoil. In an attempt to determine why this painting conveys such tumult, the focus of attention is often directed toward the hands, the one clutching the chair while the other is very relaxed. But surely the painting is not composed just of gestures of this type, and if somehow the Cardinal's hands were not visible, would one nonetheless not still have the same impression?

It is sometimes observed that the chair is placed oddly with respect to the frame of the painting. The Cardinal is not looking directly at the viewer, but is at an angle. Some suggest that an imbalance is created by turning the Cardinal away from his audience, and that this is one of the things that creates the attitude of tension expressed by the work. However, all of these suggestions about the hands and the angle of the chair are based upon interpreting the painting merely as a real event and not as an intellectual structure. If seriously considered, one would hardly want to maintain that all El Greco did was simply to pose the Cardinal the way a portrait photographer would have done. Portrait photography is not commonly accepted as one of the great art forms of history and surely what El Greco did is not what one would do in taking a photograph of a friend: putting him in a chair; turning the angle of that chair and having him clutch one arm of the chair while the other dangles down relaxed. Would we then have this painting? Surely not. While one would answer "no" to this question, aesthetics must be prepared to say why the answer is "no," or at least to suggest the clue.

A closer examination of the axes of the work and the background and floor pattern demarcated by the axes will provide the answer. If one examines the El Greco closely, it will be seen quite clearly that the artist has stationed the Cardinal exactly at the geometric vertical axis of the painting. In other words, half the Cardinal is on one side of the axis and half is in the other side. Even more important than this are the backgrounds on either side of the axis. There is a very marked and obvious difference between the background on the left side and the back-

ground on the right side. The background on the left side is in muted dark tones of a single continuum and in terms of its geometric structure is organized into panels which are square. There is calmness and repose and regularity of geometric organization in the background which enhances the effect of the limp hand. The gesture of the relaxed hand in combination with the tone of the background and the recurrent square elements reinforce this impression of relaxation.

The same is true if one moves down to look at the floor. The floor on the left side is defined by regular geometric shapes and that contrasts with the floor on the right side which is very vague in its treatment. On the right, the floor disappears as a clear cut pattern so that all one sees is spots of colors and it is difficult to determine that it is the same kind of tiled floor that it quite clearly is on the left hand side. The same formlessness of the right side floor is evident in the wallpaper on the Cardinal's right side. The wallpaper is filled with sinuous curves, the tortuous, undulating floral pattern being a way of describing turmoil and agitation.

The chair is placed at odd angles with respect to the walls so one has the incongruities of the trapazoidal relationship between the chair and the wall, a positioning which creates anxiety. On the one hand, the background reinforces the sense of relaxation in the limp hand; on the other side there is the extravagance of the wallpaper and the clenched fist.

The regularity in the occurrence of these opposing elements demonstrates that their appearance is not accidental or exotic but that they are an integral part of the technique by which El Greco creates impressions. Thus, when attitude words such as in this case "anxiety," "repose," "calm," etc., are used, what is being discussed is a relationship between elements in the painting which in turn give an impression of these attitudes. In this El Greco painting we have an excellent example of how structural elements create attitudes as they were described in Chapter II.[52] Attitudes were described as characteristics of structure and here one clearly sees how the agitation and turmoil and tension in the painting are encoded by the artist. Attitude we now see is a product of structural relations. Also in the El Greco, as in any painting, we have expressive configurations and the important factor is the way in which they are handled. That the object happens to be a Cardinal or a hand, etc., is no more important than the background or the floor or anything else, for as elements they function similarly; however, the representational objects are significant in that they give clues for decod-

ing since they are landmarks of expressive configurations in the work.

We have said from the beginning that the task of aesthetics with regard to the work of art is twofold: first, to analyze a work of art, to describe its properties, to uncover its organization. This task has been the subject of the present chapter; however, we also said that this work is simply preparatory to our second task, the interpretation of the work, the making of aesthetic judgments.

Aesthetic judgments require additional steps in that the judgment of a work of art involves the application of value categories to it. It is quite possible to analyze and understand a work of art without applying to it any value terms whatsoever. We can analyze a piece of music or a poem or a painting entirely in terms of its structure and never say anything at all about how good it is. But we cannot interpret a work of art if we cannot adequately describe it and uncover its structure. Any kind of evaluative statement concerning the work of art must rest upon understanding the actual structure of the work of art. For these reasons it is first necessary to be able to describe works in order to apply a uniform set of value categories to them.

Having worked out a satisfactory vocabulary for describing works of art, we can, in the next chapter, proceed to the problem of value categories. Additionally, within a value framework we shall offer a definition of art. It will be suggested that structures must achieve a certain level of value before they may seriously be considered as art. The question may be raised as to why one would choose this stipulation rather than simply

[52]There is an interesting similarity between El Greco's *Cardinal* and the *Portrait of Doge Leonardo Loredan* by Bellini which was mentioned earlier. If one reads the traditional books of criticism this painting by Bellini will be described in phrases almost identical with those used in describing the El Greco. Except here, the degree of contrast is less tumultuous than in the El Greco, and Bellini does not achieve contrast by any obvious means, e.g., there are neither limp hands nor hands clutching the edge of a chair. Yet, the complexity of the man's personality is thought to rival that of the El Greco. How does Bellini achieve it? If one looks at the painting very carefully and compares the left side of the man's face with the right side, what one discovers is that in terms of light and shadow, in depth of color, and geometric forms which oppose each other, the technique is almost equivalent to that which El Greco used. The contrast between the two sides of the face gives the impression that there is a person of "two minds." It is a common view that what an artist does is to give the viewer some insight into the personality of the man whose portrait is being painted, but it would be more accurate to say that what one interprets that way is, in fact, the mode of structure in the painting.

Figure 15. Music, Poetry, Painting: Table of Resemblances

	MUSIC	POETRY	PAINTING
Primary Elements	pitch	voice pitch	(color) hue
	amplitude	stress/unstress	value
	timbre	phoneme	intensity, saturation
	duration	duration (length/shortness)	(space) configuration, outline
Thematic Elements and Development		(image)	(gesture)
	rhythm	rhythm (a) stress (b) length	rhythm (a) variations of value (light and dark) (b) variations of contour and shape
	melody	patterns of intonations and pitch	hue variation and contrasts
	orchestration	patterns of phonemes (image sequence)	saturation, intensity, harmonies (expressive configuration of gesture)
	themes created by rhythmic contrasts plus melodic contrasts	themes created by structure of poetry against the structure of the language	themes created by variation of the two types of rhythm primarily but occasionally by color harmonies
Structural Forms	interrelationship of themes (themes relating to themes)	interrelationship of themes (themes relating to themes)	interrelation of themes (themes relating to themes)
Totality of the work	totality of the composition	totality of the poem	totality of the painting

base a definition on certain family resemblances which obtain between structures. The reason is one of economy. The family resemblances, when one deals with objects, is so vast that it is impractical to use family resemblances as grounds for a definition; therefore, using a level of value is a rule of practicality, or perhaps prudence.

Chapter Four

Devising a Common Vocabulary
of Aesthetic Value Terms

The uniformity of relationships which obtains, despite the variance of medium, makes possible the discussion of common features of works of art and also provides the basis for common standards of evaluation. In the previous chapter, it was observed that a work of art consists of multiple levels, the physical level consisting of the material elements of the particular medium, and the intellectual level where themes are developed and related by principles of organization. We can imagine that each of these various levels will have certain characteristics, and it remains for us now to work out what those characteristics might be.

By examining the way in which people respond to works of art, one sees that there are levels of response to a work and that the nature of their response, in terms of appreciation, changes through time if they continue to apprehend the work of art. This means that the aesthetic response is a gradual process; and the presence of these various levels of appreciation makes it convincing to suggest that a work of art also has a hierarchical value system. One can posit that each of these levels will have its corresponding values; but the problem is to create an evaluative vocabulary which could appropriately be used for all types of art and levels of response, a requirement in order to satisfy our rule of commonality.

In attempting to work out such a vocabulary, it may be well to examine works of critics in a variety of areas of art. If one makes a list of the evaluative terms used in the criticism of various art types, along with a short description of what the writers using the terms seem to have in mind, it then becomes

113

apparent that no matter what area of art is under discussion certain value terms regularly recur. If value terms collected from the criticism of various art types are assembled, it becomes strikingly obvious that the list is composed, not of independent terms, but rather of groups of terms which correspond to levels of appreciation of a work of art. So, in this chapter, terms that have heretofore been simply aesthetic terms in the sense of value terms of a nonspecific sort, will be reclassified in such a way as to correspond to one of the levels of structure as we have worked them out in the preceding chapter.[1]

Primary Levels of Appreciation: Some of the values that may be possessed by a work of art appear to be values which correlate with the primary elements described in Chapter III. The initial response is an appeal to those material elements in that one's immediate experience and pleasure in works of art lies in the pleasantness of the raw material of the medium. For example, people enjoy sound, *qua* sound; color, simply as color; and words as they are spoken, not for any particular meaning they may have, but as sounds alone. At this level the word "beauty" is often employed as a description, as in "beautiful sounds" and "beautiful colors."

There is a certain entertainment value inherent in primary elements which seems to appeal to the senses. Some artists exploit this appeal more than others. For example, in music one enjoys the sensations of Wagner's sound in a way in which one does not enjoy the sensations of a Bach sound. In the case of color, there is thought to be something sensual about the colors of the Impressionist's palette that is not true of Early Renaissance frescos, even though, in their time, these frescos were considered remarkably sensual when compared to what went before. Giotto, for example, in his frescos of the *Life of Christ* in the Scrovegni Chapel at Padua made use of color in a way that struck his contemporaries as oddly sensual. In the context of his time he was using color in a very vigorous way,

[1] The question may be raised as to why these particular value terms were selected as opposed to others. The answer is simply that the chosen terms are introduced as terms that occur frequently in the literature and seem representative of the kinds of values that are commonly singled out. If a further question were raised about why there seems to be a general agreement for example that balance is to be preferred over imbalance, or complexity is more valuable than the obvious, the justification for those preferences would I think lie in psychology and not in philosophy. My own suspicion is that these terms relate to certain kinds of patterns of thinking which we regard as significant.

but compared to the way color was used by the Impressionists, or the way color is routinely used today, Giotto's work seems very restrained. The foregoing discussion illustrates that sensual appeal is contrastive, becoming so in terms of context. In the context of medieval colors, the yellow of Judas' robe in the Giotto frescos for example, was an exceedingly sensual color; however as compared to Venetian oils, it does not appear sensual.

Clearly, the notoriety of certain styles of art, when they are new, is due to just this sensual appeal; but a fundamental issue is whether this sensual appeal is aesthetically significant. Although these sensuous qualities introduce a very direct pleasure which accounts for the appeal, akin to eroticism in general, that works of art have for many people, enhancing enjoyment of art, the important issue is whether one can assume that this sensual pleasure is the fundamental part of the aesthetic response.

In connection with this question, it is very clear that certain commentators regard the sensual qualities of the work of art as a possible impediment to its value, and this position is held by both message advocates and structuralists. For one who holds that the message is the valuable thing about a work of art, the sensual qualities of the medium can serve as a detraction from the message; on the other hand if the relationship between the elements is of primary value, undue attention to materials may result in over valuing a work simply because of surface attraction. It is also clear that those works of art to which tradition has ascribed greatness are works which, by and large, do not have any significant sensual appeal. For example, late Beethoven quartets are works of art in which the sensual appeal of the work is, as music goes, minimal; unlike the lavish sensuality of a composition such as Debussy's *L'Apres midi d'un faune*. And no critic would hold that one of the Dutch masters of still lifes with his extraordinary skill in rendering the sensual qualities of the translucence of glass, the softness of velvet, or the quality of fur, is equivalent to the late Rembrandt in which the sensual properties of the medium are, comparatively speaking, minimized. In contrast, Rembrandt's later work is almost monochromatic, the colors ranging from shades of gold to shades of brown. The de-emphasis of sensual qualities in such works of art and the high value placed on them raises the question whether response to a work's sensuality forms the essence of the aesthetic experience.

Let us examine more closely the kinds of values inhering in

colors and sounds. On this level of response, the qualities found desirable are also shared with natural objects. For example, the properties most admired about precious jewels are those which pertain to certain kinds of color; we prefer colors to be *vivid* rather than faded, *clear* rather than muddled and *precise* rather than diffuse. Characteristics such as vividness, clarity and precision are also terms that could be used to refer to sounds. While no claim is made that this is an exhaustive array of terms for the qualities which are significant in sound and color, they are at least a representative list.[2] Thus, instead of characteristics such as hazy, dull or indistinct, it is more likely that the terms encountered to praise beauty of sound and color would fundamentally give the idea of intensifying or heightening the effect.

The response to these qualities of vividness, precision and clarity is pleasure; that is, pleasure results from seeing clear, vivid and precise colors and hearing sounds with the same qualities. In the selection of the materials, the artist may enhance the effect of the work by choosing materials which are attractive and to which audiences will respond.[3] The reason they respond is that they take pleasure in the primary elements of the work of art. This also explains why delight is taken in hearing language pronounced certain ways. We find that persons who speak so that their speech is vivid, clear and precise enhance what is said. People who take acting lessons learn to project in such a way that they are able to incorporate these qualities into their voices.

Specific examples of the characteristics under discussion as they occur in musical compositions and paintings will be use-

[2] We can hypothesize that value terms like "vividness," "clarity," and "precision" are common to all media. However, there probably are in each medium certain additional terms which could be used. That is, since each of the arts is perceived in one of two basic ways, either visual or auditory, there might be certain characteristics which are distinctive to those art types.

[3] It should be kept in mind that this is the fundamental difference between works of art and other intellectual activities. Thus, no mathematician would give the slightest thought to the material of a book of mathematics. Similarly, one does not respond to the colors which might be involved in a book of scientific theory. However, the sensuous qualities of primary elements are more obvious in some media than in others; for example, the primary elements of music and painting are much more obvious than the primary elements of architecture or of poetry where they seem to be less interesting. Thus, people who exclaim that they experience enormous sensual enjoyment from a poem are much rarer than those who get a sensual enjoyment from music or painting. Sculpture seems to fall somewhere in between these two.

ful. Vividness in music is exemplified in the brightness of the opening trumpet in Ravel's orchestration of *Pictures from an Exhibition* while vividness in painting is found in the vibrancy of a Van Eyck or the intensity of a particular bottle green sometimes used in the background of a Hans Memling. Clarity of sound is apparent in the lucidity of tone in Wagner's *Rhinegold*; while in painting, clarity of color is seen in the translucent details of a Van Eyck such as the *Adoration of the Lamb* panel of the Ghent Altarpiece. Precision in sound reaches its height in almost any selection one might choose from the works of Mozart, while in painting precision, or purity of hue, is illustrated in *Broadway Boogie Woogie* by Mondrian.

Demonstrably these lush qualities of sound and sight are the sensual parameters of a work of art and encoding is not involved. Notice that if sensual qualities are lacking, the aesthetics of a composition is not affected. A musical piece may be judged to be good even if one has the misfortune of hearing it in a bad seat or one hears a performance in a defective music hall. In such an instance, we only miss those aspects of good sound quality. Similarly, in painting, we would not want to say that those Rembrandts with their vast layers of varnish distorting the original colors are any less masterpieces than those paintings which have been restored. In both cases, the structure of the work remains unaffected. Thus, while response to the sensual qualities of a work's primary elements may be pleasurable, nothing that is intelligible is involved. Nothing sensible is involved, and thus, this response is not in the fundamental sense of the word, part of the *aesthetic* pleasure of the work of art because it does not depend upon encoding nor upon decoding. Thus, when a badly orchestrated portion of a composer's symphony is reorchestrated, the result is regarded as a technical improvement, but not a change in the work of art. A great many composers in the past made mistakes in orchestration; that is, they misjudged the aural effect of the orchestration. Consequently, conductors with great regularity changed the orchestration so that the music would sound "correct;" meaning, "vivid," "clear" and "precise." The point is that works having *only* these characteristics are enjoyable and nothing more. We enjoy them as we would good wine or perhaps a great meal; but this enjoyment is not aesthetic since such pleasure does not involve the intelligible structure of the work.[4]

More needs to be said about the fact that value terms which apply to the sensual or primary level of appreciation in works of art are also value terms used to describe natural objects such

as gems, in the earlier example, or sunsets, sea shells, or precious metals. In this respect, responding to the sensuousness of an artistic medium is not unlike responding to the sensuousness of natural objects. Because natural objects in their appeal and aesthetic objects in their appeal share the same material properties, it becomes an easy leap for some to suggest that the pleasures which sunsets give are akin to the pleasures which paintings give, and it is clear that the doctrines of pleasure which aestheticians develop do in fact spring from an emphasis on these material elements. The emphasis on material qualities creates certain expectations about what art should do, and reintroduces the question of verisimilitude.

There is in each art type certain possibilities of verisimilitude to natural objects; and while these are not entirely ignored in music and poetry they are most frequently exploited in painting. However, the issue of verisimilitude in painting is really the issue of the clarity of the primary elements of the painting. When one talks about the tactile values (for example, the fuzziness of a peach, the furriness of an ermine cape, etc.) of the painting, one is using a confused linguistic way of saying that the work of art is vivid and sharp. We find the success of the illusion exciting, but what we are really reacting to is the exploitation of sensual elements. In painting, the tendency is to associate it with the objects portrayed rather than with the elements of the painting itself.

The connection between material, or primary, elements and verisimilitude can be illustrated with a painting that was celebrated in its day for its extraordinary verisimilitude, Caravaggio's *Bacchus*. The technical virtuosity of the work is obvious especially in the glass of wine. Extraordinary skill is required to paint, behind a transparent glass stem, the folds of a garment, or to show the softness of the skin of the fruit, or the texture of the leaves.

Since the material qualities of paintings can be used so effectively to create an illusion, impressions arise about what a

[4]I do not mean to imply here that the intelligible structure does not, or ought not, produce pleasure. Although the pleasures derived from decoding are not connected to the aesthetic value of a work, it is nevertheless true that pleasures do accompany the understanding of how a piece was constructed. As discussed in Chapter II, a consequence of coming to appreciate a work involves a certain pleasure in the decoding, but this pleasure is of a rather more contemplative sort than the more immediate pleasures of reacting to the sensuous qualities of primary elements.

painting ought to do. That is, paintings can imitate or mimic the world by portraying natural objects. From this point, one might leap to the conclusion that the goal of painting is to portray nature, while additionally refining nature in some way to eliminate that which is untoward. Although going down the wrong path altogether, those who hold this view start from the fact that naturally occurring objects provide the onlooker with pleasure simply upon observation. The overlooked point is that such pleasure is not significant from an aesthetic point of view since the sensuous qualities that produced it do not apply to organizations or structures; that is, they are not part of the process of encoding.

In summary, the apparent aesthetic qualities of natural objects may be explained by the fact that, like aesthetic objects, they do contain sensual elements. That is, the apparent similarity between works of art and natural objects is explained by the presence of sensual elements in both and by the fact that people respond to the physical properties of works of art. In fact, it is this sensuous level which links together natural objects, crafts and fine arts for all of them have the appeal of sensuality; however, there are additional values which correspond with other levels of appreciation which these groups do not share, thus demarcating them one from another. These will be examined as the value terms which correspond to the components of the structure of the work are explored.

Thus far, we have said that the pleasure one enjoys as a response to the primary elements of a work is not aesthetic since, on the pre-aesthetic level of sensuous qualities, there is no involvement with decoding structural relationships which, according to the view here, is what aesthetic understanding entails. In terms of structure, however, a work of art consists of at least three parts, (a) what may be called the "themes" which form the basic elements out of which the work is constructed, (b) the organizational principles which go into creating the total structure and (c) the totality of the work itself. Just as the primary elements had their corresponding values, these higher levels will also have their appropriate value terms.

Thematic Elements and Their Development Into Themes: Beyond a mere appreciation of the non-structural, sensual aspects of an art medium is the next stage of awareness. This is one in which the structural relationships of the elements become apparent. One sees "how the work was put together;" that is, one becomes aware of rhythms and recurrent

119

patterns. Thus, the tendency is to move from those things which are fundamentally material elements with regard to the work of art, to those things which may be called "thematic." All works of art are composed of thematic elements; that is, there are identifiable sub-structures which recur in such a way that the patterns of their recurrence are significant. Creating themes involves putting together a particular combination of primary elements in such a way that there is intelligible structure. This may involve, for example, contour of line, contour of rhythm, recurrence of shape, etc.

At this level of themes, the point is reached at which a kind of participatory insight into the work develops rather than a mere passive appreciation of it. One really "hears" or "sees" the work rather than simply being exposed to it. On this level, one is no longer just aware of the beauty and sensuousness of the material elements, but recognizes their manipulation and organization. At this point one leaves the material of the work and enters into its structure. That which is thematic is the product of thought. The thematic is a product of encoding and not something which is inherent in the materials themselves. A theme need not be pleasant or appealing in the way color or sound which is vivid, precise, or clear is appealing or pleasant.

The "atomic" elements, they may be called on this thematic level, are "rhythm," "melody" and "orchestration," and we need to keep in mind that these thematic elements are not restricted to music only, but have their functional equivalencies in poetry and painting as well. However, the value terms appropriate to these thematic relationships are still only those same values that are appropriate for the materials, or primary elements, of the medium. When these atomic elements are developed into themes another set of value terms is required.

What kinds of characteristics could themes possess? *Subtlety,* what we call "nuance" is one of the things which is interesting about a musical composition, a poem, or a painting, subtlety being defined as the minimum degree of contrast where contrast remains discernible. A work of art is said to be subtle, if the first time we apprehend it, we are not immediately aware of everything that occurs within it.

In addition to subtlety or nuance, a theme can also be complex. The *complexity* of the work of art is a function of the intricate interrelationships among the various elements of which the work is composed and the term refers to the manifold number of possibilities expressed in the construction of a theme. The difference between the two characteristics, *subtlety* and

120

complexity, can best be shown by an example. In Bellini's *Portrait of Doge Leonardo Loredan,* the difference in the shading of the two sides of the face is subtlety which in turn makes the work complex. That is, the subtle differentiation, or the fine discrimination, increases the number of perceived connections. The same can be said for El Greco's *Cardinal* in that the subtle differences that become apparent between the left and right sides of the picture open up many hitherto unseen connections.

Subtlety and complexity seem to be a pre-condition for another quality, *richness*; this is to say that there is a logical entailment of richness in subtlety and complexity. Richness applies to the overlapping character of the relationships, that there are many inter-relationships between the elements. The richness of the work of art is that which gives the impression that the work is infinitely variable and inexhaustible. That is, one feels that one could read, or listen to, or look at the work innumerable times, never tiring of it and never exhausting the possibilities of combinations inherent in the work. It is true that no work of art is inexhaustible; inexhaustibility is only an impression related to the richness. The richness of a work makes it possible for us continually to apprehend the work without growing tired of it; therefore, the judgment that a work is "timeless" is nothing other than the judgment that it is rich.

The next factor to be dealt with is the organization of the work. The organizational principles of a work of art encompass that area of the work which possesses the operational properties which other intellectual products share. The virtues to be considered here are: economy, fecundity and elegance.

One of the anomolies of criticism is that the same work of art may be praised for its magnificent simplicity and for its incredible complexity. When a critic states that a work of art is simple, it does not mean that it is apparent or commonplace. What is meant is that the work shows a higher order of simplicity; that behind the surface richness, complexity and subtlety there is *economy* of structure. When a work of art is described as economical, the statement means that the principles of encoding entailed in the work, as primary assumptions of the work, are very few in number. For example, Chinese works of art exhibit an extraordinary degree of economy by Western standards; while by contrast Respighi's *Pines of Rome* lacks economy.[5]

[5] Japanese aesthetic vocabulary has long included this concept of economy in *yugen* where one subtracts everything except what is absolutely required.

Economy goes hand in hand with the *fecundity* of a work of art. Fecundity in this case refers to the impression of infinite possibilities which derive from a very few primary terms. These are, of course, the same properties that we find admirable in all intellectual systems: economy of assumption and fecundity of implication. What one is dealing with here are two levels of characteristics. While the surface is complex, subtle, rich, so that it captures and sustains interest, further analysis and acquaintance with the work of art reveals that along with its apparent richness, it is in fact, logically tightly organized in such a way that its economy, its direct simplicity, its fecundity, are evident upon extended acquaintance.

To show how these organizational terms of economy and fecundity differ from the crucial term of the preceding level, richness, the point that richness refers to the thematic presentation of the work while these terms refer to its logical structure must be kept in mind. The implication is that the impression of richness may exist without economy, in which case, one would ultimately judge that the work of art is a failure on the intellectual level. For example, especially long works of art, as in music, might give the impression of enormous richness, but that richness might not be the product of fecundity and economy (the logical structure) in which case, the composition would be regarded as an inferior work of art. There may be "richness" without "economy" and "fecundity," but economy and fecundity will certainly be accompanied by richness.

Oddly enough, there are some works which show extraordinary examples of the structural characteristics of economy and fecundity which are not particularly beautiful—Moslem buildings. The Seljuk Turks discovered that if bricks were shaped and standardized, every element in a structure could be related to the measurements of the brick. A brick has three measurements, height, width and length. If a mathematical ratio among these dimensions is employed, the result will possess economy since every part of the design will be worked out in basic mathematical terms. These buildings demonstrate extraordinary fecundity based upon a few simple propositions. The design is based upon a few simple ratios and everything in the building is designed in terms of primary propositions. Gothic architecture gives that same impression for much the same reason, but is not as mathematically regular as Seljuk buildings.

In addition to fecundity and economy, works may have a property which in a logical system or a mathematical proof

122

one would call *elegance*. While this is not a common aesthetic term in that critics are not found using it in the literature, it is common in mathematics and physics. A mathematical proof is said to be elegant if the interconnections between the steps are particularly tight. If there is precision and tightness of reasoning in the steps of a proof, the proof is described as elegant, surely an aesthetic judgment.

In so far as one might talk about responses to what has been identified as the structural level of human products, it seems that one responds to a really elegant, extraordinary mathematical proof or scientific argument, particularly in physics, in just the same way one does to a Beethoven sonata. Evidently those who understand mathematical and physical theories to a high degree, experience much the same kind of pleasure and excitement as that experienced when the arts are dealt with. However, science or mathematics involve none of the material qualities discussed earlier. That is, while they differ concerning material relationships, on the structural level both art and mathematics display economy, fecundity and elegance. In contrast, subtlety, richness and complexity are not terms which could be applied to mathematical arguments which by contrast lack material or medium and are pure intellect.

Of all the properties, elegance is the most difficult to define as it applies to works of art; however, it is fairly easy to recognize. Elegance results when a sudden unexpected turn occurs in a work in such a way that relationships which were seemingly discrete are suddently connected in a brilliant fashion. One suddenly realizes the extraordinary appropriateness of what has happened, and the realization of appropriateness constitutes part of the elegance of a work. That is, the work has a degree of fecundity and economy that one did not at first discern; the connections are much tighter and much closer than one at first realized. Another characteristic factor is that some things demonstrate extraordinary simplicity over and above mere economy. Not only are the items few, but they are very direct and very discrete, in the sense of being separated, and then they are brought together in a kind of intellectual tour de force.

One sees the significance of economy, elegance, and fecundity when a musical composition like Beethoven's Opus 111, *Sonata 32 in C Minor*, is compared with a work like Strauss' *Don Juan* or Balakirev's *Islamey*. The latter works have a surface complexity, while Beethoven's Sonata by contrast is simple. The first movement consists of a myriad of swirling notes, but by the time the variation series is finished one sees the true opera-

tion of fecundity, economy and especially elegance in its logical order.

At this point, a level of organization is being dealt with which seems to exclude certain kinds of activities. One can imagine, for example, that a fine Persian carpet is subtle and complex, and while one might have some doubts that the design was rich it would be plausible. On the other hand, it is very difficult to imagine that a Persian carpet is economical. In fact, one really does not know what one could mean by saying that it is economical, or that a Meissen figurine is elegant (Figure 16) in the way that a piece of Sung pottery (Figures 17-18) is elegant. While the daintiness of Meissen Figurines show them to be exquisite examples of craftsmanship, they do not possess the higher order *simplicity* that characterizes elegance in the mathematical sense in which the term is used here.

This organizational level can be seen as that which constitutes the distinction between fine arts and mere crafts; the degree of tightness of organization which fine arts entail. Crafts appear not to possess the same type of logical structure as fine arts. For example, one can see that a Michelangelo sculpture might have elegance, fecundity and economy, but in keeping with our definition, one could hardly imagine that the figures made by the masters of porcelain have these characteristics. The distinction between fine porcelain figurines and Michelangelo's sculptures is one of organization. The latter possess a logically coherent organization exemplifying the virtues of fecundity, elegance and economy while the former do not.

Similarly, we might imagine watercolors to be rich and subtle but we would have difficulty imagining that they also have fecundity, elegance or economy. Yet these qualities are precisely what impresses us about the works of great painters like Raphael or Rembrandt. Those artists whom we regard as secondary are artists whose work is seen as merely subtle, merely complex or merely rich, but lacking logical form or coherence. In other words, when we judge something to be coherent, what is referred to is that particular closeness of logical connection which is a product of economy, fecundity and elegance.

Totality of the Work: Finally we come to a work of art as a totality. On this level the work becomes "symbolic." Saying that the work becomes "symbolic" means that the material begins to have a grammar and a logic of its own, which is identifiable and stateable because the units begin to function in

Figure 16. Figurine: Seated Lady with Monkey. German, Nymphen-burg. c. 1900. The Philadelphia Museum of Art.

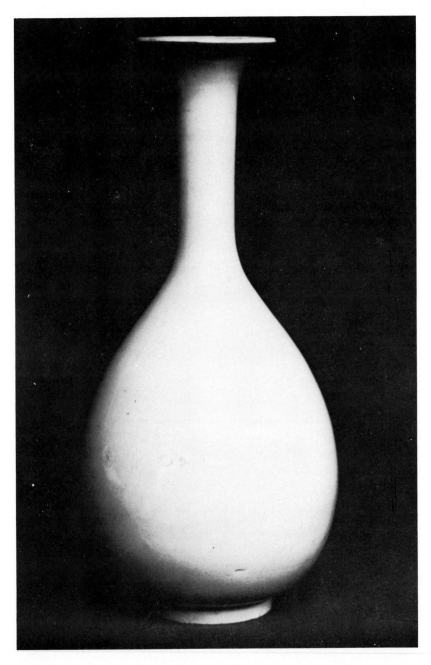

Figure 17. Oviform vase with tall tubular neck and spreading mouth. Sung Dynasty. Reproduced by courtesy of the Trustees of the British Museum.

Figure 18. Porcelain Bowl. Sung Dynasty. Crown Copyright. Victoria and Albert Museum, London.

terms of the overall composition, rather as words do, but without references.

Value terms belonging to this level refer to the end product of the work. They involve the total relationship of the work and not individual relationships. In this sense they are descriptive of the whole structure.

In identifying value terms which can describe a total structure, one which surely must be included is *harmony*. Harmony means that there is a symmetry between the various thematic elements of the work; that is, tensions or contrasts have been resolved. Works of art create interest because of contrast and tension; but the resolution of tension gives the impression of the harmony of the work; i.e., that the work is integrated.

Secondly, the structure of a work of art must exhibit *unity*. The unity of a work means that it is finished and complete as an entity. Unity is fundamentally the judgment of the intelligibility of the total structure in the sense that the work is not fragmented and there is a kind of propinquity of connection between the parts. That is, there is an integrity to the total structure which involves the integratedness of the parts. This is the kind of connection machines have; that is, the parts are integrated in such a way that each part functions with regard to

127

another as one gear meshes with the next. In this way, units are joined in a sequence and are related as opposed to a mere collection of unrelated parts, like disassembled clockworks in a bag.

There is another facet to organization on this level, the aspect of *wholeness*. A work of art is said to be whole because, among other things, it has, as a product, consistency; and this consistency is that which enables us to not only link one part of the work to another, but recognize an interrelatedness of *all* parts, so that one part of the work seems to require the other parts.

Wholeness involves the impression that the linking together of the parts is sufficient in and of itself and does not require anything exterior to the work of art for its completion. Wholeness implies the absence of external organization and a certain autonomy, a self law, a factor which points to the difference between unity and wholeness. Unity in a work of art means that there is not anything missing, that there is a completeness of the work; however, to judge that a work has nothing missing is not to judge it whole. For example, machines are units, but they are not wholes, because the kinds of connections between the parts is not one which implies necessity.

The wholeness of a work of art gives the impression that something *organic* in character is involved rather than something mechanical. To say that art works are organic is to suggest they seem to have a sense of life or vitality about them. In contrast, when it is said that a work is mechanical or a performance is criticized by being described as mechanical, what is meant is simply that it lacks that organic quality. To say that a work lacks organic quality means that the execution of the work is such that it impairs the kinds of close connection of all parts to each other which we call "wholeness." In other words, perceiving that a work is mechanical is perceiving that while it was unified, it lacked wholeness. Simply put, the notion of a work of art as organic is the perception that beyond the connection between units, each part of the work of art entails every other part in a way in which we would elsewhere characterize as inevitable. The characteristic of wholeness gives the impression of predictability in the work. Thus, the impression that works of art are organic is due to the fact that we conceive of them as whole and not merely as units, and the difference between a whole and a unit is a kind of inevitable, predictable internal mutuality of relationship which wholeness requires but which unity does not.

These levels of appreciation and their appropriate value terms may be utilized to differentiate between works of art and other things such as crafts or natural objects. *One can imagine that natural objects and certain primitive art forms are to be found at the material level. Crafts characteristically exhibit a combination of the virtues of both material and thematic levels, but do not exhibit the principles of organization. Fine works of art typically demonstrate the three levels of material, thematic and organizational principles. Works which are judged to be great in the profound sense of the term, structurally must possess all four levels.*

What this means is that those qualities which are present in great works of art are present to a lesser degree in a great many other objects. For the special purpose of evaluating works of art, what one does is to draw a line so that there is a reasonable domain. The line has been drawn here to include two things: (a) structural characteristics and (b) the object must be one of design or arrangement rather than natural objects.[6] Thus in determining the aesthetic value of works of art, the aim would be to establish to what degree they contain the particular characteristics discussed. At a certain point, where great works of art are concerned these characteristics will be present to a very high degree; whereas in the case of fine works of art they will be less extensive.

Of course, determining exactly where objects belong is not always easy, but the method by which such a distinction may be made can be illustrated. It is clear that the making of macrame is not an art, and similarly most pottery making does not partake of art. The one exception which is commonly admitted is that of Chinese Sung pottery which many people feel attains the level of fine art. These vases are not containers for plants or flower arrangements and it is thought that the design in these objects is one which transcends the usual level of craft.

In terms of the aesthetic system outlined above, it is possible to point out the differences between Chinese pottery and crafts more clearly. Crafts quite obviously exploit the material elements, often to brilliant effect. The clearest and most obvious examples of craft exploitation of the material elements is jewelry, and it could be argued that fine works of jewelry do have complexity or subtlety or richness. In other words, there is in the design of some jewelry the qualities for which those

[6]In Japanese aesthetics, this second criteria is omitted.

129

kinds of terms might be employed. On the other hand, the principles of organization in jewelry do not attain that intellectual level in structure which would make it reasonable to say that some piece of jewelry had economy, fecundity or elegance in our sense of the terms. What has been said of jewelry can also be said of most pottery with the exception of Sung pottery since this pottery does, in fact, exhibit principles of organization that transcend those of crafts. This assessment of Chinese pottery can be demonstrated with examples. Photographs of Sung pottery (Figure 19) show exquisite use of the materials. Even though Sung vases involve vividness and clarity of color, it is the combination of the subtlety of form and the reflection of light that is particularly striking. The interplay of rich vibrant color against simple form makes the work exceedingly subtle, and in certain respects rich, though not necessarily complex in the usual sense.[7] This leads to the notion that these works are truly elegant and economical but not fecund. On the level of totality of structure, they do appear to have harmony, but unity and wholeness seem to be alien to them. In short, the perfect simplicity of color and form is overwhelming, and most apparent in Chinese Sung pottery is a combination of elegance, richness and subtlety.

The implication of this theory is that the differentiation between levels of works of art is based upon the kind of qualities which they possess. These characteristics are hierarchical in in that some are primary and others secondary. Some are more important and others relatively less important. For example, one can imagine a work of art that has economy without the work's having totality in the sense of wholeness or harmony; however one could not have a work of art with harmony, wholeness or unity without the other characteristics being present as well. It is on this basis that we judge natural objects or crafts to be less valuable aesthetically than some other work which possesses more virtues on the level of totality of structure, e.g., a Michelangelo sculpture.

It is not suggested here that this is an exhaustive list of value terms, but it is an illustrative one. One can take virtually any other value term which might be suggested and show that in

[7]"Complexity" is generally used in referring to ornamental or decorative design. In the case of Sung pottery one has the impression of subtlety and richness and this is due to the complex connections; but these complexities involve such minute things that they are difficult to specify—the slight irregularities of the shape, the cracking and the depth of the glaze, etc.

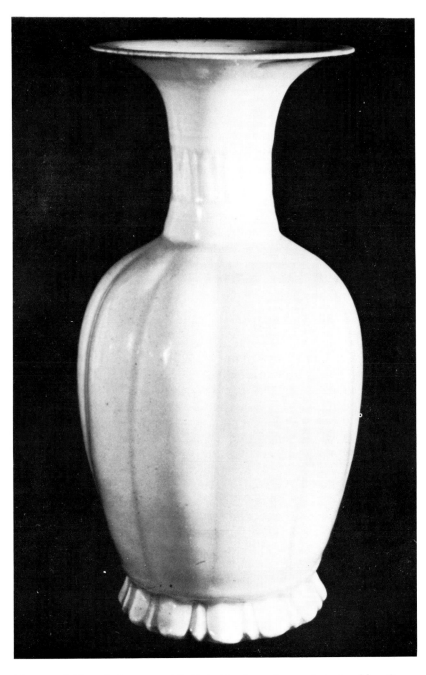

Figure 19. Porcelain vase with fluted body and rounded shoulder. Sung Dynasty. Reproduced by courtesy of the Trustees of the British Museum.

131

some way it connects as an expression of an interconnection between various value levels, or is redundant of a term already in the system. An example of redundance is the notion that a work of art has a "rightness" about it. "Rightness" is the perception of the close logical connection which in terms of our system is called "elegance." Another word that is frequently used regarding a work of art is the term "control," and to say that a work lacks "control" is adversely to criticize it. "Control" might mean one of several things; for example, it could mean that the artist understood the necessity of vividness, clarity and precision of the material, or it could mean that he or she mastered the logical organization necessary to realize the economy and elegance of the work of art.

We can show too, that other terms suggest possible interconnections between the levels, and such a word is "spontaneous" which is used to recommend performances as well as works themselves. It is obvious that in saying a performance is spontaneous we do not mean that it was improvised, but rather that the artist has arranged the elements of the work in such a way that repeated experience of the work remains fresh (going back elsewhere, we called this "inevitability," "infinite variety" or "inexhaustability"). By the term "spontaneous" we see a connection between the richness of the work, the fecundity of its organization and the wholeness of its composition. It is clear that there are closer and more logical connections between the terms than the terms which we have selected. Because of the vertical relationships as well as the horizontal ones, we are able to see connections which need not be stated explicitly and thereby reduce the number of entities that must be employed in doing aesthetics. Our system has "economy" and conversely is "fecund" because one can see these connections without the necessity of stating the terms.

Thus, it is evident that the terms on each of these levels are not only related laterally, but are connected with the terms of other levels in a distinctive way; and so we read the value chart both horizontally as well as vertically:

Thematic Elements:	Subtlety---Complexity---Richness
Organizational Principles:	Elegance---Economy---Fecundity
Totality of Structure:	Harmony---Unity---Wholeness

Thus there is a horizontal integration to the structure of this system as well as vertical integration. For example, "subtlety" occupies precisely that place among thematic elements as does

"elegance" in organization and which "harmony" occupies pertaining to the whole. Subtlety, elegance and harmony deal with the juxtaposition or the connection of elements as they are perceived. The relationship among these terms has to do with the detail of connection between elements. That is, the work contains a whole series of related elements which are the details; they are juxtaposed in such a way as to create an impression of subtlety because one perceives that they are harmoniously linked.

In the vertical series, "complexity," "economy," and "unity," tightness of connection is the common feature. Here one is dealing with reduction in the sense of applying rational principles to complexity so that it becomes economical, and those same rational techniques of analysis which make a work simultaneously economical and complex also make it unified. In the vertical pattern, "richness," "fecundity" and "wholeness" the commonality rests on the depth of connection. There are certain fundamental principles which enable a work to be whole; those same principles, or their equivalent, enable the work to be fecund and that is what causes it to seem to be rich.

Certain things are evident in looking at the aesthetic value system described in this chapter. The theory does not characterize works of art at all; that is, the theory neither implies nor requires that works of art make any statements that may be denominated either true or false, valuable or not valuable, profound or shallow. It does not require that the work of art be in any particular medium; one could not imagine that the theory could apply to poetry but not to sculpture, for example. It enables us to see why certain activities are probably not fine arts, or at least the objects resulting from such activities are not aesthetically significant. It gives us a method for distinguishing between mere crafts and the so-called fine arts; that is, there is a fundamental difference between the lack of organizational characteristics in crafts and the organizational characteristics which fine arts have. Also, it points out that the thing which distinguishes great art from merely fine art is the quality of total structure which ordinary works of fine arts do not possess. The implication of this, of course, is that many of the objects presented as fine arts are not materially different from crafts. A case in point is the Oldenburg sculpture in Chicago (Figure 20) in the shape of a baseball bat. One would be hard pressed to suggest that this object has economy, fecundity, or most especially, elegance of structure. Instead, it is a very primitive pattern akin to simpleminded decorative art.

133

Figure 20. Claes Oldenburg: Baseball Bat., Chicago Tribune Photograph.

Additionally, applicability of the value terms to all three areas of aesthetics may be seen. If one begins with the thesis of the tripartite division of aesthetics into creation, work of art and response, and to ensure consistency and adequacy one takes as a metarule the rule of symmetry that every statement that we make in aesthetics in any one of the three areas will have some corollary in the other two, then the value terms we have just outlined as being applicable to works of art will also be characteristic of creation and response as well. That is if artists were judging the process of encoding which originally led to the work of art, they would judge it to be significant in so far as it had precisely those characteristics. Persons decoding the work of art would judge their response to be more valuable than other experiences because through it they come to understand what experiences with those characteristics are like. Thus, there is a parallel series of values among the three areas of aesthetic investigation, exhibiting an additional symmetry which is built into the system.

Certainly it is not likely that a person speaking in terms of either creation or response will use "fecundity," "elegance" or "economy," but that is a function of customary modes of expression. It could be that one of the reasons people find certain experiences more valuable than others is that these experiences have the characteristic of "elegance." To put this in different language, the connections between things are much more sharply seen when the characteristic of elegance is present than they are at other times, and this sharpness of expression is considered valuable in and of itself.

The next task is an obvious and straightforward one. A workable set of value terms has been devised and we have an idea of the way in which works of art are created as well as what is entailed in response to a work of art. The task now is to evaluate works of art. We should, at this point, be able to determine without serious difficulty whether a work is or is not great, and to what degree greatness is involved. Here, a purely practical problem is introduced as opposed to a conceptual one: "How does one go about analyzing and evaluating works of art? It is to the specific application of the theory outlined in Part I that we now turn in Part II.

Figure 21. Table of Resemblances with Value Terms

	MUSIC	POETRY	PAINTING	VALUE TERMS
Primary Elements	pitch	voice pitch	(color)	vividness, preciseness, clarity
	amplitude	stress/unstress	hue	
	timbre	phoneme	value	
	duration	duration (length/shortness)	intensity, saturation	
		(image)	(space) configuration outline	
			(gesture)	
Thematic Elements and Development	rhythm	rhythm (a) stress (b) length	rhythm (a) variations of value (light and dark) (b) variations of contour and shape	subtlety, complexity, richness
	melody	patterns of intonations and pitch	hue variation and contrasts	
	orchestration	patterns of phonemes	saturation, intensity, harmonies	
		(image sequence)	(expressive configuration of gesture)	
Structural Forms	themes created by rhythmic contrasts plus melodic contrasts	themes created by structure of poetry against the structure of the language	themes created by variation of the two types of rhythm primarily but occasionally by color harmonies	elegance, economy, fecundity
Totality of the work	interrelationship of themes (themes relating to themes)	interrelationship of themes (themes relating to themes)	interrelationship of themes (themes relating to themes)	harmony, unity, wholeness
	totality of the composition	totality of the poem	totality of the painting	

PART II

Chapter Five

Analyzing and Evaluating
Specific Works of Art

In Part I it was said that the creation of a work of art involves encoding, while an aesthetic response to the work involves decoding. Decoding, however, presents some difficulties. First, how can one be sure that the decoding is successful? The word "successful" here does not mean "correct," and the question becomes one of how "adequate" and "comprehensive" is the decoding when compared to others? For example, does one theory leave unaccounted for portions of the work which another explains? In testing one's method, it simplifies matters to have a technical vocabulary which eliminates the ambiguity of terms and enables one to *explain* the connections in a work, and the development of such a vocabulary was a major concern of Part I.

A second impediment stems from the fact that no one lives in a vacuum and each of us apprehends works in terms of our own experience and, sometimes worse, in terms of our educational background. It should be kept in mind that what one thinks about art is usually less a product of experience than what one has been taught to think. This introduces what we shall call various false expectations about works of art and these fall into distinctive patterns. In technical terms, we can call them the "skewing" factors which, if we depend on things other than the work of art itself as a basis for our judgments, are distinctively characterizable and predictable. In I.A. Richards' *Practical Criticism* the author gives a list of such flaws demonstrating the profound importance of what one has been taught in terms of response. Thus, looking at a painting which we know to be a Rembrandt, is different from the experience of viewing a painting which we believe not to be a Rem-

brandt, because most of our responses to works of art are not based on decoding at all. We must constantly guard against this error as we turn now, in Part II, to analyzing and evaluating specific works of music, poetry and painting. In each case, works have been chosen which the author thinks are outstanding in their area since it would not be illustrative of the hierarchical value structure outlined here to do otherwise.

Sonata 32 in C Minor, Opus 111 by Beethoven

David Ewen, in *The Complete Book of Classical Music*, describes Beethoven's final sonatas, which include his Opus 111, in the following way:

> In his last five sonatas (Numbers twenty-eight through thirty-two) Beethoven strikes a new course for piano music. Here (as in his last string quartets) we encounter spiritual concepts and mysticism, probings into regions never before ventured into by music. Here, too, structure must give way and crumble before the hurricane of Beethoven's tempestuous moods.[1]

In a more specific reference to the *Sonata in C Minor,* which is the focus of interest here, Ewen writes:

> ... in the last sonata movement he was destined to write for the piano, Beethoven finds true serenity. This second (and concluding) movement is an Arietta with variations. These variations, says Romain Rolland, 'lap around it (the melody) tenderly, like waves caressing the sands on a beautiful calm day. The first variation gently stirs the rhythm of the theme. The second doubles the movement, and the third redoubles, and yet the peaceful calm is not disturbed. Into the coda steals one of those beautiful pensive movements in the minor key. This emerges into the return of the theme, scintillating with heavenly radiance. Thus, Beethoven closes his sonatas in a heavenly peace.'[2]

The analysis and evaluation of the Arietta which is the subject of this section will involve an examination of the theme and its variations and will attempt to determine if, as Ewen suggests, Beethoven's structure crumbles before his moods, or whether upon analysis a structure emerges which is so care-

[1]David Ewen, *The Complete Book of Classical Music*, Prentice Hall, Inc., Englewood Cliffs, New Jersey, 1965, p. 328.

[2]*Ibid*. p. 330.

fully constructed as to make message laden language such as "spiritual concepts and mysticism" or "scintillating with heavenly radiance" of very little value in dealing with the work.

In the musical form of theme and variations, the theme is usually written in what is referred to as "binary form," a type of construction traceable to the Baroque period. As the name suggests, this form consists of two sections, each of which is usually repeated. The theme of Beethoven's Arietta is put together in just this way; there is an "a" section and a "b" section, each containing eight measures and these sections are repeated to total the thirty-two measures which make up the theme.

The form of the overall construction of the Arietta follows in this thirty-two measure pattern, each variation sharing this pattern with the theme. Usually in variations on a theme, both the rhythm and the melody undergo changes differentiating them from the theme and from the other variations. Therefore, as the variations are analyzed they will be broken down into what is being varied from the point of view of rhythm as well as melody. From this we can determine not only how each variation compares with the original theme but also its connection to other variations. Since the five variations are a remolding and reshaping of the theme, the analysis of the Arietta will begin with an examination of the thirty-two measures of the theme in some detail.

Theme

Rhythm: The theme begins with 9/16 meter (9 16th notes to the measure). It is common to think of 9/16 time as 3 beats to the measure, with a division of each beat into 3 equal parts. In music this is called "compound meter signature" as opposed to "simple meter signature" where there are two parts to each beat:

Simple meter signature: undotted notes indicate the beat is divided into two parts.

Compound meter signature: dotted notes show the division

of the beat into three parts.

Beyond the division of compound meter signature, it is also possible to subdivide the beat, and Beethoven embellishes the Arietta in just this way. That is, in the theme, he uses 16th notes in dividing the beat and 32 notes in the subdivision. Characteristic of the variations is the breakdown of the beat into divisions and then into subdivisions.

beat (theme)

division of the beat
(Variation I)

subdivision of the beat
(Variations IV and V)

Melody

1-8 "A" Section: In typical binary form the "a" section should begin in tonic (the first chord) and modulate, or change key, to dominant (the fifth chord) just before the termination of the first part. The "b" section would begin in a dominant key and modulate back to the tonic key (T D:‖ D T:‖). Beethoven departs from this familiar pattern. He begins this "a" section in the key of C and instead of going to the dominant, (which in this case would be G) he goes to the relative minor, A. Thus, the unusual feature here is that in repeating the "a" section and taking the second ending, he modulates to the key of A minor since for typical binary form in the second ending he should be in the key of G.

Of particular interest is the introduction of a motive, here occuring as a CG interval (see circled notes in example below). This motive will be referred to hereafter as the "skip" motive because of the 4th interval between C down to G and the repetition of G.

Arietta.
Adagio molto semp

This nomenclature needs some explanation. In music the lines and the spaces are called "degrees." From one space to the next line, or from any one line to the next space, is called a *step.* Anytime more than a degree is passed over, the progression is referred to as a *skip.* In the case of this motive there is an interval of four degrees, thus creating a "skip."

9-16 "B" Section: A second significant motive is introduced, this time in the "b" section of the theme (see brackets in example below). This will be called the "step" motive since its identifying characteristic is the step down and a repetition of the same note:

143

In the beginning of the "b" section Beethoven goes to, or at least alludes to, the key of A minor, a key closely related to C. In the middle of the second phrase, he brings the listener back to the original tonic of C (measure 5 of the following example), locking in and establishing very soundly the key of C. At the end of the repeat he ends again with C. This completes the theme and the first variation begins:

It should be noted that both of the motives introduced in the theme, the "skip" and the "step" are related in that they are both characterized by a repetition. The difference between them being that in the first case there is skipping and then a repeat, while in the second there is just a step down and a repeat; nevertheless both motives are in a sense joined through the idea of repetition.

Variation I

18-32

Rhythm: This first variation is still in 9/16 time, but while the meter and the beat are the same, Beethoven begins, in part of the accompaniment, to break down the beat. One still hears the three beats, as were heard in the theme, but in the variations the division of the beat appears three parts to one beat. The tendency of breaking down the beat was foreshadowed in the theme; for example, on beat three in measures four, six and seven of the "a" section of the theme where two notes indicate that division of the beat into three parts. This tendency is constant throughout the remainder of the movement; that is, with each succeeding variation the measures will become busier and busier due to the breaking down of the time into the underlying division and subdivision. Another characteristic of this variation is tied notes in the accompaniment.

144

Melody: In dealing with the "a" section of the theme, reference was made to the "skipping" characteristic of the motive introduced in that section. In this particular variation Beethoven uses the idea of skips more extensively as can be seen in the bracketed sections of the first measures. The "skip" motive can be detected in the "pick up"[3] but it is not in the CG pattern as it was in the theme.

While rhythm is different from that of the theme, and notes occur at a different place in the beat because of the change of rhythm, many of the notes of the theme still occur in the measure (see circled notes). In fact, the pitches in this first variation match almost measure for measure with those of the theme, although in this case they have been displaced. Typical of variation form, as the variations develop, the measures become so embellished that it becomes increasingly difficult to find these original notes either visually or auditorily.

Most noteworthy is the fact that despite the change in rhythm and rearrangement of the notes of the melody, two constant elements remain. They are found in the fifth and seventh measures. That is, there are two patterns found here that are identical to those of the theme. In the fifth measure there appears a pattern of notes, CEG which matches the fifth measure of the "a" section of the theme, and in the seventh measure, BCD, a pattern which also occupies the same spot as in the theme.

Variation I
fifth measure

Theme
fifth measure

seventh measure

seventh measure

[3]A pick up is an incomplete measure and is not used in counting measures, since one counts from the first measure which has the complete time.

145

In the second section of the first variation, although not in the same place as in the theme, there is a recurrence of the "step" motive which was introduced in the second part of the theme. Although the same notes do not appear, this pattern does have the same melodic feature of being down a step and a repetition of the same note.

Because the motive does not occur on the same pitches here, it is said to have been "transposed," and an additional device has been added in the form of a "sequence." This means that after stating the motive in its transposed state Beethoven uses the last note to overlap another motive and then repeats this procedure to form a sequence. Then the composer inverts the motive so that instead of stepping down, the direction is a step up and a repetition. Following the inversion he develops the idea of repetition even further by repeating other notes continuing through the next measure.

Variation II

33-48

Rhythm: In comparing this variation rhythmically to the preceding one, it is apparent that the time signature has changed to 6/16. Whereas in Variation I the main idea in the accompaniment was a break down of three beats to its underlying three component parts, here, each of the original components is divided in half alluding to simple meter, or the beat into two. This idea occurs first alone in the left hand, then in the right hand and sometimes together.

146

Melody: In the first, or "a" section, the melody begins with the same "skip" motive of the CG interval (see above); however here it occurs in the bass. Again the fifth measure with its CEG pattern and the seventh measure with its BCD pattern can be matched with those of the theme:

fifth measure

seventh measure

In the second part of this Variation II, we find the "step" motive that occured initially in the "b" section of the theme. Again, as in Variation I, there is an inversion of the motive with a sequence following it. First the motive is announced followed by a sequence in which the composer repeats the motive several times in lower steps; he then repeats the last two notes ascending the staff. Here, there is a connection to the theme in the step and repetition, and a link to Variation I in the idea of transposing notes in sequence and then ascending the staff in the other direction:

Variation III

49-64

Rhythm: Although the time signature changes to 12/32, the division of the beat remains the same. There is a feeling of acceleration, the piece has become stronger and more intensified due to smaller rhythm values. There is, however, a link to Variation II in that both have notes that are tied.

Melody: This variation is formed around a new idea; that of arpeggiation. By arpeggiation is meant a broken chord. In this instance, the composer takes a C-chord (CEG) and instead of playing it simultaneously, he breaks up the notes, playing each tone one at a time melodically. This arpeggiated melody begins in the right hand, passes to the left and then returns to the right hand, forming a dialogue between the hands. The arpeggiation continues for almost the entire variation and this innovation sets Variation III apart from the others in a melodic way. This device also serves to link this variation with the theme since the idea of a skip is being employed. Another reflection of the theme is the CG interval with which this variation begins, and there are similarities with the first measure of the theme in terms of pitch. Also, tying the "a" section of the variation to the first section of the theme are their fifth measures, patterns of CEG notes and seventh measures with BCD notes:

fifth measure

seventh measure

In the beginning of the second part of Variation III is the "step" motive, but so concealed that it is difficult to discover:

Variation IV

69-95

The form of this variation is somewhat different in that the eight bar repeat pattern we saw before does not appear; instead the composer writes out the complete thirty-two measures.

Rhythm: This variation returns to the original time signature of the theme, 9/16. It will be remembered that Variation I continues the time of the theme, but the time is altered in both Variations II and III. Beethoven returns to the time with which he began. There are not only the three beats in three parts; but the parts, or division, in turn are subdivided into triplets. So, rhythmically this variation is much more complex.

Melody: Variation IV is embellished to the point that the original theme is almost imperceptible; however, close scrutiny reveals some measures which match those of the theme. The variation begins with the C to G skip motive, and the second measure of the "a" part melodically employs some G notes. This is also the case with the "a" section of the theme. Further, the third measure here has G to E and this matches the third measure of the first strain of the theme. In the fifth measure of this "a" section, the CEG pattern recurs and in the seventh measure of this section the BCD pattern is also apparent. However, in this variation, Beethoven does not simply repeat the "a" section as has been his practice before; instead, he writes out the measures and includes still another way of presenting these CEG and BCD patterns in the fifth and seventh.

fifth measure

seventh measure

150

In the first and second measures of the "b" section the "step" motive can be found. In this instance, the step appears in the CBB pattern as on previous occasions. But, one should remember that this is not invariable, since the composer transposes the "step" in Variation I.

There is another link to the theme in the second measure of the "b" portion and that is the pattern B to E, which reflects the second measure of the "b" section of the theme.

While it is possible to detect traces of the theme, there is a great deal of embellishment and in Variation IV this tendency becomes more and more pronounced. In the original statement, every note was integral, but as the movement develops into the variations one finds one, two or sometimes three notes between the notes of the theme. Perhaps only one note of the theme occurs in a measure, the rest all being embellishment.

Variation IV has a Coda followed by an Interlude into a change of key. Beginning in the Coda's measures 103, 104 and 105, an arpeggiation begins which links this section to Variation III in which the arpeggiation appears in every measure.

In the Interlude between Variation IV and V, both the "skip" and the "step" motives appear.

Additionally, previous pitch patterns occur but in a less structured way than before. This should not be surprising since this section is an interlude, almost like a transition or a development; therefore, it will not follow previous patterns. For exam-

ple, remembering that we have moved out of the key of C and into a different key, E flat, in the fourth measure a pattern is found that is equivalent to the CEG pattern in the key of C. The pattern E flat, GB flat is the same relationship but expressed in different notes since a different key is used. The composer then changes back to the original key, so by the time the BCD pattern in the seventh measure is reached, he is back in the original key.

Variation V

130/131

Rhythm: The time signature continues to be 9/16, the time with which the original theme opens. Also, Beethoven is continuing the same kind of style in the left hand here in that he uses the same kind of triplet subdivision that was used in Variation IV.

Here, Beethoven does not provide an extra eight measures in the "a" section but goes directly to the "b" part. The form of Variation V is eight without repeats instead of eight with repeats.

Melody: This final variation begins with the "skip" motive, the CG interval, which first appeared in the "a" section of the theme and which has become so familiar throughout the variations. The theme is very much intact here but this has not been the case since the original statement of the theme. All the notes of the melody occur in their correct places without other notes being interposed. However, even though Variation V is like the theme melodically, there is an important difference. While the melody is being played with the right hand, there is very heavy embellishment with the left. The middle voice and the bass are much busier because of the division and the subdivision of the beat. The result is that this variation is extremely ornamental, to the degree that it surpasses all the other variations in this respect. That this is the most elaborate variation is not in itself surprising or unexpected. Usually, the final variation of a work is the most highly developed since it is the concluding portion.

Again, in the fifth measure we find the CEG pattern and in the seventh, the BCD pattern reappears (see circled notes above). Also, at the end of the "a" section and the beginning of the "b" section the "step" motive is visible.

The Epilogue begins at measure 147 and continues to 161, followed by the final statement of the theme which runs from 161-169. In this last presentation of the theme, the original melody recurs, but here it is placed underneath or over the trills which continue all the way to the end. Within this section are contained both the CEG and BCD patterns.

In measure 172 there are runs as there were in what would have been the repeats of Variation IV so at this point there is an allusion to that variation.

In the Epilogue, Beethoven has begun to compress from thirty-two measures to sixteen; and when he arrives at the ending of the piece he compresses even more. In the last three measures he repeats both of the original motives, the "skip" and the "step" (see brackets in example below). With this summation the work comes full circle, back to the "a" and "b" sections of the original theme compressed to the final measures of the piece.

In applying value terms to the Arietta, we see that Beethoven establishes very quickly a small vocabulary of fundamentally

related patterns which are then combined in different ways to form the theme. The *manner* in which these elements are structured into the theme and then expanded to form the rest of the piece is now the focus of interest. One example of the complexity of the theme is the CEG pattern, a melody which is an arpeggiation of the C harmony. Subtlety is demonstrated in the way the "skip" and "step" motives are related through the use of repetition, although they are two different melodic elements. Also subtle is the break down of the rhythm which is barely alluded to in the theme. What one finds in this first portion of the Arietta are numerous elements which will be used over and over again. This potential for development makes the theme rich.

The organizing principles by which the theme is related to its variations also can be evaluated. The theme and its variations are economically related by the few primary assumptions that bring them together, such as the "skip" and "step" motives, and the CEG and BCD patterns found first in the theme and then in each of the variations. The nature of this last connection has, in addition, a certain elegance in that these patterns are consistently found in the fifth and seventh measures throughout the variations. It is true that in the Interlude between the Variations IV and V, the CEG pattern is changed, because of the key change, but the essential relationship remains unchanged. This last example becomes an illustration of fecundity, giving the impression of the myriad possibilities that can be produced from a few primary terms. There are other examples of fecundity as well, such as the inversions and sequences of the motive, transposed motives, and the dividing of the rhythm into divisions in Variation I and subdivisions in Variations IV and V.

The piece can also be assessed as an entity. Harmony, i.e., balance or symmetry, is displayed in the binary form, the two parts of which are usually repeated. Unity is achieved by the fact of linking each variation with its immediate predecessor, although there is a variety of linkages. For example, Variation II is related to Variation I by the inversions of the "step" motive and the sequence, Variation III is related to Variation II by notes that are tied in the same manner. Variation IV is related to Variation III by the arpeggiation of the Coda. Variation V is related to Variation IV by runs. Finally, wholeness results when all the parts are interrelated, and one is able to predict the way in which the work will develop. Factors contributing to the wholeness of the Arietta are: (1) constancy of the harmony throughout (2) the reappearance of the CEG and BCD

patterns in the fifth and seventh measures in the theme and its five variations (3) the "skip" and "step" motives remain evident in the theme, the five variations and the epilogue and the ending. (4) The rhythm moves from three original beats to division, then to subdivision, with the embellishment becoming so elaborate that the composer needs something to hold melody and rhythm together. Therefore, in the fifth and seventh measures the melody is played *on the beat* as was done in the original theme. The melody is not kept on its original beat in other measures, but it is maintained in these particular measures. (5) All the variations are a reworking of the theme and in the final measures he compresses the motives of the theme.

Musee Des Beaux Arts by W. H. Auden

Before a poem can be analyzed it must be read, preferably aloud, not with any attempt to decipher meaning, but simply for the purpose of hearing the sounds themselves. When reading, attention should be paid to the fact that the function of a line in poetry is to serve as a key to what the tempo should be. For example, upon examination of Auden's poem, *Musee Des Beaux Arts*, certain things are immediately apparent; for example, one line is exceedingly short, "They never forgot," while others are exceedingly long, as the line, "While someone else is eating or opening a window or just walking dully along." It is clear that this long sentence has a beat where there are relatively few accented syllables and an abundance of unaccented syllables. On the other hand, the line "They never forgot" will be heavily accented. Despite the difference, both lines will be read at approximately the same tempo. In this respect, lines in poems function as do bars in music.

For ease of reference we have numbered the lines in the following text of *Musee des Beaux Arts:*

1. About suffering they were never wrong,
2. The Old Masters; how well they understood
3. Its human position; how it takes place
4. While someone else is eating or opening a
 window or just walking dully along;
5. How, when the aged are reverently, passionately
 waiting
6. For the miraculous birth, there always must be
7. Children who did not specially want it to happen,
 skating
8. On a pond at the edge of the wood:

157

9. They never forgot
10. That even the dreadful martyrdom must run its course
11. Anyhow in a corner, some untidy spot
12. Where the dogs go on with their doggy life and the torturer's horse
13. Scratches its innocent behind on a tree
14. In Brueghel's Icarus, for instance: how everything turns away
15. Quite leisurely from the disaster; the ploughman may
16. Have heard the splash, the forsaken cry,
17. But for him it was not an important failure; the sun shone
18. As it had to on the white legs disappearing into the green
19. Water; and the expensive delicate ship that must have seen
20. Something amazing, a boy falling out of the sky,
21. Had somehwere to get to and sailed calmly on.

It was pointed out in the section on poetry, that thematic development in poetry is comprised fundamentally of a coordination of three elements; (a) rhythm patterns, (b) sound patterns, and (c) image sequences. An understanding of *Musee Des Beaux Arts* will involve an appreciation of the ways these elements function in the poem.

Rhythmic themes in the Auden poem are especially interesting. For example, the completion of some strophes extends for one and a half lines so that expressions like "The Old Masters," "Its human position," "the miraculous birth," "They never forgot" and "Water" are set off in a curious way. Because of the way Auden breaks the line these images occur at an unusual position in the "melody" of the line and thus become noteworthy. If one were speaking musically, it could be said that the images cross "bars," and that a syncopation occurs as a result. Another interesting use of meter is to be found at the end of line 7 with the surprising choice of the word "skating." It is surprising because one would expect the line to end with " . . . want it to happen." However, because "skating" is at the end of the line, like an afterthought, it possesses almost a kind of glimmer of light which illuminates "their not wanting it to happen," and this is accomplished metrically.

Throughout the poem, Auden uses meter in a musical way. Sometimes a break in the middle of a line indicates a pause similar to a rest in music. This occurs in line 2 after "Old Masters" and also in line 3 after "human position." On the other hand, in line 5 after "reverently, passionately waiting" there is

158

no rest indicated and similarly "skating" in line 7 does not indicate a rest but rather implies, in musical terms, an "accelerando." Lines 7 and 8 are to be read very fast, "Children who did not specially want it to happen, skating / On a pond at the edge of the wood." This fast tempo is to prepare the reader for the very slow, "They never forgot" in line 9 and the continued slowness of line 10, "That even the dreadful martyrdom must run its course."

In addition to these rhythmic devices there are also phonetic patterns of significance. In lines 1-13 "o" sounds are particularly common: "wrong," "old," "how," "someone," "opening," "window," "who," "not," "wood," "forgot," "martyrdom," "course," "corner," "some," "spot," "dogs," "go," On," "doggy," "torturer's," "horse," and "innocent." With "innocent" is introduced the "i" sound which becomes dominant in the last section of the poem. It should be noted that although there is an overlap of "o" and "i" sounds, the sharp "Icarus" marks a dividing line separating the poem into two sections as far as sound is concerned. In charting the "i" sounds we see, "In," "Icarus," "instance," "thing," "it," "important." Then there is a move to the diphthongs, "ai," and "ei" with "leisurely" and "failure," then back to the "i" sound in "it," "disappearing," "into," "delicate," and "ship." Finally in the last two lines of the poem, 20 and 21, there is a remarkable reoccurrence of the "o" sound. "Something amazing, a boy falling out of the sky, / Had somewhere to get to and sailed calmly on." The use of the phonemes here is like an orchestration in which there is a certain pattern of orchestration for a long period in a musical composition, then suddenly a sharp change in the pattern of orchestration, then a recurrence of the original pattern.

Although the "o" and "i" sounds are the dominant sounds in the two parts of the poem there are other patterns as well. For example, there is an abundance of "l," "f," "p" and "m" sounds in the first part. These sounds do occur in the second part but by and large there is a larger number of "s" sounds in the second part, "disaster," "splash," "forsaken," "sun," "shone," "ship," "something" and "sky."

Internal assonances are also used effectively to underline or give emphasis to certain expressions. For example, the combination of "sun shone / . . . on" in lines 17 and 18 is surely an important combination of sounds. Due to the internal assonance, "As it had to" of line 18 stands out. The same technique occurs in line 21, where the internal assonance of "sailed calmly on" gives emphasis. Similarly, in line 4 the "ing" assonance

in "eating," "opening," and "walking" underlines their semantic equivalence.

The question one must ultimately come to is, "What is this poem about?" In other words, "What is the image sequence of the poem?" The image sequence of the poem will be different than the message of the poem if one were to prepare a prose paraphrase of the poem. The following summary could be written to set forth what the Auden poem is saying; that is, what might be construed as its "idea."

> Auden theorizes that the attitude toward suffering which is incorporated into the works of the Old Masters is correct, insofar as they showed pain and suffering in an ordinary and indifferent human condition. Auden agrees that this is in fact the position of human suffering in the world, and one can see this exemplified in a particular fashion in Brueghel's painting where the suffering of Icarus as he plunges into the water is ignored by the indifferent ploughman, sun and ship's captain.

If one were to contend that the poem was an argument or philosophical position the precis would serve as a summary of it, but surely seen as a philosophical argument the poem has no merit. It is not even especially interesting, and like all poetry reduced to philosophy, it is naive, simple and crude. The idea that poems demonstrate profound philosophies is plausible only if one does not know profound philosophies, and whenever we try to reduce a poem to a philosophy the poem is trivilized. While a poem might identify a problem which is conceivably philosophical, the poem itself is certainly not philosophically profound and its value cannot lie there. For example, if two works on the subject of suicide are compared, the "To be or not to be" soliloquy in *Hamlet* and *The Myth of Sisyphus* by Camus, both being presumably about suicide, one would assume that one or the other of these writings is better with regard to the way in which that particular problem is handled. Camus takes the view that suicide is the basic philosophical issue, a view which he proceeds to examine. His arguments would have to be compared with how Hamlet's question, "When he himself might his quietus make / with a bare bodkin? who would fardels bear, . . ." enriches the philosophical understanding of that issue. The answer is that it does not. It is scarcely intelligible. This leads us to the position that poetry is not based upon the analysis of argument, the analysis of an idea, or for that matter, the elaboration of an idea. It is not based upon argument and counter argument the way philosophies are. In that respect, it

is quite different. Although poetry may express an attitudenal framework, that attitude should not be construed as a position.

When one deals with a poem, one must deal with explications of the images, but it is clear now that explicating the images of a poem is *not* the same as saying what its concept entails. Explicating the images deals with the evocativeness of the images, and some images are more obscure than others. For example, in the Auden poem, some of the images are quite clear and the reader has no difficulty picturing what is involved: "Children . . . skating / On a pond at the edge of the wood," or " . . . someone else . . . eating or opening a window or just walking dully along" or "Where the dogs go on with their doggy life and the torturer's horse / Scratches its innocent behind on a tree." These are common images in that they are part of ordinary human experience and need no special explication. However, while these images reflect usual events they are in fact learned. They are learned in that they are derived from particular paintings.[4] This means that the full explication of the poem would involve recalling these paintings in which these instances occur, but it is not necessary to know what the instances are in order to grasp the image.

Later in the poem Auden writes, "Brueghel's Icarus for example" and there he does cite a particular painting. Although it is not necessary to know the painting itself one must be familiar with the Icarus legend to know the significance of the image. The poem is perfectly intelligible without reference to the painting if one knows the story of Icarus. Thus, the painting of Icarus stands in relation to the poem in the same way "someone else is eating or opening a window or just walking dully along" or "Children . . . skating / On a pond," are related to the poem. Knowing them, one can grasp quite clearly the image sequences of the poem without seeing that they are referential.

After the reference to Icarus the other images described are in that particular Brueghel painting. For example, if we were to look at Brueghel's *Icarus* we would see the ploughman, the sun, the white legs disappearing into the ocean and the ship sailing calmly on. But seeing the painting will not improve the poem because the poem is in fact complete. Brueghel's *Icarus* is really mentioned not just for the painting but also so that

[4]For example, "Children . . . skating / On a pond at the edge of the wood" is from Brueghel's *The Numbering of the People of Bethleham*, while "the torturer's horse / Scratches its innocent behind on a tree" is reminiscent of his *Massacre of the Innocents.*

161

one can grasp the Icarus legend which explicates the poet's attitude toward suffering.

While it is true that one need not explicate the full implications of the images in an intellectual way to appreciate the poem, it is necessary to know the Icarus legend. If one were unfamiliar with the mythology, lines like "But for him it was not an important failure" would make no sense. The Icarus legend, it is fair to say, is part of the shared experience of Western culture. For this reason we would not say the poem is obscure as one might say of the last part of T.S. Eliot's *Wasteland* or Ezra Pound's *Hugh Swelyn Mauberly,* poems which even in their own day were usually not understood.

Poets make use of a wide range of experiences, some more intellectual in character than others, but this does not mean that a poem is necessarily incomplete. It does mean, however, that the more learned the images are the more likely the reader must share the experiences of the people of a particular culture. For example, Japanese poet Basho's haiku, "Scent of chrysanthemums— / And In Nara all the many / Ancient Buddhas" requires a good deal of explication for Westerners.[5] The fact that much of poetry is to some degree dependent on the shared experiences of a certain culture makes it difficult to assess ancient poetry.

In applying the nine value terms which have been previously delineated to Auden's poem, one should keep in mind that for the first level terms, i.e., subtlety, complexity, and richness, a specific element will not belong exclusively to any of these. Rather, it is the way in which the elements work together that produces these values. In order to demonstrate this first level of values, one wants to show that the function of meter and the choice of sound combinations enhances and enriches the image sequence.

Subtlety exists where the relationships to which the work calls our attention are not the obvious ones. An example might

[5]Although the translation does not capture the phonetic effectiveness of the original poem, it does reflect a certain attitude. As in most haikus, the poem involves the juxtaposition of two images which in direct terms, have no connection. The ancient Buddhas of Nara refer to the capital of Japan in the Heian period, which in Basho's day would have been 900 years earlier. The image of these ancient Buddhas with their paint gradually fading and flaking from the wooden sculptures coupled with the other image in the poem, the musky odor of chrysanthemums, bring to mind a common connection in Japanese terms, that connection is the term *sabi*. *Sabi* designates the peculiar kind of beauty in the West referred to as "patina," that is, an appreciation for the old and faded.

be the fact that "miraculous birth" and "Children who did not specially want it to happen" are images in the first part of the poem which can be compared with two images in the second part, "Something amazing, a boy falling out of the sky" and "Had somewhere to get to and sailed calmly on." The connections are these: "Miraculous birth" and "Something amazing, a boy falling out of the sky" are comparable in that both are images of an extraordinary happening, while "Children who did not specially want it to happen" and "Had somewhere to get to and sailed calmly on" are images of indifference.

The distinction that is being made between the characteristics of subtlety and complexity is that subtlety is the quality of the interrelationships of the nuances involved whereas, in complexity the focus is upon intricacy of relationships as, for example, in the technique mentioned earlier where the concluding part of an image sequence is at the first position in the next line such as "The Old Masters," "Its human position," "They never forgot," and "Water." Moreover, in the case of "They never forgot" it is the climactic. There is a parallel case of this kind of complexity in T.S. Eliot's *Burnt Norton*, "Words after music reach / Into the silence." Poets regularly use this device but in the Eliot and Auden poems it is used with particular clarity, especially in Auden's use of "Water." On the other hand, there are examples where this device is used frivolously as in Hopkin's poem *The Windhover*, "I caught this morning morning's minion, King / dom of . . ."

The richness of Auden's poem is demonstrated by the overlapping sounds and rhythms. The sound patterns overlap the rhythm patterns which overlap the image patterns.

In considering the second group of terms, economy, fecundity and elegance, the first two are closely related in that the poem will possess fecundity if economy is present. The economy of the Auden poem consists in the fact that this poem is basically triadic. There are three images in the first part and three images in the second, and they are parallel. This triadic arrangement forms the basic economy. Specifically, there is a ploughman who heard a splash, the sun shining, and the ship. Thus, in the second part of the poem there are the three images of the ship, the man, and the sun. These images have their corresponding parts in the first section. The sun is like the dogs and their untidy lives or the horse scratching its innocent behind, both natural events that go on anyway. The ploughman for whom "it was not an important failure," is in many respects as commonplace as someone eating, opening a window or just walking dully along.

163

The ship and the children are comparable in that just as the purposes of the children conflict with the purposes of the aged, so too, the purposes of the ship and the failure of that miraculous thing do not relate to each other. So, even though amazing, like the miraculous birth, Icarus' fall means nothing, it is of no consequence. Thus a symmetry which is part of the economy is revealed. That is, everything is reducible to the symmetry which is not immediately evident, but which is nevertheless part of the fundamental structure. Fecundity consists in the development of the poem from that fundamental symmetry.

We have suggested that of all the properties elegance is perhaps most difficult to define but fairly easy to recognize. This poem would not be characterized as one that is particularly noteworthy for its elegance, but one might say that some elegance is present in how strikingly appropriate is the use of Brueghel's *Icarus*. Elegance is exhibited in a work when there is a sudden unexpected turn in the work which connects in a brilliant fashion relationships which were seemingly discrete; and the most striking example of elegance regardless of media, with which I am familiar, will be demonstrated in the painting *Six Persimmons* by Mu Ch'i where the stems are used so effectively to balance the work.

The overall value relationships are harmony, unity and wholeness. If we say that harmony results when tensions are resolved, we can demonstrate this in *Musee Des Beaux Arts* by showing that Auden balances in an interesting way the images that are created. For example, he creates a series of images, "suffering," "wrong," "human position," " reverently passionately, waiting," "miraculous birth," constitute one sequence of images. Then there is another sequence, "eating," "opening a window," "walking dully along," "did not specially want it to happen, ""skating," "corner," "untidy spot," "dogs," "doggy life", "torturer's horse," "innocent behind," "tree." These image sequences present the interplay of serious, grave images against light trivial ones. A test for unity involves the completeness of the work and here unity is illustrated in the way in which the images are continuously linked together. Unity in *Musee Des Beaux Arts* is created in the way the same kind of relationship that links two images from part one, "miraculous birth," and "Children who did not specially want it to happen," draws together two images from the second part, "Something amazing, a boy falling out of the sky," and "Had somewhere to get to and sailed calmly on." In each section, the coupling is of an extraordinary event image with an image of indifference. This gives

rise to the wholeness of the poem in so far as the linkages are predictable. Whereas unity involves the idea of consistency of approach or consistency in the application of a principle, wholeness involves the idea that the work of art has some sort of intrinsic destiny or inevitability about it. That is, wholeness results from the sense of predictability one has that those threads will connect the parts of the poem as an organic whole.

The point is that we can construct "the plain sense" of the poem to use the words of I.A. Richards without ever looking for ideas, messages or ideologies at all. One sees what the poem is without reference to "philosophical" positions such as "the indifference of nature" or how the Old Masters understood that suffering is not important to others. Stated independently, such philosophical positions are not interesting. If true they add nothing, and if false, detract not a bit from the value of the poem.

Six Persimmons by Mu Ch'i

Six Persimmons is a famous Chinese painting done in the 13th Century by the monk Mu Ch'i. It is done in blue-black India ink on paper and there is a very light colored wash in one corner of the painting. Paintings of this type will be destroyed if they are exposed to light over any length of time, so as a result, *Six Persimmons* is shown once a year only on a special occasion, and a viewer must be at the temple in Kyoto where it is kept in order to see it.

Six Persimmons has been thought to be, by consensus of Chinese and Japanese scholars, one of the very greatest of Chinese paintings. However, this statement usually elicits a certain humor from a Westerner because of the extreme simplicity of the work. The Chinese say it is fine because of the absolute concentration the painting exhibits, and the Japanese say it is the absolute intensity of feeling in the context of controlled expression that makes it so remarkable. Though Westerners generally have trouble agreeing with either view, the oriental interpretations make sense if a person is partial to what is called the charm of the Zen Buddhist philosophy because this painting is a religious painting, though one would not normally think that in looking at it.

In addition to not being burdened with the content a Buddhist sees in the painting, there is another advantage of working with this painting for purposes of analysis and evaluation. There are so few objects in the work that we cannot overlook

anything since each object is so functional. This is in contrast with Western paintings in which there is usually such a plethora of objects that it is difficult to determine which ones are more important and which are relatively unimportant. Fundamentally, the Mu Ch'i consists of six circular forms on a piece of paper, and indeed, if this were a contemporary Western work, "Six Objects" might well be its title. However, while Westerners, when first introduced to the painting, are perplexed and tend not to regard it as a serious work, further examination reveals that the artist has put shapes together in such a way as to create a painting that is interesting and complex despite its apparent simplicity.

In establishing the "tonic" of the painting, we notice immediately that the vertical axis of the painting is the geometric axis; that is, things are arrayed proportionally along the verticality of the painting. The horizontal axis is obviously somewhat lower than the geometric axis and will go somewhere through the various persimmon shapes. In this respect, the axial organization in the Mu Ch'i is distinctly Western rather than Chinese, that is, the horizontal axis is important while the diagonal is neutral in that nothing is arrayed along it. This is rare in Chinese paintings, which like Baroque painting in the West, tend to make the diagonal axes functional.

The persimmon shapes in the Mu Ch'i are grouped along the horizontal axis in certain ways with regard to the three kinds of contrasts previously mentioned. That is, the persimmons will differ from each other with respect to certain common standards; (a) they differ by their location to the intersection of the axes (b) they differ in terms of the average size of objects, and (c) they differ from each other in terms of darkness, i.e., whether they are dark or light with respect to the background. As a result of these contrasts, tensions result that are not unlike the tensions which are created in poetry and music where contrasts of elements are made up with regard to some constant standard.

These contrasts and their resulting tensions are the focus of our aesthetic analysis. Previously we defined "movement," or rhythm, in painting as uniformity of relationships with regard to contrast, and we pointed out that tension is created by a sequence of comparable elements. Keeping this in mind, we shall now be able to plot the movement in a painting. For example, if there is a sequence of objects arranged by size in a certain order, we can say there is movement from the smallest to largest. If they are arranged by color, we can say there is move-

ment in this case from the lightest to the darkest, and when they are arrayed in the scene itself, in terms of the axes of the work, we can say that there is movement from the one nearest the center to that object farthest from the center.[6] While these sequences designate movement, we may define "directionality" in a painting as the predominant movement in the painting with respect to any identifiable group. We shall now proceed to chart the directionality to determine how this work is to be "read."

In order to show the way the *Six Persimmons* creates tensions that lead to movement and directionality, for the sake of convenience, we shall number the persimmons, beginning with the persimmon shape on the extreme right as #1, next #2, and so on until the persimmon at the extreme left will be #6. If we examine each group of three persimmons in terms of the three possible contrasts, that is, from the point of view of the location of the persimmon, the size of the persimmon and the darkness of the persimmon, the way in which they are rhythmically organized becomes apparent. Looking at the persimmons, one can determine from their arrangement that any three persimmons constitute a theme. The task now becomes to examine the manner in which the themes are put together.

Series One: Persimmons #1, #2 and #3

Location: In terms of location, the more distant an object is from the point of reference, the higher degree of tension that is created. Therefore, persimmon #1 is higher in tension while persimmon #2 is next closest to the point of intersection and is less tense. Persimmon #3 happens to be virtually at the center and is least tense. Since the object that is least tense is the beginning of the movement, in this case the movement is from the center of the painting outward to the margin.

Size: In terms of size, the greater the size the greater the tension, and in this group the greatest amount of tension is found in #3 then #2 and finally #1. Again, since the object that

[6]The rules of tension involving location, size and shading were first discussed in Chapter III. These rules are arrived at apriori. If one took the reverse hypothesis (the less the tension the farther an object is from a point of reference, the larger an object is the less tension results, the darker an object in contrast to the background the less tense), as long as one does it consistently there will be no practical difference in the analysis of the painting in that the mirror image of the painting will result.

is least tense is the beginning of the movement, the movement here is from the smallest persimmon at the margin to the largest persimmon in the center.

Shading: (contrast to background) In terms of darkness, it is #3 which is most tense, #2 is next, and #1 is least tense. Therefore, if we look at the color or darkness of the persimmons, the movement can be traced from the very light persimmon #1 to the very intensely dark persimmon #3.

We have said that the directionality of the work can be defined as the dominant pattern of tension which develops in the work, therefore, if we observe the most frequently occurring movements in this first series of persimmons we can determine the directionality.

Location	(most tense)	1 2 3	(least tense)
Size		3 2 1	
Darkness		3 2 1	
Flow of Movement		3 2 1	

In examining the tension chart above, it is evident that persimmon #3 most frequently has the highest tension level. Persimmon#1 occurs most often in the "least tense" column. Persimmon #2 consistently occupies a middle position with respect to tension. Therefore, the flow of movement in this first series proceeds from right to left. (For clarification as to how this is applied to the painting itself, see Figure 22.)

Series Two: Persimmons #2, #3 and #4

Location: It is apparent that #3 is closest to the center and therefore the least tense. There may be some question as to which shape is, in terms of a common point, farthest away, but the choice here is that #4 shape is next tense and #2 is most tense. On our graph, in terms of movement, this reading will produce a loop.

Size: In terms of size, there is no ambiguity so that one goes from the smallest shape #4 to #2 and the largest #3.

Darkness: Persimmon #4 is the lightest and least tense, #2 is darker and #3 is obviously the darkest and most tense.

In plotting the flow of these movements to determine the directionality of this series, we find:

Location	(most tense)	2 4 3	(least tense)
Size		3 2 4	
Darkness		3 2 4	
Flow of Movement		3 2 4	

Figure 22. Mu-Chi. Six Persimmons. Southern Sung Dynasty. Daitoku-ji, Kyoto.

Figure 23. Mu-Chi. Six Persimmons. Southern Sung Dynasty. Daitoku-ji, Kyoto.

For details of the movement in Series Two, see Figure 23.

Series Three: Persimmons #3, #4 and #5

Location: In terms of location, it is almost certainly #3 that is least tense, next is #4 and the most tense is #5.

Size: In terms of size, it is quite clearly #4 that is least tense, #5 is next and #3 is most tense.

Darkness: In terms of darkness, #5 is least tense, #4 is next and #3 is most tense.

Location	(most tense)	5	4	3	(least tense)
Size		3	5	4	
Darkness		3	4	5	
Flow of Movement		3	4		

Although the directionality in this series is not so clearly demarcated as before, it can still be charted, as in Figure 24.

Series Four: Persimmons #4, #5 and #6

Location: In terms of location, #4 is least tense, #5 is more so and #6 is the most tense.

Size: The movement here is the same as above, that is, #4 is least tense, next is #5 and the highest degree of tension is #6.

Darkness: Persimmon #6 is the lightest and therefore the least tense. Number 5 is next and #4 is darkest and most tense.

Location	(most tense)	6	5	4	(least tense)
Size		6	5	4	
Darkness		4	5	6	
Flow of Movement		6	5	4	

Here, the directionality is quite clear (as illustrated in Figure 25).

From this analysis of the Mu Ch'i, it is apparent that rhythm is created in several ways: there is rhythm of placement, rhythm of size, and rhythm of shading. Also, in plotting the directionality of these various rhythms, it is revealed that the total movement in the painting appears to be from right to left. In this sense, the Mu Ch'i is typically Chinese in that one "reads" it from side to side. Western paintings tend not to be directional in the same sense, in that they are usually viewed as though seen through windows. However, before the development of perspective in the 16th Century, Western paintings too were directional. All one need do is to examine paintings of the early Gothic and Renaissance periods and it can easily be determined that they, more frequently than not, begin on the left margin and

Figure 24. Mu-Chi. Six Persimmons. Southern Sung Dynasty. Daitoku-ji, Kyoto.

Figure 25. Mu-Chi. Six Persimmons. Southern Sung Dynasty. Daitoku-ji, Kyoto.

173

end at the right margin. It is to be expected that left to right would be the directionality of Western paintings since in Western culture people read in this direction, while the Chinese who read in the opposite direction, show a preference for starting the directionality of their paintings from the right, moving to the left.

By exposing the interlocking relationships of the persimmon shapes, the directionality of the Mu Ch'i becomes apparent. However, this analysis at the same time seems to have exposed a structural problem in that this movement appears to lead beyond the painting. If directionality were allowed to go unchecked, it would exclude the *Six Persimmons* as a great work of art since by definition the painting would lack harmony as well as unity and wholeness. What we have not yet been able to show is that the net effect of the work is one of balance and proportion. The analysis so far indicates that the painting is not resolved, and if balance is to be achieved we have to show that there is some counter-balancing element which resolves this unchecked movement.

We have not yet discussed the persimmon stems, but they are interesting for several reasons. The stems themselves are a kind of pattern hitherto untreated. Each stem consists of the same basic elements, a series of dots arranged differently in each of the stems, while retaining a fundamental similarity in each case. More significant than this is the way the stems function. That is, if we can see the stems to be also another rhythm, something surprising emerges. The stems are not uniform, but are clearly directional. Actually, the stems function as flags pointing, and if one notices the direction in which they point, particularly with regard to the main triads (persimmons #1, #2, and #3 and persimmons #4, #5, and #6), it becomes apparent that the stem pattern points in the direction *opposite* to the net direction of the other factors that were mentioned.

As in the case of the other themes, this directionality is not at all obvious. Beginning with the stems on persimmons #1 and #2, they can be described as "right-handed" since the horizontal stroke is to the right of the vertical and this weights them in such a way as to emphasize their directionality toward the right. The case is not so simple with the stems on persimmons #3, #4, #5 and #6 since they can be classified as "left-handed" stems and would, at first, appear to be pointing from right to left. Their true directionality, however, can be determined by examining their construction, and it is here where the shape of the stem becomes interesting. In each case, the horizontal stroke is made

first, beginning at the left and curving up to the right. Then there is an overlap of ink as the second stroke comes down to form the vertical line. At the point of overlap, a dark spot is formed due to the double coating of ink. These darker spots of overlapping layers of ink form points like arrows pointing back to the right and this is the way the eye interprets them. Thus, the nature of the strokes used to form the stems in persimmons #3, #4, #5 and #6 leads in a certain direction from left to right. If one studies the painting closely enough, it is apparent that the brush strokes forming the stems will not stay perfectly together all the time and it is possible to see the individual hairs of the brush and the directional traces they leave. So, while all the persimmon stems point to the right, they do so for different reasons, #1 and #2 because of the weight of the stems, i.e., they are "right handed" and #3, #4, #5 and #6 because of the calligraphic character of the strokes, the strokes being interpreted as moving in the direction in which they were written with a brush.

Since the stems are pointers and they point in each case from the left to the right side, the result is that the stem shapes counteract the effect of the movement of the other elements of which the painting is composed. The resolution provided by the directionality of the stems can be illustrated if we chart the tensions of the two basic triads:

Triad One (composed of persimmons #1, #2 and #3)

As we have graphed it, there is obviously an imbalance of directionality from left to right, but if we consider the stems as a rhythm, we see that they work in exactly the opposite way. That is, the stems are directional in precisely the opposite way from the other elements in terms of their rhythm:

Similarly, in the case of the second triad, there is an imbalance:

Triad Two (composed of persimmons #4, #5 and #6)

But again, the rhythms are resolved with the directionality of the stems correcting the imbalance:

Thus Mu Ch'i has successfully resolved the rhythms through the interplay of triads in the composition, plus the directionality of the stems themselves, thus producing a sense of balance. As a result, the net effect is one of *controlled tension* in a balanced whole.

We can now apply value terms to the *Six Persimmons*. From the analysis of the painting we see that there is a kind of movement in the painting that goes from element to element and this constitutes the true complexity and subtlety of the painting. Each of the groups of persimmons is an example of complexity in that what appears to be a very simple group of six objects turns out to be objects inter-related in quite an intricate fashion. Subtlety in the painting has to do with the refinement of those connections. Certainly, those inter-relationships are not easily apparent. The emergence of the triads could be an example of subtlety, or the realization that the stems, each different, are made up of the same pattern of strokes. Thus what appears at first to be unrelated aspects of the work are in fact, variations of the same thing. The construction is rich in that the sheer number of interconnections which are variable within the same groups of elements is large, that is, the overlapping character of the relationships is numerous.

On the surface, the painting looks incredibly simple, but the structure bears repeated examination. The Chinese and Japanese suggest that the more one looks at it, the more one has the impression that the painting changes. This impression of change can be traced to the detection of new patterns, that is, the perception that the number of relationships is greater than one first thought. The economy and fecundity of the painting consist in the fact that while the increments, or elements, of which the structural parts are composed are quite simple, being few in number they are, nevertheless, capable of a large number of variations. These variations are related to one another without there being a single paradigm, that is, without any one of them being dominant, thus constituting part of the elegance of the painting. Also, contributing to the work's elegance is the masterful resolution of the imbalance by the directionality of the stems.

Concerning the overall structure of the work, the harmony consists in the fact that all of the rhythms which are set in motion are resolved, even though the resolution is not necessarily of the same type in every instance, i.e., the rhythm or directionality of the persimmons is resolved by the stem directionality. The resolution of each element so that each has some significant function with regard to another element in the painting, and forms some part of the combination of the primary structures of the painting, constitutes the work's unity. The wholeness of the painting consists in each of these elements interrelating to the others in such a way that a viewer has the impression that the nature of the unity is not a mechanical one of gears to gears. That is, the nature of elemental connections is not a sum relationship; instead these relationships have an organic quality, one of inevitability and predictability. Of course, when we first view the work we are not able to articulate in direct terms the nature of the interconnections among the elements in the work, but we do sense them and this is what gives us the ultimate impression of unity, harmony and wholeness.

Concluding Remarks

As aesthetics is currently being written, little is offered in the way of aid for practical criticism. Philosophers offer few suggestions as to what kind of things critics should look for regarding the valuable features of works of art. Should a comparable situation exist in the areas of physics or chemistry, with books on the subject having little or nothing to say about what one does when confronted with the phenomena under discussion, this lack would surely be seen as a flaw. If people turn to criticism to determine what art entails, there, too, they will meet with frustration since critics are bound by their special interests and expertise to restrict their endeavors to a particular medium. In contrast, I consider what is distinctively aesthetic to be the conjunction of qualities among the arts, and not those characteristics which are peculiar to any one of them. Thus, the aim of this investigation has been to devise standards applicable to any work of art, despite its medium or cultural context. A result of evaluative criteria that can be made public and demonstrable is that the mystery usually surrounding aesthetic appreciation is dispersed since analysis becomes a straightforward matter.

Thinking about aesthetics has been confused because of insistence on focusing on areas which are essentially unknowable: the acts of creation and response. Theories preoccupied with notions of creativity as an essential part of the aesthetic experience because originality is seen as the essential characeristic of the art work, or those which persist in dealing with aesthetics as though it were reducible to matters of individual response, both have the same deficiency, they depend on certain kinds of psychological explanations which are not forthcoming. The strategy in the system outlined here has been to restrict the locus of aesthetic inquiry to that which is public, the struc-

ture of the work of art, which has the happy advantage of verifiability.

To devise general standards applicable to works of art which can be translated, freely and without difficulty, from art type to art type requires the development of a common descriptive vocabulary clarifying those features which are shared by both audio and visual arts. All media have physical properties and by investigating the physics of light and sound, certain functionally equivalent characteristics emerge which necessarily lead to structural resemblances between audio and visual forms of art. For example, examination reveals that works of art possess multiple layers of structure which are interrelated in various ways determined by the artist. More specifically, works of art, regardless of medium, consist of physical and intellectual levels and the activity of the artist consists in taking the materials of the medium and using them to construct detectable intelligible arrangements. The apprehender's response corresponds to these levels and value characteristics can be assigned to the levels according to a hierarchy based on the sophistication of construction. Thus, it is on an empirical basis that we have the means for devising a common method for describing works of art, and this leads to common trans-media standards of evaluation.

While this approach results in a reliable way of describing and evaluating works of art, the theory may be unpalatable to many people because it does not provide what they want, or expect, from aesthetics, i.e., it does not account for a person's particular responses to works of art. In fact, it suggests they are aesthetically irrelevant. Unfortunately, however, people are usually less interested in explicating and evaluating works of art in some structural sense than they are in understanding the nature of their responses and the relation of their responses to what they would call the creative process. In contrast, the assertion here has been that the aesthetic appreciation of art is different from art as a part of one's personal or emotional development. It is different from one's religious or philosophical convictions, and it is different from viewing art as an investment. All such considerations are merely personal in the way they enhance or detract from the experience of art and do not reflect on the area with which aesthetics is concerned, the value of art as part of the generalized human experience rather than the experience of any individual.

What some may regard as the narrowness of this approach, and therefore an inadequacy, may result in the rejection of the

system, but in so doing one must also forgo certain advantages. The feature which most recommends this theory is its consistency. It has the benefit of being able to demonstrate in both audio and visual examples that art can be appreciated through structural characteristics alone without any appeal being made to whatever message the work may contain.

No claim is being made that the theory, as it stands, is complete. Further work needs to be done to show how the system could be expanded to include arts not directly discussed, e.g., three dimensional art forms such as sculpture and architecture as well as composite arts like opera and drama. Since it has been demonstrated that the physics of the media is significant to the structural properties of the work in that the physical properties form the basis of the language of the art in that medium, what must be done in these cases is to map out the physical elements of the art forms and show how the levels of structure are composed from them.

Another implication of the theory which needs attention is determining whether there might be a hierarchy among media in the sense that some art types might be more likely than others to produce significant works of art. That is, the question might be raised as to whether there is a theoretical difference between media so that a given work from one media would likely be of a higher quality than a given work in another. Presumably, the process of encoding entails the selection of procedures from amongst a repertory of procedures; hence, the greater the potentiality for the work of art. Thus, where an artist's choices are severely confined by a' tradition within terms of which the artist operates, some media will not be developed because the range of choices is too narrow. Now, suppose there was a medium which, by its very physical properties was incapable of wide ranges of choices, could it be aesthetic? The answer seems to be that if it were aesthetic, it would be low level. Thus, the intrinsic richness of an art form, the possibility of selective relationships in an art form becomes a significant issue. However, the intrinsic richness of an art form does not necessarily set a limit on what the artist can do because other factors also come into consideration; i.e., value characteristics such as economy, for example.

Additionally, finer discriminations are needed to clearly distinguish among works of art that share many of the same values. As it is now one can, by using the common evaluative vocabulary, describe ways in which a composition by Beethoven is aesthetically superior to a story by P.G. Wodehouse, or why a

certain Shakespearean play is more valuable than a tune by Gershwin, but further precision would facilitate choosing among works which exhibit the more important value characteristics. For example, Auden's *Musee Des Beaux Arts,* Mu Ch'i's *Six Persimmons* and Beethoven's *Opus 111* all possess the values of each level, seemingly to a remarkable degree. How could one rank such outstanding works according to aesthetic merit? One way of refining the evaluative instrument would be to quantify the system by assigning a numerical score to each of the three levels of appreciation. And, while the scaling can only be relative in the sense that instead of an absolute standard it is in reference to some assigned mean, it is important that such arbitrariness which exists in assigning that mean not be confused with the arbitrariness which is the result of subjective judgments. Also, in order to clearly indicate the ascending order of importance placed on the values at each level, the relationships between the levels would be seen as a product relationship rather than an additive one; thus this scheme would allow for a minimizing of the lower, more common, values and a maximizing of the higher, less common, ones.

The attractiveness of approaching aesthetics in this manner is its simplicity, one might even say its greater degree of elegance. It is only through a method such as this that makes it conceivable that people could appreciate any work of art except those produced in their own time. The degree to which we stress a message component in aesthetics is the degree to which we make all works of art contemporary ones, privy to a selected few. The result of the theory presented here is that aesthetic appreciation is open and available to anyone willing to undertake the task and exert the required effort.